The Sports Show *Athletics as Image and Spectacle*

THE SPORTS
SHOW

Athletics as Image and Spectacle

DAVID E. LITTLE

Essays by Simon Critchley and Joyce Carol Oates

MINNEAPOLIS
INSTITUTE OF ARTS

This book was published in conjunction with the exhibition "The Sports Show," held at the Minneapolis Institute of Arts, February 19 through May 13, 2012.

Generous support was provided by Dorsey & Whitney LLP.

Editor: Elisabeth Sövik
Designer: Jessica Zubrzycki
Digital image postproduction: Josh Lynn
Proofreader: Laura Silver
Publishing and production management: Jim Bindas,
 Books and Projects LLC, Minnetonka, Minnesota

Excerpt from "On Boxing," by Joyce Carol Oates, copyright © 1987 Ontario Review. Reprinted by permission of John Hawkins & Associates, Inc.

Portions of "Working-Class Ballet," by Simon Critchley, appeared in conjunction with the exhibition "Men with Balls: The Art of the 2010 World Cup," apexart, New York, New York, and in "A Puppet or a God? On the Films of Philippe Parreno," *Philippe Parreno* (Paris: Centre Pompidou, JRP/Ringier, 2009).

Printed in Singapore by Tien Wah Press

Distributed by the University of Minnesota Press
111 Third Avenue South, Suite 290
Minneapolis, Minnesota 55401
www.upress.umn.edu

Library of Congress Cataloging-in-Publication Data

The sports show : athletics as photography, media, and spectacle / David E. Little [exhibition curator] with essays by Simon Critchley and Joyce Carol Oates.
 p. cm.
 Summary: "This book explores the role of photography and media (television, video, and digital technology) in transforming sports from a casual leisure activity into a spectacle of mass participation. It catalogs photography and other media exhibited at "The Sports Show" — an exhibit held at the Minneapolis Institute of Arts, February 19 through May 13, 2012"— Provided by publisher.
 Includes bibliographical references.
 ISBN 978-0-8166-7937-9 (hardback)
1. Photography of sports--Exhibitions. 2. Sports--Social aspects. 3. Mass media and sports. 4. Digital media. I. Little, David Eugene, 1963–
TR821.S73 2012
779'.9796--dc23
 2011041220

CONTENTS

FOREWORD

Museum leaders like to remind people that significantly more Americans visit museums each year than attend professional sporting events. With the Minneapolis Institute of Arts exhibition "The Sports Show," the public doesn't have to choose. Capturing the excitement and rush of adrenaline experienced in any sporting event, the exhibition spotlights the artistry of more than one hundred years of photography and media works. Created with the unique vision of innovative artists, these works reveal the transformation of sports from community entertainment into spectacles of mass participation.

Astounding works by renowned artists such as Alfred Stieglitz, Andreas Gursky, Alexander Rodchenko, and Andy Warhol put viewers in the center of the "game" with dramatic images and arresting points of view. The images presented here transcend the specifics of sporting events and communicate enduring social, political, economic, and cultural issues. The fame of the artists is certainly matched by the fame of many of the players, and the exhibition explores the role of photography and media in creating the popular sports icon.

I am grateful to our catalogue essay authors, including the organizing curator, David E. Little; Simon Critchley, professor of philosophy at the New School of Social Research; and award-winning writer Joyce Carol Oates. Their essays challenge readers to consider the deeper historical and cultural significance of sports and its images. In short, this is an exhibition that brings together art fans and sports fans.

Fervent sports fan and passionate photography scholar David E. Little, Curator of Photography and New Media, arrived at the Minneapolis Institute of Arts in 2009 and immediately began to work on this exhibition. Drawing on his expansive knowledge of both sports and photography, this project has definitely been a labor of love for David. I am grateful to him for his vision and dedication.

"The Sports Show" highlights many classic sports photographs from the MIA's outstanding collection of over 11,500 photographs in the Department of Photography and New Media, including our recent acquisition *Lew Alcindor, basketball player, 61st Street and Amsterdam Avenue, New York, May 2, 1963*, by Richard Avedon. Founding curator Carroll T. Hartwell, who organized a landmark Avedon exhibition in 1970 at the MIA, helped build the museum's superior modern photography collection with strengths in American photojournalism and documentary work. The department continues to grow into the twenty-first century under David's leadership.

Kaywin Feldman
Director and President
Minneapolis Institute of Arts

PREFACE AND ACKNOWLEDGMENTS

Playing and watching sports has always been a part of my life and my relationship to culture and politics. I still remember the day Ali fought Frazier in the "Thrilla in Manila," Satchel Paige autographing my program, arguing Cold War politics in a pub after basketball games with British teammates, and listening to the crowd roar at the Country Club in Brookline, Massachusetts, as the Americans came back to win the 1999 Ryder Cup. I suspect many readers of this catalogue and visitors to "The Sports Show" exhibition have their own memories of sport.

Despite this connection with sports, I never imagined that I would undertake serious research on the topic or organize an exhibition focused on sports photography and contemporary media. "The Sports Show" project was sparked during research in Berlin on a completely different topic. There, at the Hamburger Bahnhof Museum für Gegenwart, I experienced Paul Pfeiffer's media installation *The Saints*, which expressed the powerful role of sports and its images as a collective social experience. The installation inspired the exhibition, and I am delighted to premiere it in the United States.

An idea, though, is just an idea. Making "The Sports Show" into a book and an exhibition was a collaborative effort requiring the dedication and hard work of many people. I am grateful to everyone who contributed to this project at the Minneapolis Institute of Arts and beyond

the museum. Kaywin Feldman, Director and President of the MIA, enthusiastically supported "The Sports Show" from our first conversation. Though not a sports fan, she immediately understood my aim to illuminate the artistic significance of photography and media in sports. Matthew Welch, Deputy Director and Chief Curator, guided the project throughout, supporting its intellectual and aesthetic ambitions while making sure pragmatic details were attended to.

The catalogue and the exhibition were enriched by many institutional resources and talented people: Sarah Meister and Dan Leers, Museum of Modern Art; Jeff Bridgers, Verna Posever Curtis, Jonathan Eaker, Kristi Finefield, Barbara Natonson, and Jan Grenci, Library of Congress; George K. Rugg, Curator, Department of Special Collections, Hesburgh Libraries, University of Notre Dame, and Charles Lamb, Assistant Director, Notre Dame Archives; Freyda Spira and Mia Fineman, Metropolitan Museum of Art; Jon Evans, Veronica Keys, and Anne Tucker, Museum of Fine Arts, Houston; Virginia Heckert and Paul Martineau, J. Paul Getty Museum; April Watson, Nelson Atkins Museum; Gisela Jahn, Leni Riefenstahl Foundation; Steffi Schulze, Camera Work Photogalerie GmbH; Harvey Robinson, Ali Price, Alecia Colen, and Howard Greenberg, Howard Greenberg Gallery; James Danzinger, Danzinger Projects; the always generous Martin Weinstein and Leslie Hammons,

Weinstein Gallery; Frisch Brandt and Jeffrey Fraenkel, Fraenkel Gallery; Samantha Sheiness, Andrea Rosen Gallery; Jochen Arentzen, Sally Hough, and Ana Castella, Sprüth Magers gallery; Emily Devoe, Greenberg Van Doren Gallery; Janice Guy, Murray Guy gallery; Andrea S. Huber and Danny Solomon, Solomon Fine Art; Maya Piergies and Peter MacGill, Pace/MacGill Gallery; Robbi Siegel and Sean P. Corcoran, Museum of the City of New York; Annette Völker, Andreas Gursky studio; Rachel Rampleman, Paul Pfeiffer studio; Amanda Schmidt, Arcangel studio.

Friends, colleagues, and collectors who provided important recommendations during different stages in the project include Julian Cox, at the Fine Arts Museums of San Francisco and the de Young Museum; Catharina Manchanda, Seattle Art Museum; Christopher Bedford, Wexner Center for the Arts; Maurice Berger, University of Maryland, Baltimore County; Paul Roth, Avedon Foundation; Janet Borden, Janet Borden, Inc.; Henrietta Huldisch, at the Hamburger Bahnhof Museum für Gegenwart; Peter Cohen, friend and collector; Claire Lozier and Andrew Smith, Andrew Smith Gallery; Marc Bauman; W. L. Pate, Jr.; Jim Cook; Darius A. Hines, co-founder of Radius Books; Denise Wolff, editor, Aperture Books; Jon Sisk and Sheila Burnett of Rowman & Littlefield Press; Yasufumi Nakamori, at the Museum of Fine Arts and his former colleague, Heather Brand; and Roger Conover at MIT Press.

Elisabeth Brandt dedicated long hours to completing a lengthy grant application days before giving birth to her first child. Thanks to my grant advisory committee: Kota Ezawa, Assistant Professor of Film at the California College of Arts and an exhibiting artist; Susan K.

Cahn, Professor, University at Buffalo, SUNY; Josh Siegel, Associate Curator, Department of Film and Media at the Museum of Modern Art; Benjamin G. Rader, James L. Seller Professor Emeritus of History; and journalist Jay Weiner. Thanks to Vince Leo, MFA Director, Minneapolis College of Art and Design, and Susan Kismaric, former colleague at the Museum of Modern Art, for their close readings of my essay. Much appreciation to Simon Critchley for his contribution to the catalogue and to Joyce Carol Oates for granting permission to reprint an excerpt from her essay. Also, Kristine Stiles, Bruce Payne, and Kenneth Surin at Duke University, for being great teachers.

Thanks to supporters of the Department of Photography and New Media who provided special advice and help with "The Sports Show": Linda and Lawrence Perlman, Harry Drake, Alfred and Ingrid Lenz Harrison, Beverly Grossman, Myron Kunin, Nivin MacMillan, David and Mary Parker, Henry Roberts, Eric J. Dayton, Andrew Dayton, Blythe Brenden, Diane Lilly, Mary Ingebrand-Pohlad, and Charlie Pohlad. Thanks as well to the Department of Photography and New Media Affinity Group.

Artist and friend Tom Arndt provided much needed inside perspective on camera technology. Nicole Soukup did a wonderful job assisting with research and the time line. The following people aided her research: Susan Larson-Fleming, Hennepin Historical Museum; John Wareham, Librarian, Star Tribune; Erin George, Assistant Archivist, University of Minnesota Archives; Roger Godin, Curator, Minnesota Wild; John Schissel and Rebeccah Longawa, Timberwolves/Lynx; and Nicole Delfino Jansen, Minnesota Historical

Society. Tom Arndt would like to thank Brian Peterson at the *Minneapolis Star Tribune* and John Doman at the *St. Paul Pioneer Press*, with special thanks to Mark Peterson for his insights and his enduring friendship. Thanks also to friends Garrison Keillor and MIA trustee Ralph Strangis.

Many other Minnesota sports fans helped navigate the local sports scene, including Clark Griffith, Clyde Deopner, Jim and Donna Pohlad, Jim Gehrz, Tom Sweeney, Michael Sweeney, Chris Wright, Ralph Burnet, and Jennifer Phelps. A special advisory group provided important links to community leaders: Mike Opat, Chair, Hennepin County Board of Commissioners, and MIA trustees Sheila Morgan, Mike Ott, and John Himle. Trustees Mary Olson and Betty MacMillan also lent a hand.

Many thanks to my fabulous colleagues who worked on the catalogue and exhibition at the Minneapolis Institute of Arts: Brian Kraft, Jennifer Starbright, Tanya Morrison, Roxy Ballard the exhibition designer, Tom Jance and the installation team, Bill Skodje the model builder, Mary Jane Drews, Mary Mortenson, Katie Murphy, Julianne Amendola, Kathryn Wade, and intern Elizabeth Rooklidge. Special thanks to the dream media team Ryan Lee and Mike Dust, to Katherine Milton, Sheila McGuire, Susan Jacobsen, and Alex Bortolot in Learning and Innovation, and to Anne-Marie Wagener and Tammy Pleshek, the dynamic public relations team. Laura DeBiaso, Kristin Prestegaard, and Jim Bindas kept the book on schedule with good cheer. Dan Dennehy and Josh Lynn ensured the digital images were just right. Kurt Nordwall provided framing expertise for the exhibition. DeAnn Dankowski gave important help with the rights, checklists, and various other project details. Intern Anna Leicht compiled the bibliography. Thanks to the "smart team" who helped plan the exhibition details (you know who you are). Special thanks to Elisabeth Sövik, who read over the entire manuscript with a keen eye attuned to every word and argument, ensuring that the writing was clear and the facts were correct. Finally, Jessica Zubrzycki produced a fantastic design under a very tight deadline, and remained enthusiastic and smiling throughout.

Thanks to friends who shared good food and laughs along the way: Olga Viso and Cameron Gainier, Elizabeth Alexander, David Wilson and Dr. Michael Peterman, Andrew and Lisa Duff, Frank and Diane Lassman, John and Martha Gabbert, Maurice and Sally Blanks, Peter and Annie Remes, Tim Peterson, and Paul Shambroom. And heartfelt thanks to Dr. Jeffrey Myers and Dr. Michael Mooney, who really made this book possible.

Finally, this project and much more would not have been possible without my family, Dr. Arthur Bert and Catherine Little Bert, James and Margie Little, Joseph and Marion Little, and John H. and Mary Alexander. My wife, M. Darsie Alexander, listened patiently to many sports stories over dinners and offered her curatorial expertise and keen insights on the project. Nina, Sophie, and, of course, Buddy, provided pure joy.

I dedicate this book to Lt. Col. Walter E. and Mary Little for their unconditional love and support.

David E. Little
Curator and Head, Department of Photography and New Media
Minneapolis Institute of Arts

Untitled [Women boxing], n.d.

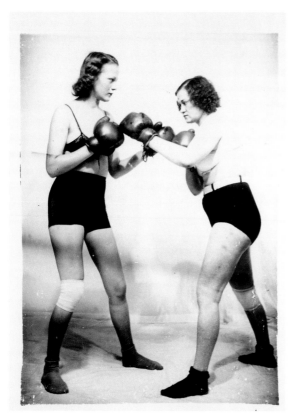

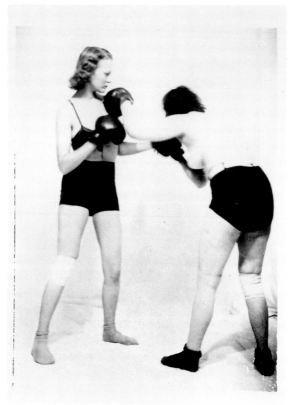

01

02

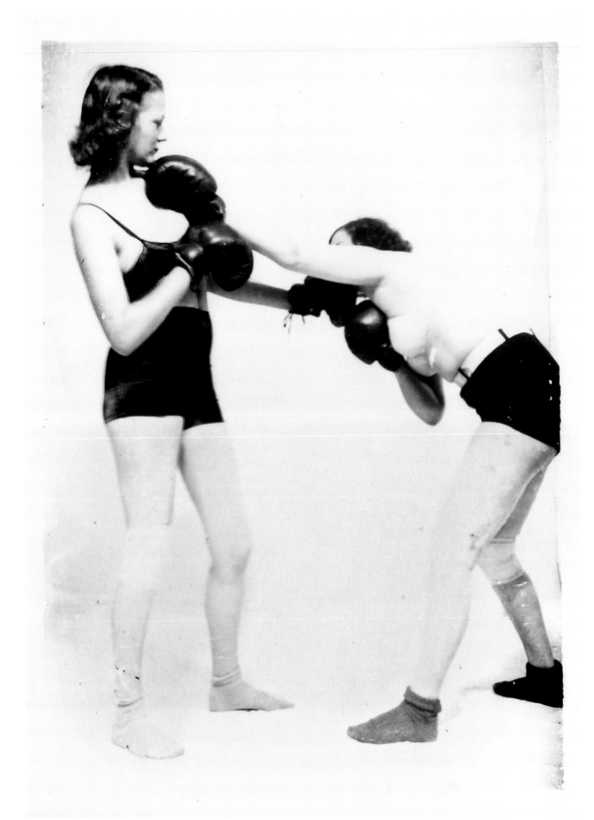

EADWEARD MUYBRIDGE

Animal Locomotion, plate 344, 1887

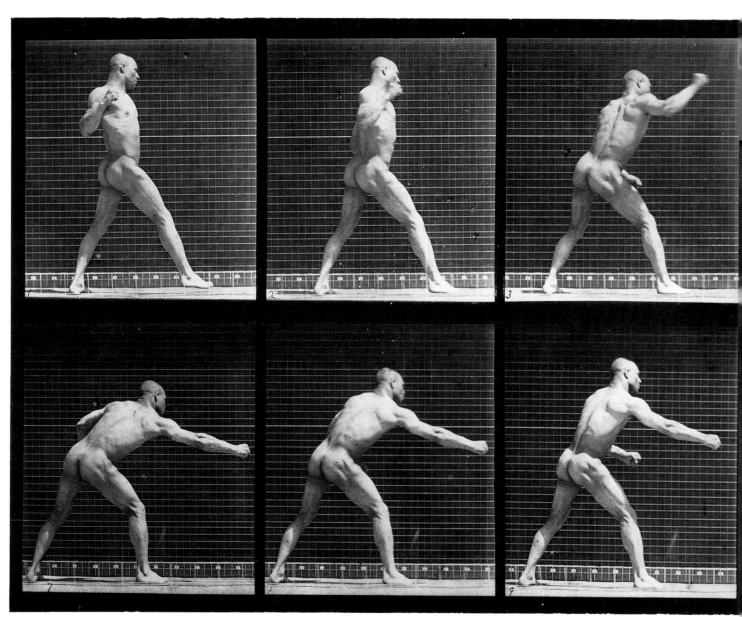

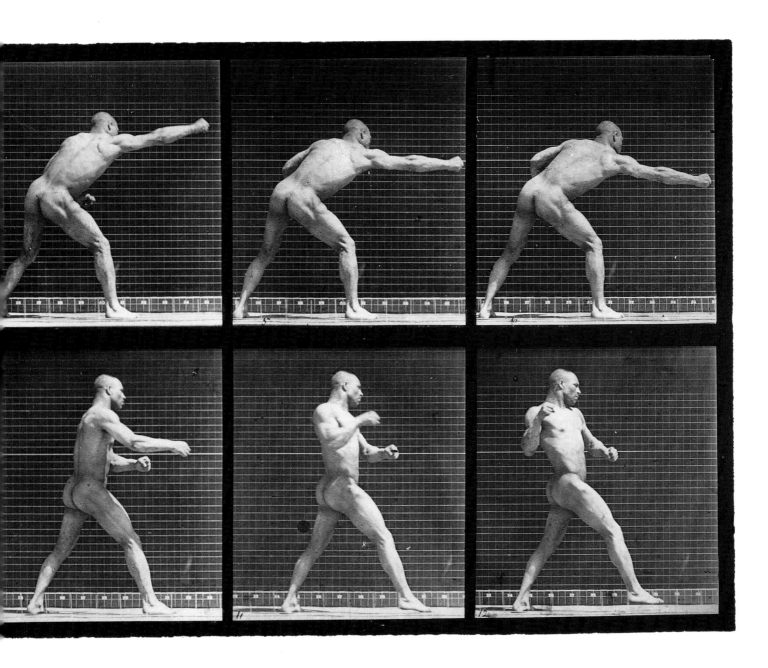

Babe Ruth, 1919

Babe Ruth was one of baseball's most photographed players. Nearly one hundred years after this picture was taken, his round face and droopy eyes are still familiar, while the visages of Ty Cobb, Honus Wagner, Christy Mathewson, and Walter Johnson—Ruth's fellow inductees in the first and most famous class of the Baseball Hall of Fame—are mostly unrecognized, even by avid baseball fans. At first glance, this straight-on, three-quarter-length portrait from 1919 looks quite ordinary: Ruth in front of a dugout with fans in the background. But look again. The great New York Yankee is wearing the uniform of the Boston Red Sox, the Yankees' archenemy. In 1919, after pitching several years for the Red Sox, Ruth was sold to the Yankees and became famous for the game-changing drama and "Ruthian" power of his lengthy home runs.

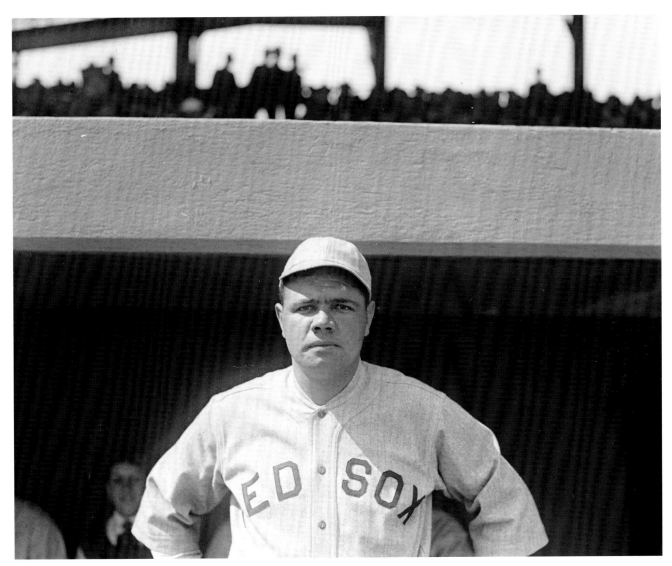

05

Untitled [Chief Paris (Sequoia Green Feather)], c. 1936–37

06

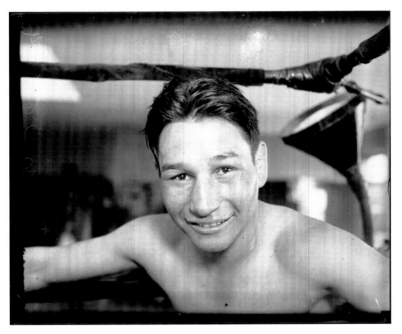

LOURDES GROBET

Untitled [Masked wrestler reading letter], 1983

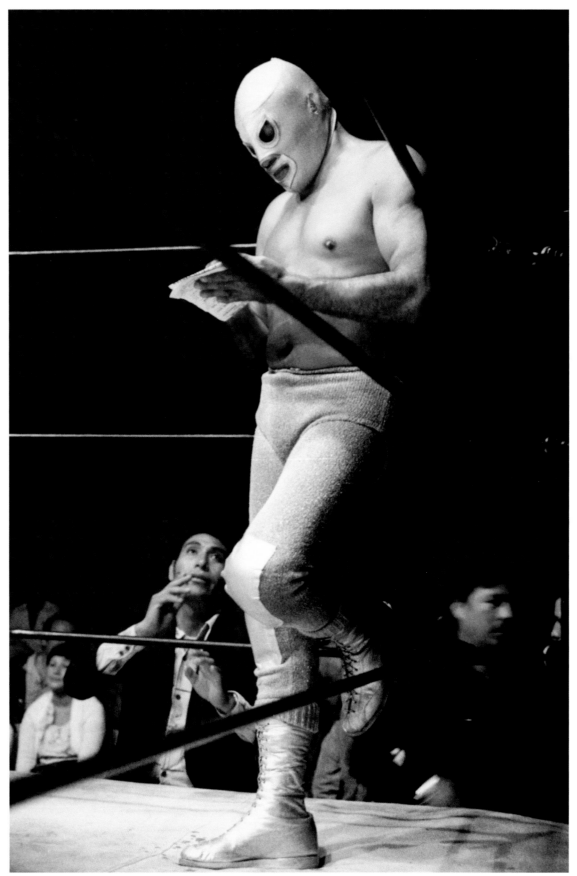

WOLFGANG TILLMANS

Heptathlon, 2009

ANDREAS GURSKY

Klitschko, 1999

Collection Walker Art Center, Minneapolis
Gift of Charles J. Betlach II, 2009

DAVID E. LITTLE

How Sports Became the "Sports Show"

FROM THE BEGINNINGS OF PHOTOGRAPHY TO THE DIGITAL AGE

Sports pictures are manifold. Created and distributed in a variety of shapes and sizes and styles, they display an array of subjects. They are odd. An anonymous snapshot shows two older women in dresses squaring off with boxing gloves (no. 35). They are retrospectively funny. Arnold Schwarzenegger, bodybuilder and future governor of California, strikes a pose for Robert Mapplethorpe (no. 121). They are historic. Thomas Eakins photographed nude boys bathing as a study for a painting (no. 16). They are scientific. Eadweard Muybridge dissected athletes' movements in photographic sequences (no. 4). They are political. Leni Riefenstahl portrayed Olympic athletes as Greek gods to feed Nazi ideology (no. 55). They are commodities. Just choose from millions of sports images available from major photo agencies. They are racially inflammatory. Former heavyweight champion Joe Frazier, wearing a blue bonnet, sits behind a stack of pancakes to advertise margarine (no. 123). They are spectacular. See the images published weekly in *Sports Illustrated*. In all of their many guises, sports images permeate culture, because few activities and rituals are as deeply embedded in culture as sports.

To twist a phrase from the British culture historian Raymond Williams, sports are a whole way of life. They have a seemingly ubiquitous presence. They are grist for water

cooler conversations—like weather, food, politics, and office gossip. They are part of childhood experiences for athletes and nonathletes, whether one played Little League baseball, was a high school basketball star, or dreaded dodgeball in gym class. They mark personal memory—a first pair of sneakers, a dropped fly ball, a group of teammates—in ways that are as significant to some as first communions, bar mitzvahs, and weddings.

Williams actually said, "a culture is a whole way of life,"[1] and he argued that a culture's most critical (and often invisible) forms are found in daily rituals, received traditions, and the "ordinary." He focused on "key words" (such as *aesthetics, culture, popular, jargon, sex*), whether found in great literature or penny novels, investigating how their shifting meanings signified broader cultural changes. However, words were better signposts in the 1950s, when Williams wrote his book *Culture and Society* (1958), than in today's "image world."[2]

Today, sports are a way of life that is represented by a multitude of photographs and media images. In the spirit of Williams's methodology, this essay will examine a selection of "key" sports images whose content and striking visual compositions register much more than just the players and games they document. Like the people who play and watch sports, sports images upend old-fashioned hierarchies. The notion of high and low art still undergirds academic discussions of photography, yet a Mapplethorpe portrait and an amateur snapshot can offer

insight into culture with equal force. So the images discussed range from black-and-white photographs made for the press to video installations intended for museum display. They yield critical perspectives on media, race, and culture at different moments in history.

The history of sports images took a new direction with the invention of photography in 1839, when it became possible to almost instantaneously create lifelike images. Glass-plate negatives in the 1850s allowed photographs to be replicated and more widely distributed at the same time sports clubs and organized sports teams were emerging in the 1850s and 1860s.[3] The popularity of the sports industry and the power of the sports image developed together. The history of sports as image begins in the late nineteenth century with small material objects—baseball cards and photographs of professional teams. In the first half of the twentieth century, personal snapshots, newspaper photography, and picture magazines circulated to growing audiences, and the 1950s brought television into many homes. After the 1960s, it becomes a history of elusive virtual images inhabiting electronic media and television broadcasting and reaching viewers in the millions. In short, sports as image began as a local phenomenon and operates today as a "show" on media platforms globally. With this historical shift from the physical to the virtual, viewing sports changed from a private experience to a collective one.

The expanded quantity, reach, and popularity of sports and sports images has affected players

as much as it has fans. Today, it is virtually impossible for major sports figures to avoid image-producing machines, not only when they are "in the game," but also (and just as importantly) when they are not. The resulting images find their way, almost instantly, to a complex twenty-four-hour media network. Sports programming flows with the days, weeks, and seasons—fall and football, winter and basketball, spring and baseball, summer and golf (and more baseball). This does not even include the coverage of athletes' personal lives: family history, marriage, kids, nightclub habits, drug problems, gambling, injuries, sexual preferences, political viewpoints, reading lists, calorie intake, workout routine, charitable foundations, role in the community, etc. No aspect of athletes' lives is too trivial to rate attention.

The merger of sports with media has created a show of unprecedented magnitude—the "sports show"—and the images of the athletes who are its protagonists, who have even become pop icons in the media, are central to understanding how it works. This "show" has much in common with "spectacle," as defined by art historians and theorists since the late 1950s to describe images under the conditions of global capitalism. The artist and theorist Guy Debord famously characterized "spectacle" in the opening lines of his book *The Society of the Spectacle* (1967): "In societies where modern conditions of production prevail, all of life presents itself as an immense accumulation of *spectacles*. Everything that was directly lived has moved away into a representation."[4] Sports are the ideal incubator of spectacle.

This essay and "The Sports Show" exhibition highlight images that capture not just the subjects themselves but everything they seem to—or try to—be and stand for. Many of the pictures represent sports figures as metaphors (for democracy, freedom, etc.), stadiums replete with media screens, and individuals acting out personas. At the same time, there are images that do more than describe the expansion of sports and the natural rhythms of games. They possess a critical dimension, reflecting on the nature of sports in culture. Nearly forty years ago, Susan Sontag argued for the significance of photographs in the face of immense proliferation of images. "The force of photographic images," she wrote, "comes from their being material realities in their own right, richly informative deposits left in the wake of whatever emitted them, potent means for turning the tables on reality—for turning *it* into a shadow."[5] Sontag understood that not all photographs are "potent." They do not all turn the tables. She suggested a selection of images which did—an "ecology" of images. With regard to the "sports show," these are images that offer perspective on the "show," breaking its spell. In doing so, they present a glimpse of how the "show" came to be where it once did not exist.

WHY NOT SPORTS IMAGES?

Sports images are everywhere. They rank high in quantity among the seemingly infinite aggregate of images we experience daily. Whether moving or still, sports images occupy a variety of formats, from black-and-white and color photographs to movies and streaming video. They are distributed everywhere through a media network that has its roots in the late nineteenth century and continues growing today. Since the 1880s sports images have filled dedicated sports sections in the world's newspapers.[6] Since the 1930s, magazines including *Life*, *Look*, and *Sports Illustrated* have published picture stories based on sports and sports stars. In the 1950s, more and more televisions flashed and flickered images of games. Since the 1970s, sports have been televised in prime time, a development that has produced immense profits for networks, professional teams, and players. Today, sports images, made by professionals and amateurs, stream as digital files across media platforms. They animate millions of cell-phone screens and Facebook pages, feeding a world populace whose appetite for sports of all types seems insatiable. Indeed, watching sports is as popular as playing. No other form of entertainment attracts the huge audiences that watch live and televised sporting events.[7] In 2011, an astounding 106.5 million people watched the Green Bay Packers beat the Pittsburgh Steelers in the NFL Super Bowl.[8]

While sports images may be everywhere, they are absent from critical discussion in the visual arts. Yet this is not the case in other areas of culture, such as literature. Leading writers from Ernest Hemingway and Jack London to Norman Mailer and Don DeLillo have written extensively on sports and culture. Hemingway dealt with macho sports, such as bull fighting; London and Mailer with race and power in boxing; and DeLillo with football in the nuclear age. Leading photographers, including Martin Munkacsi, Frances Benjamin Johnston, Henri Cartier-Bresson, and many others featured in this catalogue, have looked to sports as a subject. Nonetheless, sports images have never garnered critical attention among curators and art theorists—with a few significant exceptions such as Roland Barthes's insightful analysis of wrestling in *Mythologies* (1957). Museum exhibitions and photography histories have rarely considered sports a serious subject even after the growth of cultural studies in the 1980s. Halls of Fame and specialized museums have organized most shows, focusing their displays on sports highlights and personalities and offering little critical reflection. Predictably, these displays tend to be hagiographies of a single sport, lack the critical dimension of art forms, and treat sports in isolation or as a metaphor for some grand abstract notion (e.g., life, competition, America). In the last forty years, traditional art museums have held only three large-scale exhibitions examining sports.[9]

Speculating on the reasons behind the omission of sports imagery from any canonical history, let alone from a revisionist one, leads in several directions. One is the limits of traditional

photography history, which since its beginnings has often tried to situate photography within the sphere of art. The field's research, writing, and exhibitions have been centered on the accomplishments of individual photographers (Alfred Stieglitz, Walker Evans, and Robert Frank, among others), familiar genres (landscape and portraiture), and accepted stylistic categories (pictorialism, documentary, and street photography). How photographs circulate and acquire meanings in culture, particularly popular culture once they have entered that domain, has been largely ignored. The topic received some attention with John Szarkowski's work on vernacular photography in the 1970s, the emergence of cultural studies in the 1980s, and a growing interest in snapshot photographs, but these are exceptions to the field's dominant tendency.

Sports images as a critical subject have also suffered from the widespread, if biased, notion of sports as inherently anti-intellectual and often sexist. One thinks of the "dumb jock," a characterization in evidence as early as 1927 in the movie *College*, starring Buster Keaton. The movie begins with Keaton's character, the high school class valedictorian, delivering a commencement address on the evils of sports: "The student who wastes his time on athletics rather than study shows only ignorance. Future generations depend upon brains and not upon jumping, the discus or hurling the javelin." While this film, now nearly ninety years old, is full of dated caricatures, some of its assumptions persist today, particularly in an industry dominated by male athletes.[10] And though women have made tremendous advances in bridging the sports divide since the Title IX law required equal funding for women's sports, photographs of and by women are still in short supply.[11]

Critics have pointed to the narrow range of subject in sports images as an aesthetic limitation. Susan Sontag noted that "sports photographs show the team as a group, or only the most stylized balletic moments of play."[12] In fact, most standard sports photographs repeat the common portrait. But sports' leading artistic cliché, as Sontag suggests, is the idealized human body. Such images highlight the poetic wonder of athleticism. How did she do that with her body? The body as grace and gracefulness has been a mainstay of art since the ancients. Leni Riefenstahl's still images from the 1938 movie *Olympia* reveal the body in a variety of heroic poses. Her intention was to historicize the body within the lineage of the ancient Greeks, depicting athletes against the backdrop of the Parthenon or in poses based on classical sculpture such as the *Discobolus* (Roman marble copy after a bronze original of c. 450 B.C.). Eroticized bodies are a mainstay of photography from Pictorialism to porn. But the body in frenetic, rather than balletic, motion is the body of the modern age, energized with Filippo Marinetti's futurist spirit. Riefenstahl depicted these bodies as well, in the film *Olympia*, through the dynamic motions of runners and divers. The most typical images show the body in motion, in pain, in ecstasy, in slow motion. The body is leaping,

jumping, struggling, grimacing, flowing, and flailing. A ball is often in the mix somewhere, on the tip of a player's fingers, foot, or bat. These acrobatic images reinforce the power of muscular, chiseled, and perfect bodies reacting in ways that are unimaginable to the everyday viewer.

In truth, only a very small fraction of sports photographs merit critical discussion and inclusion in museum collections.[13] Most sports photographs in commercial newspapers and magazines feed on a visual cliché, a picture taken over and over again to the point of being interchangeable from one game to another and one season to the next. These images are just about games and nothing more. They have no lasting impact as aesthetic or historical images. Their expiration dates pass soon after the daily newspaper is delivered.

Taking an original sports picture is difficult because sports are so familiar and predictable. Sporting events unfold under highly controlled conditions, as players participate in games circumscribed by rules, rituals, and time, with distinctive uniforms and visual fields (the football grid, the baseball diamond, the swimming pool). As a result, standard typologies of sports pictures repeat across generations: team portraits with prescribed rows of players (tall ones in the back, short ones in the front); action shots of bodies in motion; documentary and social-interest pictures of fans; panoramas; and fashion shots of superstar athletes. Photojournalists also depend on basic pictures that convey the main story of a game. They want readers to see the winning dunk, the final run sliding into home plate, or the horse crossing the finishing line. This is what they are paid to deliver. Photographers covering baseball, for example, will prefocus an additional camera on home plate or second base, so they don't miss the obvious news picture.

Despite these pitfalls, amateurs and artists alike have created sports images that merit discussion in an art context. These are complex pictures with content that extends beyond the field of sports and reflects on culture at large. They show, for example, how athletes' images are shaped for a growing public, transitioning from sports stars to popular icons. They reveal the tensions of stardom against the background of racial prejudice. And they also depict sports as a site of entertainment and spectacle. Over time, the changing nature of sports images has moved audiences seemingly ever closer to the game.

IN THE GAME: The Machine-Eye

Short histories of photography and media often note that technological advances have altered the visual form of imagery. The kind of camera, lenses, and film, and the equipment's physical mobility, can literally shape both what a photographer sees and the creative possibilities of the final image (see Tom Arndt's "Sports Camera Technology," in this book). The technology available at different historical moments determined, for example, whether a photographer could produce clear pictures in low light levels or take a close-up picture of an athlete from great distances.

But knowing that advances in technology have changed the types of sports images produced is only a small part of understanding how those images have acquired cultural meaning in different historical periods. Other complex factors are involved: individual artists' approaches, stylistic tendencies, the intended function of images, and various nuanced cultural and historical influences.

The following discussion examines the changing relationship between viewers and sports images. Three key moments provide a general historical perspective on the emergence of sports as a visual "show." These occurred at the end of the nineteenth century, in the 1920s and 1930s, and in the 1960s. They serve as a framework for understanding how sports images are read in terms of fame, race, and spectacle.

Photographs offer viewers a more precise vision—through cropping and by isolating fleeting movements that would otherwise be invisible to the human eye. This makes them an ideal ally for sports audiences. By capturing moments in a game, photography allows for sustained pleasure and endless analysis. Freezing and enlarging an instant in time, it becomes a new and enhanced form of seeing. An important precedent for sports photography was Eadweard Muybridge's use of photography to arrest movement (nos. 4, 47). In 1872, using multiple cameras, Muybridge famously settled a wager regarding the gallop of a horse. He proved through a sequence of photographs that horses do indeed fly, if only momentarily, with all four hooves above the ground. In 1883, at the University of Pennsylvania, Muybridge began a comprehensive scientific investigation into animal and human locomotion. This was one of the earliest touchstones in what would become the machine-vision of sports representation. Muybridge's photographs were meant to be scientific and objective. They are taken straight on, with an adherence to Renaissance formulations of three-dimensional space. At the same time, they divide movement into sequence and offer flat-footed images as documentation.

Over forty years later, photographers used the latest technology, the handheld Leica camera, to create dramatically different photographs of movement that established a new and closer relationship to viewers. These photographs were not about dissecting movement for scientific study; they were about celebrating movement as an attribute of a new modern and social impulse of experimentation and revolution. The technically advanced Leica, introduced in 1925, was a radical tool for avant-garde artists, notably the Russian Constructivist Alexander Rodchenko, who used it to promote social and political goals for a new Marxist government in Russia. Holding this lightweight camera in one hand, Rodchenko was able to create photographs with dynamic viewpoints from various oblique angles, images that represented the photographer's movement and the camera's machine-eye.[14] The camera-eye's sharp, off-kilter views were a metaphor for Rodchenko's aspirations for cultural change. The viewer was no longer an isolated observer but part of a social whole.

Rodchenko's photographs may have been motivated by politics, but they also offered a new vision for sports audiences. They situated sports fans in the center of the action, as participant-observers. In *Dive* (no. 50), a muscular diver is suspended at the picture's left, framed by a horizontal set of numbers across the top and what appears to be a raft at the top right. The slightly rippled water far below him forms a backdrop dominating most of the picture field. In such a composition the viewer, like the diver, is untethered, with no ground from which to observe the scene. This destabilizing vision orients viewers in an imaginary space created by the camera, where they hover above the diver. *Pole Vault* (no. 51) has a viewpoint even more extreme. The perspective is an upward diagonal with a cloud and pole vaulter, as though gravity does not exist. This expressive image situates the viewer "in the game": the viewer's positioning (as created by the photographer) is as striking as the athlete's. What the new mobile camera in Rodchenko's hands offered was an opportunity to be in the game and to experience a form of seeing possible only through the camera-eye.

On April 20, 1938, around the time Rodchenko was taking his photographs, the German photographer Leni Riefenstahl premiered *Olympia*, one of the most experimental sports films and one of the most politically compromised films.[15] Ostensibly commissioned by the International Olympic Committee to document the 11th Summer Games, held in Berlin while Hitler was in power, the film was in fact funded by the Nazi party and its propaganda minister, Joseph Goebbels.[16] Hitler had commissioned Riefenstahl to direct *Triumph of the Will* in 1934, a model of filmmaking in the service of propaganda. Her budget for *Olympia* was vast. She used over thirty cameramen and developed experimental film techniques that have had a lasting influence on the way that sporting events are filmed today. Her cameraman Hans Scheib operated the "Big Bertha," an enormous telephoto lens that produced crisp images of the athletes, including a dramatic close-up of the American runner Jesse Owens (no. 53), who would win four gold medals. Another cameraman, Hans Ertle, whom Riefenstahl hired for "difficult and experimental athletic shots," developed a water-resistant camera that took some of the first pictures of swimmers and divers under water (no. 54),[17] and built steel towers inside the stadium to take panoramic images.[18] Riefenstahl also built tracks for moving cameras, dug pits next to the pole vault, and placed machines high above the field to take pictures at dramatic angles. These film techniques laid the groundwork for those used today to televise major sporting events.

The introduction of digital technology in the 1960s brought about unprecedented image production and distribution. Now, readers no longer need to wait for tomorrow's newspaper or next week's magazine; market pressures on outdated print formats have dictated that images be made available online an hour or

even minutes after they have been taken.[19] During seventeen days of the 2008 Summer Olympics in Beijing, ten staff photographers working for *Sports Illustrated* took 319,000 images, and that represents but one magazine. Because of the high stakes and money in sports, fans benefit from some of the most sophisticated visual techniques available. With each advance in technology, networks attempt to get the edge on their competitors with a new visual product, and fans have ever higher expectations of seeing every small detail, movement, and angle of the game. To meet those expectations, television has added a variety of visual guides over the years, including super slow motion and reverse angles, and, more recently, animated overlays such as a yellow line drawn on the field to indicate the first down marker in football, a virtual tennis ball indicating whether a ball is in or out, and a "trackman" system that shows the flight and distance of a golf ball. Today cameras surround and invade games. They hover above the field in blimps, race across wires suspended above the play, zoom in on players' facial expressions, hands, and feet, and record other fragments of a game. The sports action is sliced into microscopic moments that serve as hyper visual aids for viewers and add to the event's drama.

Cameras also have become partners of officials and audiences, mediating the experience and, in some instances, the outcomes of competitions. They are fans' eyes, moving bodiless above track, court, or rink as they follow players' every action. Camera images are evidence for making or confirming a call that the eye simply could not register. In the 2008 Summer Olympics, an underwater camera revealed that the American swimmer Michael Phelps had defeated the Serbian Milorad Cavic in the 100-meter butterfly gold medal finals. Phelps's victory seemed inconceivable to viewers watching the race from above the water.

The relationship between audiences and sports was redefined by the developments in photography described here. Muybridge in the 1880s captured motion by dissecting movement into images accessible to the human eye. Rodchenko and Riefenstahl in the 1930s took dynamic stop-action sports images at oblique angles, destabilizing classic perspective with the roaming camera-eye. These perspectives put viewers in the game. Since the 1960s, innovations in digital imaging have broken down and accentuated game action further. The new visual technologies do not serve science, as Muybridge's motion studies did, nor do they promote a specific ideology like Rodchenko's advocacy of leftist politics or Riefenstahl's propaganda for the Third Reich. Rather, the new vision is instrumental, driven by a desire to give fans the best possible "show."

IMAGE MANAGEMENT:
Up Close and Very Personal

The changes in sports photography that put audiences "in the game" also gave them a new sense of proximity to players. They had the impression that they somehow knew the players, even on a personal level, and television executives, sports advertisers, and athletes all capitalized on this illusion. Photography and stardom had, in fact, always been natural allies. In the age of entertainment and enterprise, from 1890 to the 1950s, photography made images of the stars available for public adoration.[20] Athletes of the era posed for the camera, giving the public an image of the player's face and also his position on the field.

Most of the pictures are run-of-the mill portraits, such as baseball players throwing a ball or holding a bat. Boxing, however, was an exception. The sport used photographs to promote its stars as personalities, fashioning notions of what it meant to be a sports star and entertainer. Jack Johnson, the first black heavyweight champion, was an early master of images that would promote the sport, however inflammatory they might be as pictures of an African American. He posed in front of a Rolls Royce and played the part of a movie star and a dandy. Baseball, which emerged as a national pastime in the late nineteenth century, used photographic images on cards to promote the teams, with advertisements on the back to raise funds for the sport.[21] Fans could hold images of their favorite players in their hands, bring them home, and post them on walls to be admired and adored long after the last strike was called. Baseball cards were

traded early on. The most famous players were handed off among children and later collected by those same children as adults, "to have and to hold" for a lifetime.

Even early in the twentieth century, leading players like Honus Wagner, star shortstop for the Pittsburgh Pirates, recognized the connection between the power of widely distributed images and personal fame and reputation. Though not well known today except among baseball aficionados, Wagner is considered one of the five best baseball players of all time and was in the first group of players inducted into the Hall of Fame. The sale of Wagner's T206 card (no. 97) in 1991 to hockey star Wayne Gretzky and sports executive Bruce McNall for $451,000 and in 2007 for $2.35 million to an anonymous buyer brought him back to national attention. Based on the carte de visite (a small portrait photograph mounted on cardboard, popular in the 1860s and avidly collected in albums),[22] the card is a modest 3 x 4 inches—small by all measures except the grasp of a child's hand. Although the picture on it is actually a colorful lithograph made from a photograph, this card provides an important example of the debate about ownership of personal images, applicable also to photography and film. The face is that of a common man with deep-set eyes and an oversized pug nose. While he may not conform to modern ideals of the handsome athlete, in his day Wagner represented the league as the image of a proud everyman baseball player. When the baseball card was published in 1909

and presented in cigarette packages, however, Wagner requested that it be pulled from circulation. He did not want to be associated with selling cigarettes to children.[23]

Star athletes such as Babe Ruth and the boxer Jack Dempsey had their photographs taken regularly in the early part of the twentieth century, but the emergence of illustrated photography magazines such as *Look* and *Life* in the 1930s brought a new depth of coverage for sports personalities. Founded in 1937 by Gardner Cowles, *Look* aimed to meet "the tremendous unfilled demand for extraordinary news and feature pictures." It told stories through pictures before the advent of television and digital slide shows on Web sites.[24] An ongoing feature in *Look* was "Day in the Life," carefully composed picture sequences (or photo stories) highlighting movie stars, politicians, everyday people, and athletes. *Look* had an extraordinary staff of photographers covering stories, but few rivaled Stanley Kubrick, the great director of *2001: A Space Odyssey* (1968), *A Clockwork Orange* (1971), *The Shining* (1980), and other celebrated films. In 1945, at the age of seventeen, Kubrick sold his first picture to *Look* magazine: a newsstand with a headline announcing Franklin Roosevelt's death. It earned him a staff position for the next five years, until he moved to film.[25]

The "Day in the Life" stories reveal a marked shift in the representation of star athletes to the public through a biweekly mass circulation that reached 2.9 million in 1948, 3.7 million in 1954, and peaked at 7.75 million in 1969. Sports stars are presented with a casual intimacy and vulnerability rarely found in today's media. As athletics and public relations have tended to merge since the 1960s, athletes and their agents have become strategic regarding the placement of images; they want images that complement the athlete's brand. In contrast, *Look* photographs were less concerned with the individual athlete than with what the *Look* editor sought to communicate about American culture. Athletes are aligned with American and humanist values, not necessarily a specific brand. The pictures tell stories of athletes in the streets, at home, in the gym, and with family.

Look's February 14, 1950, issue featured Kubrick's photographs of Rocky Graziano (no. 89) for a story called "Rocky Graziano: He's a Good Boy Now." The pictures show Graziano preparing for a middleweight fight after his suspension from the New York State Athletic Commission in 1946 for failing to report a bribe. Presented in a cinematic sequence and layout, they show Graziano sitting on a stool with his muscular arms hanging forward and hands wrapped heavily with white tape, and Graziano from below as a towering figure in a fitted shirt with the boxing logo "Everlast N.Y." These heroic pictures are paired with others that humanize the boxer: Graziano sitting at a wooden table with a towel wrapped around his waist, Graziano waking up in bed, Graziano in the shower. The photographs offer a sexualized and tamed version of the athlete. He has a life and goes through daily rituals just like us.

By the late 1950s, 90 percent of American households had televisions. By the 1960s the growing partnership of television media with college and professional sports (especially basketball, baseball, and football) began to dramatically alter the economics of sports, athletes' cultural standing, and fans' participation.[26] The first television contracts were signed in the early 1960s for a few million dollars. Ten years later, sports economics and audiences had exploded into the hundreds of millions. And today, contracts are worth billions. Sports' changing relationship to an expanding media and its audience brought about a new relationship between athletes and the media moguls who increasingly sought control of their public profiles. It also marked the beginning of new types of images, a new consciousness of the power of images, and, of course, new income. A lot of income.[27] Soon agents emerged to manage star athletes' images and branding. In 1960, Arnold Palmer was among the first to have an agent, hiring Mark McCormack, who would go on to found IMG, now one of the most powerful sports marketing agencies. (Under McCormack's management during the first two years, Palmer's endorsement income grew from $6,000 to $500,000.)[28] And charismatic professional athletes such as Muhammad Ali achieved a new status unattainable before media expansion—that of international pop icon.

Richard Avedon's portrait of a basketball player (no. 112) is one example of a new genre of iconic images of athletes in the 1960s, presenting a star high school athlete with a glamour and psychological insight rarely seen in photographs before this period.[29] On May 2, 1963, Avedon's photograph of a tall and gangly sophomore basketball player at New York's Power Memorial High School appeared in *Harper's Bazaar.* The player was Lew Alcindor, known today as Kareem Abdul-Jabbar.[30] Twenty-six years after Avedon's picture, he would retire as the National Basketball Association's leading scorer and winner of six championships.[31] In this rare picture of an athletic star in formation, Alcindor appears as a teenager with a lanky, oversized body (he would grow to seven feet, two inches), yet he possesses the stoic, mature, and confident gaze of a seasoned leader. Avedon's low-pitched perspective emphasizes Alcindor's long legs, torso, and flowing arms, making him appear stretched out with the relaxed strength and elegance of a ballet dancer.[32] Indeed, Alcindor was known as "Sweet Lew" for his seemingly effortless movements on the court. Avedon framed the full-length portrait with washed-out, geometrically composed apartment buildings in the background, situating the star in the gritty urban streets of New York, the center of the world media.

As television's moving images began to shape athletes' personas in the 1970s, an iconic photograph in a fashion magazine wasn't enough. Audiences craved more background information, wanting to know athletes and their challenges on a "personal" level. The young producer Roone Arledge understood this.

Called "indisputably the most important person in the history of sports television,"[33] Arledge developed techniques and narratives that fed sports fans' desire for a more personal relationship with their heroes even if that relationship was completely manufactured. In 1960 he wrote, "Heretofore, television has done a remarkable job taking the game to the viewer—now we are going to take the viewer to the game," and "We are going to add show business to sports!"[34] As the first president of ABC Sports, Arledge introduced sports to prime-time television with the 1968 Olympics in Mexico City, and *Monday Night Football* in 1970.[35] He recognized that televised sports could be about more than the game; it could be about the people who played and the collective experience of watching sports on television with your friends and family. This meant that sports needed to be treated as entertainment. To build drama for an event, Arledge gave audiences access to the "private" lives of participating athletes through a segment called "Up Close and Personal." These behind-the-scenes stories personalized sports stars and zoomed in on their lives, sometimes literally, with close-focused shots. They typically looked at "the story behind the story"—abuse, a childhood accident, a family tragedy overcome.

The decades of the sixties and seventies left filmed residue of these personal moments, which artists have since manipulated or reused as found material, adding a critical perspective that attempts to disrupt the presentation of images as entertainment. For viewers today,

Roger Welch's video installation The *O. J. Simpson Project* (1977) reintroduces the famed running back when he was "Juice," the football star and fledgling movie actor trying to make the jump from athletics to pop star (no. 143). Simpson must have sensed the end of his athletic career approaching. Four years earlier, he had become the first player in NFL history to rush for more than 2003 yards, but now his rushing numbers were declining. Two games after the filming of the interview, his 1977 season would end with a serious knee injury that shortened his career. He retired two years later, in 1979, when he was a rising celebrity. Fittingly, that year Andy Warhol took several Polaroids of O. J. Simpson wearing street clothes and holding a football: was he an actor or a player?

Welch's project presents a relaxed and forthright Simpson with a keen sense of the power of images and a clear desire to shape them. He seeks longevity in the public sphere once his football career ends. He wants to offer fans a new image: Simpson the actor, who can occupy many roles besides that of model citizen.

I had a certain image that I found I was becoming entrapped . . . getting trapped within the image other people have of me. You know, my image was dictating what I did and who I was. I even had a manager at one point. I was going to do something and he said, you can't do that. O. J. Simpson would never do that. I said, hey, wait . . . wait a minute. I'm O. J. Simpson [laugh]*, and I'm going to do it.*[36]

History can be cruel to the subjects of pictures, especially when the viewer knows that things turn out badly in the end. A sweet image of Anne Frank on the cover of her diary; a picture of astronauts with the space shuttle Challenger before they take off for their deaths; President William Jefferson Clinton wagging his finger at the camera, stating, "I did not have sex with that woman." History lives on with greater power than the quotidian flow of popular culture, imparting new meanings to images as they age. During Welch's interview, O.J. appears as a character in a movie unaware of his destiny. His words presage his later actions as an accused murderer of Nicole Brown Simpson and Ronald Goldman, guilty in the public eye even though acquitted in the courts in 1995. (In 1997, he was found guilty of wrongful death in the case and ordered to pay $33.5 million.) In 2007, Simpson was charged with felonies including armed robbery and kidnapping and was sentenced to thirty-three years in prison, a minimum of nine without parole.

The O. J. Simpson Project is not just a record of a tragedy in the making. It also marks another change in the shaping of the personal representation of sports stars in the media. O.J. may not let a consultant shape his image, but he is confident that he can shape his own. Image is crucial to O.J. He comments on the power of representation and the importance of staying out of the political arena, rejecting the political ambitions of many professional black athletes in the 1960s. For O.J. and many athletes of all races who would follow him, politics is too dangerous to one's image. O.J. makes this very clear to Welch. The image as a flexible brand is of the utmost importance. In an odd process, though, as cameras got closer (and more "personal") to players and as those images were distributed more broadly than ever in the 1970s, the players became distanced from their images and lost control of how the images were received and interpreted. In short, the image game is a complex one that athletes cannot control.

These examples of key images from the early twentieth century to the present reveal three critical phases in the representation of sports stars. In the early days of sports coverage, roughly the late nineteenth century through the 1930s, athletes' images (such as Honus Wagner's) were used to promote sports and encourage fan participation through advertising and collecting. The next phase, beginning in the late 1930s, coincided with the emergence of mass picture magazines and the photo stories in *Look*. Athletes were seen in more intimate settings (home, locker room, local coffee shop) and as human beings. And they also exemplified accepted social mores and types—the good family man, the hard-training athlete, the soldier serving his country. By the 1970s, athletes were hiring managers to fashion their images and distribute them in the most economically advantageous way. They attempted to discipline an image and care for it like a heavily scripted character. Hence, the surprise when in 2009 Tiger Woods's infidelities were exposed and,

unsurprisingly, many of his sponsors ended their relationship because of brand damage. The relationship between networks and athletes has become ever closer, as they collaborate on exclusive media coverage, with keen attention to the athlete's image as a popular and saleable figure that can also contribute to the network's popularity. The sports network ESPN, for instance, broadcast the show *The Decision*, presenting live coverage of the basketball player LeBron James's decision in 2010 about which team to join as a free agent.

EXCESSIVE IMAGES: Race

When images are repeated and recontextualized, they take on unforeseen meanings that cannot be anticipated or contained despite the best efforts of sports agents, publicists, reporters, and the athletes themselves. These "excess" meanings undermine the original intent and reveal contradictions in the accepted readings of images. O. J. Simpson's words, quoted above, underscore how in the 1970s athletes became more conscious of images and more invested in controlling them to maintain their value. Yet, two decades later, Simpson's images circulated with little control from him.

How African American athletes have been represented at different historical moments will be examined here in selected images of the heavyweight boxers Jack Johnson, Joe Louis, and Muhammad Ali. Johnson, the first black heavyweight champion of the world, retained a bold and flamboyant personality in the face of racial prejudice. He was Ali's hero. Louis, who had a modest persona, like Jesse Owens, was embraced as a symbol of American democracy in his fights against the German Max Schmeling, Hitler's favorite boxer. Ali had Johnson's flamboyance and used his own promotional skills to champion broader social issues. The historical changes in how athletes have been depicted shed light on the "show" of sports.

There are few pictures of African Americans in the sports history of the late nineteenth and early twentieth centuries, because they were excluded from professional sports. The unregulated and brutal sport of boxing provided one of the few arenas where African Americans and other minorities could participate. No other sport has spotlighted racial and class conflict in America as brightly as boxing. Boxing had its roots in American slavery and violence, but it offered the greatest financial and social opportunities to men of all races willing to risk their lives in the profession.[37] Jack Johnson became an early hero and antihero of boxing after winning the heavyweight championship of the world in 1908. Images of Johnson in the ring show him towering over his white opponents—that is, when he had an opportunity to fight them. Most avoided fighting a black man. Johnson finally got his title shot after he chased heavyweight champion Tommy Burns to Sydney, Australia, and businessman Hugh McIntosh guaranteed Burns $30,000 to fight Johnson.[38] Johnson brutalized Burns and gained the title, becoming the first

African American world heavyweight champion. He would hold the championship until 1915.

Few events could have been more racially inflammatory in the early twentieth century than a white man losing to a black man, a black man who would wear the mantle of the heavyweight champion of the world. In 1910, white America had its "great white hope," the former heavyweight champion James J. Jeffries. Johnson knocked out Jeffries in the fifteenth round in Reno, Nevada. In the racial violence that ensued throughout the country, at least eight people lost their lives. Johnson's victory was seen as a threat to the racial hierarchy in the United States, where blacks were treated as second-class citizens with few rights.[39] Although Johnson was not the social activist for African American causes that athletes such as Bill Russell and Muhammad Ali would be in the 1960s, he was a forerunner in presenting an image of unabashed individuality that would remain a powerful model for future generations of athletes. Johnson made no effort to appease racists in his behavior and image. Ali often cited Johnson as a model, versus Joe Louis, who played the part of the good guy.

Johnson was not modest or understated in any sense. In his life and images, he defied the social conformity expected of African Americans. Photographs show him as brash and flamboyant, wearing a dandy's top hat at the gym and standing proudly in front of his Rolls Royce convertible. Johnson also rejected social mores, marrying three white women and engaging in sexual

liaisons with prostitutes and many other women.[40] In one picture with his first wife, Etta Duryea, a well-educated Brooklyn society woman, Johnson wears an elegant full-length, fur-collared winter coat over a pin-striped suit and grasps a pair of leather racing gloves in his hand (no. 84). He faces the viewer, striding forward with his right foot, and smiles with a knowing, bright-eyed, and confident expression. Duryea, wearing a fashionable plumed white fur hat and a white fur stole with matching muff, stands facing Johnson on his left, looking bored and fatigued. She took her own life in 1912, shortly after her father died and news of her marriage reached her hometown.

Eight white boxers held the heavyweight title after Johnson and before Joe Louis, "the Brown Bomber," became the heavyweight champion of the world in 1937 with a victory over James J. Braddock, "the Cinderella Man." In stark contrast to Johnson, few athletes were as beloved by the American public as Louis. The seventh of eight children living in Chambers County, Alabama, Louis helped to break the color barrier as a "good guy" in American culture. By the time he retired in 1949, Louis counted sixty victories (fifty-one by knockouts) and one defeat.

Louis's one loss, in 1936, to the German Max Schmeling in the twelfth round, was devastating for Louis and the American public. (This was the same year Jesse Owens won three gold medals at the Olympics in Berlin.) Adolf Hitler celebrated the victorious Schmeling as a symbol of Nazi Germany and the superiority of the

Aryan race. Two years later, on June 22, 1938, Schmeling and Louis met for a rematch in what one paper called "Joe Louis versus Adolf Hitler Day." Pictures from the time show two boxers of almost identical size, both with slim muscular bodies holding a classic boxing pose (no. 88). Schmeling's right hand is raised to Louis's jaw, mimicking the knockout blow he delivered in 1936 to the vulnerable opening above Louis's slacked left hand.[41] But Schmeling had no luck the second time around with the more experienced and better trained Louis (Louis was then twenty-four and Schmeling thirty-two). Before a sold-out crowd of seventy thousand at New York's Yankee Stadium, Louis knocked out Schmeling with devastating speed 124 seconds into the first round. In one of the great beat and hip-hop bursts of energetic, poetic writing long before those two trends emerged, Bob Considine wrote on deadline "Louis Knocks Out Schmeling" for the International News Service.

Listen to this, buddy, for it comes from a guy whose palms are still wet, whose throat is still dry, and whose jaw is still agape from the utter shock of watching Joe Louis knock out Max Schmeling. It was a shocking thing, that knockout—short, sharp, merciless, complete. Louis was like this: he was a big lean copper spring, tightened and retightened through weeks of training until he was one pregnant package of coiled venom. Schmeling hit that spring. He hit it with a whistling right-hand

punch in the first minute of the fight—and the spring, tormented with tension, suddenly burst with one brazen spang of activity. Hard brown arms, propelling two unerring fists, blurred beneath the hot white candelabra of the ring lights. And Schmeling was in the path of them, a man caught and mangled in the whirring claws of a mad and feverish machine.

After the receipts were counted, Louis had made $200,000 a minute and Schmeling $100,000 a minute. Louis became a national hero and despite his brown skin was seen as a personification of American grit and toughness, whereas Schmeling's whiteness represented the Aryan race and Nazi Germany.

Photographs of Louis feature the boxer as an American and African American hero. A picture by the celebrated Harlem portrait photographer James Van Der Zee shows Louis in the 1930s in a pastoral setting on a grassy path (no. 99). This studio portrait stages Louis as a noble hero with perfectly combed hair, masculine pose, and skin without a hint of sweat. He is not the Johnsonian man-about-town or the dandy. He is the hardworking, down-to-earth boxer stripped to the essentials—boxing shorts, gloves, and leather boxing shoes. He is a raw fighter before the camera. Louis worked hard to cultivate this image throughout his career. His handlers even established a set of rules to protect his image, including "never to have his picture taken alongside a white woman" and "to keep a deadpan [expression] in front of the cameras."[42]

In the 1940s, we get a very different image of Louis in *Look* magazine (no. 90). This is not Louis the boxer; this is Louis the American. The photo story portrays Louis as a well-to-do middle-class American linked with values of success through land ownership. This "Day in the Life" depicts the champion as a gentleman farmer. Each photograph is accompanied by a caption: "Joe Scrambling Some Eggs," "Getting into His Buick," "Joe Reads the Funnies," "Joe Bowls," "Manager of the Farm," "Lunch is Served," "Joe's Favorite Horse." The story's theme is Joe as everyman. But, in fact, Joe is an African American whose parents were children of slaves. He now owns the symbolic farmhouse on the hill whose owner once owned his ancestors. The full caption for "Manager of the Farm" (no. 90, p. 161) suggests this more complicated story: "Manager of the Farm is Herman Brede, who has run the 477 acres at a profit for 18 years. When Joe bought the land, Brede thought he'd lose his job. But Joe said, 'You go on runnin' the place, like always.'" The caption reassures readers that despite the success of Joe Louis the social order remains stable. The farm's ownership may have changed, but everything will stay the same. In the images and text of this narrative, Louis is an African American who represents an American dream whose roots in racial inequity he will not threaten.

Stability was never advocated in Muhammad Ali's actions and images some twenty years later. No athlete in the twentieth century better exemplified the iconic status of the contemporary athlete in the age of expanded media than Muhammad Ali. No athlete better illustrated the media's flexibility in the name of profit. A convert to Islam, a conscientious objector to the Vietnam War, and an outspoken commentator on racial inequity in the United States, Ali balanced roles as popular star and political activist.

A gold medal winner in the 1960 Olympics in Rome, the twenty-two-year-old Ali (then known as Cassius Clay) challenged the heavily favored Sonny Liston—a seemingly unbeatable ex-con with a muscular body of stone and a menacing demeanor—for the heavyweight championship in Miami in 1964 and won, stunning Liston with a "blind" punch. Ali attracted the media with his flamboyant persona, handsome looks, exuberant personality, and, above all, his sharp wit. Leading up to the Liston fight, for example, Ali taunted the champ with the nickname Big Ugly Bear. Ali was an entertainer and a performer. He studied and emulated the theatrical tactics of the professional wrestler Gorgeous George. At the same time, Ali was serious and substantive. He helped to generate discussions about the legitimacy of the Vietnam War and the legacy of slavery symbolized by his ancestral slave name, Clay.

William F. Buckley, Jr., the leading conservative spokesman of his time, interviewed Ali on his program *Firing Line* in December 1968. After a sarcastic introduction, Buckley began with the question, "What makes [you] believe that the same country that glorified Joe Louis would want to persecute you?" To which Ali responded: "Joe Louis was what you would call, or what a

white would call, a good red–blooded American boy who went to the Army and told the world, we must fight for our country. . . . In his times we didn't have the protestin' and the things that we're havin' today. But I would say that I received respect by not only blacks around the world, . . . but all throughout white America, more so than any boxer including Joe Louis. And mainly with the college youth of today. So, I'm just a lot different from . . . Joe Louis." Ali was undoubtedly different from Louis, but so was the context. Ali's images were also very different.

Neil Leifer, a longtime staff photographer for *Sports Illustrated*, captured the young Muhammad Ali in one of the best-known photographs in sports history. Ali stands above Sonny Liston after delivering a glancing blow to Liston's temple in the first round of their title bout in Lewiston, Maine, in 1965. Viewed from a low ringside angle, Ali's towering figure in white shorts is set against a black background. His mouth is open and his right hand gestures across his chest, imploring Liston to get off the canvas. It is as though he is saying, "get up, get up." Liston lies prostrate and dazed, his legs immobile and both arms above his head as though surrendering or under arrest. Ali's swift upset victory with the so-called phantom punch shocked the world for a second time. Leifer's picture is so powerful because it shows not only Ali's victory, but his ascension as a media star and public icon. Like the thousands of photographs taken inside and outside the ring since, it shows Ali in control. We always sense that he is posed in character. We see him playacting, punching the Beatles, extending his fist into the camera, opening his mouth wide in mock outrage, or smiling with a knowing glance. He is a man of many images, who rarely drops his mask.

The photographer Garry Winogrand, known for capturing complex images of daily life with his 35-millimeter camera, was perfectly suited for the media's new speed in the post–1960s era. Conscious of the camera's fabricated vision, Winogrand famously remarked that he photographed in order to find out what things look like photographed. Ali was his perfect subject. In 1969 Winogrand began a photographic series that would be known as *Public Relations*, which looked at the "effect of media on events." He photographed election campaigns, press conferences, rallies, museum receptions, and various other manufactured "events." One picture shows Ali surrounded by a mass of reporters and microphones (no. 96), his face in its familiar pose—mouth open, eyes down, intense and poised—at the very moment he is delivering his lines. The reporters' expressions of anticipation, pleasure, and laughter suggest that Ali is making some grand proclamations about his greatness and victory. The reporters and Ali know they are in the game. They know Ali will deliver a funny quip, material for a news story the following day.[43]

Winogrand stood slightly at a distance to capture the publicity machine in action. Kota Ezawa pulls us even farther back in *Brawl*, a 16-millimeter film in which the image and sound of race are dissected by layers of animation.[44]

Ezawa's subject is a player altercation that turned into a small-scale race riot. It occurred during a professional basketball game between the Detroit Pistons and the Indiana Pacers at the Palace of Auburn Hills, in Michigan, on November 19, 2004. Ezawa appropriated footage from the incident and translated it through a selective process of animation and editing. The actual brawl began with a drive to the basket by Ben Wallace, Detroit's muscular center. Ron Artest, a defensive specialist known for his physical play and unpredictable behavior, knocked Wallace to the ground. In basketball lingo, this is a "hard foul," meant to stop a basket and to intimidate the opposing players.[45] For many, it is "part of the game." Not for Wallace. He retaliated by pushing Artest to midcourt, where a group of players and coaches then scuffled in a burst of chaos.

In the television coverage, events unfold so rapidly that details are blurred and broadcasters' comments are scarcely noticeable amid the visual drama—unless the footage is replayed and slowed down many times over. In effect, that is what Ezawa's film does on many levels. First, he simplifies the event's details through a *South Park* style of cartooning, in which players are represented as silhouettes lacking even the simplest jottings of eyes, nose, and mouth (no. 142). Their faces are undeveloped, as though hidden behind oval masks. In one scene, a group of African American players is drawn as a brown mass of anonymity and power. The crowd, too, is undifferentiated. Ezawa's cartoons are akin to characters in Brechtian theater, who act out

the events and yet distance viewers from them. Ezawa also deploys a number of filmic techniques to call attention to the media—flashing bulbs, a television frame, and a slow pan of the camera. The event and the media are both onstage.

The film also explores narrative through sound. As the images slow down, the broadcasters' comments are amplified. Unprepared to discuss anything other than players, statistics, and the game, they fumble for words to describe the events. "Totally uncalled for!" begins Bill Walton, still in his comfort zone describing the game. He means that Wallace's contact with Artest is an overreaction to the hard foul. His announcing partner concurs, "You just have to let it go . . . that was not that hard of a foul and Wallace overreacted." Even early in this sequence, there is fear in the announcers' tone, as though they sense unease among the players and fans: "They need to figure out how to get this game over." Then, they move into new territory as the players break the wall with the audience. The announcer whines in a high voice, "Now Artest has jumped over the scorer's table!" And later, "Artest is looking very scary." Artest is now the angry black man who has gone into the stands to take on several white fans who had thrown beer at him and yelled expletives.[46]

Representations of star African American athletes (O. J. Simpson excepted) follow a historical pattern similar in many ways to that for images of mainstream white athletes. In the early twentieth century, Jack Johnson's portraits were character types used to promote his boxing

matches, functioning much like pictures of the great baseball stars of the period. In the 1940s, *Look* magazine's profile of Joe Louis showcased him as a good American with the right social mores, the same overlay used for Rocky Graziano. In the 1960s, Muhammad Ali carefully managed his image as "the greatest" to promote his matches and articulate his political viewpoints on race, religion, and the war. A decade later, O. J. Simpson also sought to promote his career but avoided a political stance so as not to jeopardize the malleability of his brand.

As we have seen, representations of African American athletes are unpredictable. Inflected by issues of race, they release overlooked or unintended meanings. Kota Ezawa's work filters the experience of reading representations of black athletes, allowing viewers to see, from a distance, the outlines of the "show"—the show that is supposed to retain normative meanings and keep us within the game. In *Brawl* all norms are abandoned, and we experience the tensions between the black athletes as performers and the white audiences.

To *New York Times* sportswriter William Rhoden, integration is yet another symptom of enslavement of the black athlete.

Though integration was a major pivot in the history of the black athlete, it was not for the positive reasons we so often hear about. Integration fixed in place myriad problems: a destructive power dynamic between black talent and white ownership; a chronic psychological burden for black athletes, who constantly had to prove their worth; disconnection of the athlete from his or her community; and the emergence of the apolitical black athlete, who had to be careful what he or she said or stood for, so as not to offend white paymasters. At the same time, it destroyed an autonomous zone of black industry, practically eliminating every black person involved in sports—coaches, owners, trainers, accountants, lawyers, secretaries, and so on— except the precious on-the-field talent.[47]

Rhoden may be empathizing with the wrong class of black athletes, "the forty-million-dollar slaves," and may be holding out sports as a panacea for black culture. But his point is well taken. There is a price to be paid by the black athlete within the show, and part of that price is the loss of opportunities beyond the act of performing as an athlete.

SEEING THE "SHOW"

The merging of sports with media that began in the 1960s produced the "sports show," and artists have created images that offer at least a partial view of this "show." As mentioned earlier, the "show" shares attributes of Guy Debord's "spectacle," emphasizing the role of images as cultural ciphers that carry meanings beyond the people and things pictured. Though he began writing about notions of spectacle in the late 1950s, before the development of digital media and the expansion of distribution platforms

such as television and computers, Debord had a sense of how images function today. However, in his vision of spectacle as culture, everything and everyone is a pawn in an all-encompassing, amorphous system, undefined and yet defining everything, in which observers and participants are in a state of permanent passivity—with capitalism behind it all.

In the 1990s, scholars such as Jonathan Crary went a step further than Debord in detailing the conditions that produce the spectacle and inform the ways in which images are produced and interpreted. In his *Techniques of the Observer: On Vision and Modernity in the Nineteenth Century*, Crary looks at "vision and its historical construction."[48] While proposing a prehistory of the spectacle in the nineteenth century, he locates its historical beginnings "in the late 1920s, concurrent with the technological and institutional origins of television, the beginning of synchronized sound in movies, the use of mass media techniques by the Nazi party in Germany, the rise of urbanism, and the political failure of surrealism in France."[49] This corresponds, roughly, to the time when Alexander Rodchenko's and Leni Riefenstahl's experiments with new camera equipment created innovative images that put audiences in the game.

Crary argues that the emergence of digital technologies in the mid-1970s marked a "sweeping reconfiguration of relations between an observing subject and modes of representation."[50] I contend that the "show" emerged in the 1960s, when televisions populated homes and images

circulated to mass audiences. At that time, television networks signed new contracts with professional teams, giving major exposure to leagues and their stars. Before then, images of sports and sports stars were limited in quantity and distribution. Today, decades later, broadcasts to worldwide audiences are commonplace. There are now more teams, more players, more fans, more money—a lot more money—and, above all, more images. Sports are represented and distributed in staggering quantities of images through new technologies and varied creative strategies.

The stars of the past made big money for their athletic achievements, and sporting events drew comparably large live and listening crowds. (In 1938, seventy thousand spectators watched and over a million listeners tuned in to the historic championship fight between Joe Louis and Max Schmeling.) Before television, stars' images didn't penetrate the realm of popular culture to the same extent or with such profitable results. Even athletes whom we now consider legendary heroes lacked the financial security of today's average professional athletes, profits garnered by managing one's images as well as one's game. When Jesse Owens returned from winning four gold medals at the 1936 Olympics in Berlin, he opened a modest small business, Jesse Owens Dry Cleaning Company. Only a year later, he filed for personal bankruptcy. Jack Johnson, the boxer who during his prime invited journalists to touch his immense body and watch him bathe nude,[51] ended his career doing magic tricks near Times

Square. Failing to manage his money, Joe Louis ended his career as a host in Las Vegas, struggling with cocaine and gambling addictions.

Though the "show" emerged in the late 1960s, by the mid-1970s there certainly was a new intensity in the relationship between subjects and observers. Indeed, O. J. Simpson discussed his image as an abstract entity in 1976, and Muhammad Ali performed for the camera with keen awareness of the power of images to promote both his boxing matches and his political viewpoints. For observers, the "show" at this point was not about vision; it was about visual sensations. It promoted a form of seeing that is an integrated multimedia experience of sound, image, and environment. Traditional modes of photography had limited application in this arena. How does one photograph, for example, the experience of being in a sports stadium with over sixty thousand screaming fans, a flow of food and drink, body-thumping "jock" jams ("We Are the Champions" by Queen or "Are You Ready for Some Football?" by Hank Williams, Jr.)? Every moment is filled with entertainment: mascots jumping on the dugout, cheerleaders, dancing teams, music mixes, T-shirts, video clips of past and present games. There are even in-house announcers who broadcast the "live" game through a media network that is only available to attendees via in-stadium television screen and jumbotrons. It was difficult, almost impossible, to capture this new sensation of the sports "show" with the small scale and limited impact of black-and-white photography.

Andreas Gursky, Douglas Gordon and Philippe Parreno, Sharon Lockhart, and Paul Pfeiffer are artists who use multimedia formats to engage the "show" in a critical manner that provides a glimpse of its workings. The German artist Andreas Gursky, commonly associated with the Düsseldorf school, led by teachers Bernd and Hilla Becher, takes grand photographs of public spaces—discos, rock concerts, landscapes, and sporting events. He uses vibrant color, the seamless illusion of Adobe Photoshop, and massive scale to create immersive still images. In *Klitschko* (1999), Gursky panned out to get a wide view of the layers of live and media audiences watching a heavyweight boxing match between Wladimir Klitschko and Axel Schulz (no. 9). At the center, the boxers stand in the ring, surrounded by a chaotic group of officials, handlers, and even fans. Layered around them are bright blue seats and a swath of crowd, with a ring of lights and a huge scoreboard hovering above. The scene Gursky registers with a camera and analogue technology is not enough—it does not capture the "show." In the same vein as a nineteenth-century academic painter, he adds details to the scene, constructing an image that is closer to the truth than a straight photograph. He retains a seamless vision of the real while adding the accents of an immersive experience. He suggests a world of exaggerated reality where direct modes of description are rendered inadequate.

Whereas Gursky's still image provides a fictive, but clarifying, perspective, Douglas Gordon and Philippe Parreno zoom in to dissect an individual

athlete in the film *Zidane: A 21st Century Portrait*. The film reminds us that today's athletes play under the watchful gaze of multiple cameras, from the sophisticated commercial equipment of professionals to the portable cameras of amateurs which click and flash throughout games. Gordon and Parreno used seventeen cameras to record the French soccer star Zidane during an entire ninety-minute match between Real Madrid and Villarreal on April 23, 2005, at Madrid's Santiago Bernabéu stadium.

The film may be in real time, but the images are clearly created by the artists. The film captures the grand spectacle of a major soccer game—the vast stadium with people and flags, the persistent sound of horns blowing, and the strange beauty of the bright artificial lights glowing in the evening's darkness. It bathes viewers in the otherworldly lightness, pleasure, and theater of the game as it slowly unfolds over time. The movie delivers Zidane in bits and pieces to his loving fans. Quick-paced edits shift from close-ups of Zidane's feet, face, and hands to views of his play within an isolated area of roughly ten yards to long shots of the entire field. This zooming in and out emphasizes the cameras' role as a surrogate for the viewer's vision, cropping and shaping images. At times, the cameras shift from Zidane, showing the crowd under the bright stadium lights at night; the soccer ball floating into the air; the ball caught in the goal's net; a man viewing a monitor. But cameras are always on Zidane even if the film clips are elided. He is the axis of their movement

and the movie's narrative. Zidane is mercurial, much like the game he plays, with its long pauses followed by sudden bursts of movement. He is stone-faced until eighty-one minutes into the film, when he talks with a teammate and breaks into a smile. The pleasure is momentary. Eighty-three minutes into the game, he rushes into a dispute among players with his arms and elbows flailing aggressively. A teammate restrains him, an opponent rubs his head gently, assuring and calming Zidane. The referee pulls out a red flag, a sign he is ejected. Game over for Zidane. Game over for the viewers. End of the film. Cameras off, at least for now.

Zidane is conscious of being filmed and of being watched. He is part of a generation of athletes who are always being filmed. They are subjects in a state of becoming images. In the film, Zidane speaks in a brief voice-over of knowing, intuiting a score as if it were preordained. But his imagination does more than envision the game. He also speaks of an imaginary sound track accompanying his movement. A voice is in his head, the voice of an announcer from his childhood, when he was part of the audience watching soccer games on TV. Zidane imagines that he is the object of commentary, that a narrator describes his every move. Zidane's comments point to the odd phenomenon that media can change the movements of players in some respects. It is common, for example, to see track competitors and football players look up at a large screen feeding live images of the event to see who is

chasing them. Athletes today can be detected enacting poses, some unconsciously, through a subtle gait, and others premeditated, through histrionic gesticulations after a score or a key play.[52] Sharon Lockhart explores this in *Goshogaoka Girls Basketball Team* (1997), a series of twelve images of Japanese women basketball players (nos. 140, 141). High school players enact poses based on photographs of professional Japanese women's basketball games.[53] They re-stage gesture, the gesture of athleticism as a received image of conformity.

While Gursky examines the visual components of the arena and Gordon and Parreno portray the sports and media star, Paul Pfeiffer historicizes the role of the crowd in his sound and media installation *The Saints*, which was commissioned to mark the opening of the renovated Wembley Stadium in England in 2007.[54] Pfeiffer used the historic 1966 World Cup final between England and West Germany as a point of departure to explore the relationship between the crowd, power, and politics in sports.

I'm drawn to the aura that surrounds certain mass media events and images. I'm interested in how they resonate in people's minds, their power to inspire strong feelings. You can hear it in the roar of the crowd at a football stadium, which sounds to me like religious fervor. The '66 World Cup is an example of that. What interests me about that material is the possibility of using it to tap into people's imaginations.[55]

Pfeiffer went back in time to a soccer match that was as much a political event as it was a game. With the violence, trauma, and outrage of World War II fresh in everyone's mind, two formerly warring nations were competing on a new battlefield. The 1966 match took place at Wembley Stadium, a relic of the British Empire Exhibition of 1924, and in London, which had endured Germany's nighttime bombings of civilians—ideal sites for this symbolic war. England's victory over Germany, 4–2 in overtime, was the country's first World Cup victory (and to date its only one). This was more than a simple victory. It represented a cultural triumph and signified a broader return of social order in the world. For Americans, the social and political significance is hard to grasp. Perhaps the closest parallel in American sports is "the Miracle on Ice," the U.S. Olympic hockey team's victory over the Soviet Union in the semifinals of the Winter Games in 1980. It didn't matter that they had to play Finland the following night for the gold medal; the United States had defeated its Cold War rival, the so-called evil empire.

Pfeiffer's installation is based on audio and video footage of the game that he found during his research for the project. He discovered that a single microphone had recorded the game's sounds. Although this mono recording hardly captured the crowd's frenzy, it was clear enough for a listener to comprehend their chants and songs, and these became a key part of *The Saints*. To convey the rabid emotions of 1966, Pfeiffer

decided to re-stage the crowd in the present. He did so in the Philippines, hiring a group of Filipinos to read the sounds of the German and British crowd like a Fluxus score or karaoke, posted on screens. (One of the songs, "When the Saints Go Marching In," inspired the work's title.) But the script alone wasn't enough. To motivate his hired crowd, Pfeiffer used a local theater director and film clips of the Filipino boxing star Manny Pacquiao.[56]

The Saints installation consists of a large gallery and a smaller room (no. 10). In the gallery—which varies in size and details depending on the installation site—audiences hear the rhythmic chants of the crowd from a distance, drawing them toward the metaphoric event of the past. On a small video monitor, they see an edited clip from the game's original black-and-white televised coverage. The footage has been manipulated so that all one sees is a single player running across a field; Pfeiffer erased everything else. Without teammates, opponents, referees, and the soccer ball, the player's solitary movement on the pitch is absurd and futile. This is Sisyphus soccer. In the smaller room, a dual-screen presentation shows the complete rebroadcast of the 1966 World Cup final alongside video clips of the Filipinos' crowd reenactment—a juxtaposition showing the disjuncture of time, space, and race which Pfeiffer has spliced together in this artwork.

In a striking transhistorical translation that moves across time from 1966 to 2007 and shifts geographically and culturally from England to the Philippines, *The Saints* highlights the role of sports as events through which audiences can release nationalist fervor. The crowd sings and shouts nationalist songs and anthems and taunts (the English crowd is heard chanting "We won the war, we won the war"). Indeed, there is no greater stage for international competition, both athletic and political, than the Olympics or the World Cup. *The Saints* captures a powerful moment when sports and politics merge.

————————⬭————————

I have attempted here to examine the role of sports imagery in culture against the backdrop of the "sports show." The "show" did not always exist, even though it seems as natural as next week's game on the schedule. ESPN's around-the-clock cable sports station first came on air in 1979, and CNN's twenty-four-hour cable news aired in 1980—barely more than thirty years ago. The sports show and the prominent role of sports images in culture constitute a historical phenomenon. This essay has focused on the relationship between sports images and observers over time. In general, from the beginning of sports photography to the present day, images have positioned viewers closer and closer to the athletes and the action. Simultaneously, the subjects of these images have become more and more disconnected from

PAUL PFEIFFER

The Saints, 2007

© Paul Pfeiffer
Courtesy Paula Cooper Gallery, New York

10

viewers. This gap between subject and observer is where the show exists and where observing sports becomes a participatory experience eliciting a range of emotions.

The images discussed here elucidate the complex role of sports in culture. They highlight the carefree pleasure of the amateur, whether player or participant-observer; the intensity and political consciousness of athletes like Muhammad Ali and Kareem Abdul-Jabbar; the marketing of athletes as commodities; the aura of the modern sports arena; thinly veiled racial tensions; and nationalistic fervor and pride. Still, many more considerations remain to be addressed, and I hope this discussion will prompt investigations of what social and political forces created the need for the "sports show" and what function the show serves in culture.

NOTES

1. Raymond Williams, "Culture Is Ordinary" (1958), in *The Everyday Life Reader*, edited by Ben Highmore (London and New York: Routledge, 2002), p. 95. In the late 1950s, when Williams developed his analysis based on "key words," television was just beginning to appear in households; he would analyze television later, in 1974.

2. Susan Sontag, *On Photography* (New York: Farrar, Straus, and Giroux, 1977), p. 153.

3. For an outstanding account of the development of sports in America, see Elliott J. Gorn and Warren Goldstein, *A Brief History of American Sports* (1993; Urbana and Chicago: University of Illinois Press, 2004).

4. Guy Debord, *Society of the Spectacle* (Detroit: Black & Red, 1983). First published in 1967, in France.

5. Sontag, *On Photography*, p. 180.

6. In 1883 Joseph Pulitzer created the first newspaper sports department, for the *New York World*. Twelve years later, in 1895, William Randolph Hearst created the first newspaper sports section, in the *New York Journal*. The *Boston Gazette* is credited with publishing the first sports story, covering a boxing match, in 1733. Paul M. Pedersen, Kimberly S. Miloch, and Pamela C. Laucella, *Strategic Sport Communication* (Champaign, Ill.: Human Kinetics, 2007), p. 155.

7. The Louvre museum in Paris attracts 8.5 million visitors annually to its internationally renowned collection, and the British Museum has 5.9 million visitors. Artinfo, "Louvre Remains Attendance Champion," July 13, 2010. http://www.artinfo.com/news/story/33619/louvre-remains-attendance-champion/

8. In 2010, the New York Yankees attracted 3,765,807 fans for eighty-one home games and at least another 3 million for eighty-one road games. Of course, this doesn't account for the 116 million people who watched the Yankees play in a six-game World Series against the Philadelphia Phillies in 2009, not to mention the other playoff series. http://www.espn.go.com/mlb/attendance

9. "Man in Sport," Baltimore Museum of Art, 1968, organized by Robert Riger; "This Sporting Life, 1878–1991," High Museum of Art, 1992, organized by Ellen Dugan; "Hard Targets," Wexner Center for the Arts, 2010, organized by Christopher Bedford. "Hard Targets" focused on contemporary art and gender; the earlier shows featured historical photography.

10. Only recently have women artists seen the subject of sports as an opportunity to explore various forms of masculinity. The contemporary photographers Catherine Opie and Collier Schorr, for example, each created a photographic series that looks at how sports help shape masculine identity in young men. Opie's *High School Football* (2008) mixes action scenes of night games under dramatic lights with individual portraits. Schorr's photographs examine the eroticized bodies of male high school wrestlers. Like Leni Riefenstahl's 1936 photographs of Olympic athletes, both series dramatize the androgynous male body through languid poses, partial nudity, and subjects who are between adolescence and manhood. Despite their attempts to transgress gender stereotypes, Opie and Schorr returned to one of photography's timeless subjects, the body as fetish.

11. "No person in the United States shall, on the basis of sex, be excluded from participation in, be denied the benefits of, or be subjected to discrimination under any education program or activity receiving Federal financial assistance. . . ." Title IX of the Education Amendments of 1972, 20 United States Code Section 1681.

12. Sontag, *On Photography*, p. 171.

13. American museum collections have very few sports images, but my research found an overlap of select sports photographs in several museums. These include Jim Dow's color photographs of baseball stadiums taken in the 1980s; Stephen Shore's pictures of the New York Yankees during spring training in Fort Lauderdale in 1978; and Tod Papageorge's evocative pictures for *American Sports, 1970: or, How We Spent the War in Vietnam* (New York: Aperture, 2007). These photographs fit comfortably within the period's established photography categories. Dow's color photographs of American baseball stadiums are updated versions of the grand style of American panorama; Shore's pictures of the New York Yankees fit neatly into 1970s color photography; and Papageorge's are fine examples of black-and-white photography in the vein of Garry Winogrand.

14. Leah Dickerman, "The Radical Oblique: Aleksandr Rodchenko's Camera-Eye." *Documents*, no. 12 (Summer 1998): 22–34.

15. *Olympia* is a three-and-a-half-hour movie divided into two parts, *Fest der Völker* (Festival of Nations) and *Fest der Schönheit* (Festival of Beauty). Riefenstahl worked over eighteen months to edit the film. The premiere, held in Berlin, was set to coincide with the forty-ninth birthday of Adolf Hitler, who was in attendance. For a detailed critique of Riefenstahl, see Susan Sontag, "Fascinating Fascism," *New York Review of Books*, February 6, 1975, pp. 73–105.

16. Even though Riefenstahl denied Goebbels's guiding hand in *Olympia*, Sontag notes, "The truth is that *Olympia* was commissioned and entirely financed by the Nazi government (a dummy company was set up in Riefenstahl's name because it was thought unwise for the government to appear as the producer) and facilitated by Goebbels's ministry at every stage of the shooting." Ibid., p. 74.

17. Leni Riefenstahl, *Leni Riefenstahl: A Memoir* (New York: Picador, 1987), p. 185.

18. Ibid.

19. Photographers for the *Minneapolis Star Tribune* note that in the "early days" photographers worked on their pictures up to half an hour after a game, whereas now they transfer files between innings or during timeouts. Personal communication.

20. See chapter 9, "The Age of Sports Heroes," in Benjamin G. Rader, *American Sports: From the Age of Folk Games to the Age of Televised Sports*, 6th ed. (Upper Saddle River, N.J.: Pearson/Prentice Hall, 2009), pp. 139–56.

21. Peck and Snyder, a manufacturer of baseball equipment, began to produce cards with photographs in 1869.

22. André-Adolphe-Eugène Disdéri's invention of the paper carte de visit, measuring $3\frac{1}{2}$ x $2\frac{1}{2}$ inches, launched the mass production of photographic images. Mathew Brady's carte of Abraham Lincoln made Lincoln's face known to the populace and is said to have helped him get elected.

23. Some claim that Wagner pulled the card because he was not paid enough for his image. However, accounts of Wagner's personality make this seem implausible. Regardless of why he pulled it, Wagner clearly had the star power to control his image.

24. Two other international magazines taking a similar approach were the French *Vu* and the German *Berliner Illustrirte Zeitung*. *Look* folded in 1971. For a history of *Look*, see Donald Albrecht and Thomas Mellins, *Only in New York: Photographs from* Look *Magazine* (New York: Museum of the City of New York; Monacelli Press, 2009).

25. Kubrick's first film, *Day of the Fight* (1951), grew out of a *Look* photo shoot with the boxer Walter Carter, who became the subject of the film.

26. The 1950s and 1960s produced the first major sports stars who started to benefit from the popular media spotlight. Three players, Joe DiMaggio, Ted Williams, and Sandy Kofax, never managed to adapt to the media attention. DiMaggio was the first baseball player to earn $100,000 a year; yet he lived with his sister in San Francisco and in his post-baseball career earned money as the pitchman for Mr. Coffee and from autograph fairs.

27. Disney pays between $1.8 billion and $1.9 billion per year for telecast plus broadband and mobile rights. ESPN is currently paying $1.1 billion for Monday Night rights. The broadcast rights for the 1948 Olympics in London were roughly £1000 to £1,500. With the spread of television in the 1960s and the growing popularity of the Olympics, the rights for 2012 commanded £2.5 billion. (As I write this essay, the National Football League and the National Basketball League are on the brink of a major labor dispute. It primarily concerns the distribution of profits.)

28. McCormack's clients included Jack Nicklaus, Gary Player, Rod Laver, Pelé, Nick Faldo, Greg Norman, Pete Sampras, and Tiger Woods.

29. Avedon, with Edward Steichen earlier in the century, was one of the first photographers to cross over from commercial to artistic photography. He developed a signature style of bold, dramatic, large-scale portraits. He photographed for publications such as *Harper's Bazaar*, *Life*, *Look*, *Vogue*, and the *New Yorker*.

30. Alcindor boycotted the 1968 Olympics as part of the Black Power movement. He converted to the Muslim faith and changed his name to Kareem Abdul-Jabbar soon after turning professional in 1971.

31. Alcindor led Power to a seventy-one consecutive-game winning streak and broke all of New York City's rebounding and scoring records. He starred under coaching legend John Wooden at the University of California, Los Angeles, where he led his team to three consecutive national championships; became a Hall of Fame player in the National Basketball League; and was named one of the top fifty players of all time.

32. Anyone who ever saw Alcindor play cannot help but look at his long arms and picture his body sweeping through the lane taking an elegant hook shot, a shot that was all but unstoppable by opposing players—an instant two points.

33. Frank Deford, "Roone Arledge, 1931–2002," *Sports Illustrated*, December 16, 2002. http://sportsillustrated. cnn.com/vault/article/magazine/MAG1027766/index.htm

34. "We Are Going to Add Show Business to Sports," *Sports Illustrated*, December 16, 2002. http://sportsillustrated.cnn.com/vault/article/magazine/MAG1027769/index.htm

35. Arledge later became president and chairman of ABC News, making television reporters such as Peter Jennings and Ted Koppel into news stars with their own programs.

36. O. J. Simpson, interview with Roger Welch, December 6, 1976, for *The O. J. Simpson Project* (1977).

37. David Remnick notes: "Boxing in America was born of slavery. . . . Southern plantation owners amused themselves by putting together their strongest slaves and letting them fight it out for sport and gambling. The slaves wore iron collars and often fought nearly to the point of death." *King of the World: Muhammad Ali and the Rise of an American Hero* (New York: Random House, 1998), p. 221.

38. Johnson was guaranteed $5,000.

39. Rader, *American Sports*, p. 148.

40. For a summary of Johnson's relationships with women, see the Web site for Ken Burns's documentary *Unforgivable Blackness: The Rise and Fall of Jack Johnson.* http://www.pbs.org/unforgivableblackness/knockout/women.html

41. Schmeling studied films of Louis's fights before the 1936 match and discovered that he lowered his left after throwing a punch. For more on the fight, see Joyce Carol Oates, "The Avenger: Joe Louis vs. Max Schmeling," in *On Boxing* (New York, London, Toronto, Sydney: Harper Perennial, 2006), pp. 259–71.

42. Remnick, *King of the World*, pp. 225–26.

43. Ali always seemed to control his image and to act out a scripted scene. But on rare occasions he slipped and the mask fell off. William Klein shows one such moment in his brilliant film *Muhammad Ali: The Greatest, 1964–74.* Ali is training to face the undefeated heavyweight champion George Forman. Again, Ali is the underdog. Cameras and reporters surround him and a crowd of citizens from Manila watch with great reverence. Ali then begins to act, saying, "I will be called the greatest of all time." He pretends to take a punch from his sparring partner and falls to the mat. Mimicking the voice of a sports announcer, he proclaims: "M. Ali is all washed up. It's all over. George Forman has knocked him down four times. . . . The heavy-weight champion of the world, George Forman. The lip has been shut forever." The African fans watching are upset by Ali's comments and fall seriously silent, and he says, "Tell my fans to cheer up [they then clap]."

44. "The program does very little. It's a very traditional animation technique. This could also be done just by using cut paper and cameras. There's no digital effect used to create this animation. The only reasons why I do it on the computer are time, efficiency, and cost. It's almost like backward engineering. I look at the film, and then I try to recreate it using very crude means, a very specific number of elements. For example, there's never a variation in a person's skin tone—each person has one skin color, while in reality every person has millions of different colors in their skin. By simplifying the drawings, the result can be read in a variety of ways. People who have seen this film will see the process where I extract enough information, or, in some cases, I highlight information that makes it recognizable." http://www.brooklynrail. org/2008/09/art/kota-ezawa-in-conversation-with-constance-lewallen

45. A hard foul is rather common in basketball and is intended to stop a player from lifting his arms, in any way, so he cannot get the shot off to the goal. Instead of an easy two points, the fouled player must make two foul shots.

46. Nearly fifty years earlier, baseball legend Ty Cobb attacked a heckler in the stands. He pummeled and kicked the fan with his spikes while other fans pleaded for him to stop. The targeted fan had no hands, but Cobb displayed no remorse. When the baseball commissioner suspended Cobb, his teammates refused to play until he was reinstated.

47. William C. Rhoden, $40 Million Slaves: The Rise, Fall, and Redemption of the Black Athlete (New York: Three Rivers Press, 2006), p. 142.

48. Jonathan Crary, Techniques of the Observer: On Vision and Modernity in the Nineteenth Century (Cambridge, Mass.: MIT Press, 1992), p. 1.

49. Ibid., p. 18n26.

50. Ibid., p. 1.

51. Oates, On Boxing, p. 244.

52. Indeed, gesture is key to all sports. A player's physical comportment is a psychological weapon used to project an image that will provide an advantage over a competitor. This can take the form of trash talking, physical bumping, facial expressions, and other physical taunts. It can also be manifested in a hyper coolness and poise that conveys confidence and a lack of fatigue.

53. Dominic Molon, "The Delicate Structure of the Everyday," in Sharon Lockhart (Chicago: Museum of Contemporary Art; Ostfildern, Germany: Hatje Cantz, 2001), p. 15.

54. The Saints was commissioned by Artangel, London.

55. Udo Kittelmann and Britta Schmitz, eds. Paul Pfeiffer: The Saints (Heidelberg: Kehrer Verlag, 2009), p. 50.

56. The crowd was located in a theater on the second floor of a building. Pfeiffer said the crowd became so rowdy that he feared the floor would be compromised. It was difficult to turn the crowd off.

ANDY WARHOL

Pelé, 1977

11

12

13

14

SIMON CRITCHLEY

Working-Class Ballet

Let me try and explain why football, or soccer as you say here in the U.S., is so important to me, and why it becomes more rather than less important to me as I get older. My family is from Liverpool in the northwest of England and my father used to train at Liverpool Football Club's training ground in the early 1950s until an ankle injury curtailed his career. Dodgy ankles meant he had to wear Chelsea boots for the rest of his life, although he looked kind of stylish in them.

My mum tells me that I could kick a ball before I could walk and the main plank in my somewhat tempestuous relationship with my dad was football. Until he died late in 1994—indeed during the final weeks of his illness—it was the only thing we talked about sensibly at any length. When we discussed politics, we would always end up shouting at each other. As a kid, I remember long car journeys to and from games where we would analyze every facet of the game in anticipation (on the way there) and reflection (on the way back) with scientific, indeed forensic, detail. I remember crying

inconsolably in the car on the way back from an F.A. Cup semifinal when Liverpool had lost badly to a manifestly inferior team on a muddy and uneven pitch (playing field). Football is all about the experience of failure and righteous injustice. It is about hoping to win and learning to accept defeat. But most importantly, it is about some experience of the fragility of belonging: the enigma of place, memory, and history.

My nuclear unit of a family moved from Liverpool to the south of England, which is where I grew up. We were economic migrants in a part of the country that we didn't recognize and which didn't recognize us. Liverpool Football Club came to represent whatever "home" meant to me and was a huge element in whatever sense of identity we had as a family. Our house was called De Kop, after the famous sloping terrace at Anfield where the hardcore supporters stood and sang (Spion Kop is the Dutch name of a hill in Ladysmith, South Africa, which was the location of a battle during the Second Boer War—football is also a battlefield). I made a sign

with the words "De Kop" in my woodwork class at school. It took weeks to make. I remember getting beaten up at elementary school for speaking funny, i.e., with a detectable Liverpool, or "scouse," accent. So, I learnt to speak another way, in the sort of anonymous, irritating BBC whine that I carry to this day.

I was a decent player, nothing special, but played at county level when I was ten years old. My dad was very proud and used to come to all the games. Because of the vagaries of the English class system, when I passed the entrance exam to get into a grammar school at age eleven, a kind of academic public school that has largely and happily died out, the only sports they played were rugby, field hockey, and cricket. These were gentlemen's games because football was considered too working-class. I wasn't allowed to play football, unless in my spare time, and lost any small talent I had. I played off and on until my early thirties, until time's wingèd chariot obliged me to hang up my boots.

When my first son, Edward, was born in 1992, my first violent patriarchal act was to decorate his room with Liverpool pennants and other paraphernalia. Like me, he would have had no choice but to support Liverpool. Sadly, the Liverpool team that I grew up with—a team of invincible demigods welded together through the authoritarian will of Bill Shankly, who was coach from 1959 until 1974—is no more. In the 1970s and 1980s, Liverpool were so good that, Shankly joked, they'd have to bring a team from

Mars to beat them. He also said, and I love the arrogance of this quotation:

My idea was to build Liverpool into a bastion of invincibility. Napoleon had that idea. He wanted to conquer the bloody world. I wanted Liverpool to be untouchable. My idea was to build Liverpool up and up until eventually everyone would have to submit and give in.

Despite the allusion to Napoleon, Shankly was a lifelong socialist, and it should never be forgotten that the true name of soccer, which goes back to the formal organization of the game in England in the 1860s, is *association* football. Football is an experience of association, an idea that might not be too whimsically linked to Marx's talk of "an association of free human beings" in *Capital*. The way Shankly understood socialism was very simple:

The socialism I believe in is not really politics. It is a way of living. It is humanity. I believe the only way to live and to be truly successful is by collective effort, with everyone working for each other, everyone helping each other, and everyone having a share of the rewards at the end of the day.

In 2006, Liverpool Football Club was bought by two American sports capitalists: Tom Hicks and George Gillett. A few short years later, in the 2009–10 season, with hundreds of millions of dollars of debt, Liverpool enjoyed its worst season for eleven years. This present season (2010–11) has been even worse, a disaster, and the club was taken into receivership and then

eventually bought, like a hooker on a street corner, by New England Sports Ventures, owners of the Boston Red Sox. That said, Kenny Dalglish, my boyhood hero, to whom I wanted to dedicate my Ph.D. thesis, until I was strongly discouraged from doing so by senior faculty at my university, was appointed coach in late December 2010 and things are beginning to look up.

Sometimes I think I should have let my son support some other team, like Arsenal or Manchester United (God forbid!). But maybe there's something of a parable in Liverpool's demise: football is all about an experience of disappointment in the present that is linked to some doubtless illusory memory of greatness and heroic virtue. The odd thing is that it isn't the disappointment that is so difficult to bear; it's the endlessly renewed hope with which each new season begins. I'm reminded of an interchange in Aeschylus's *Prometheus Bound* between the chorus and the god Prometheus, chained to a rock in the Caucasus. In addition to fire and technology, the chorus asks what else Prometheus gave humans.

Prometheus: "Yes, I stopped mortals from foreseeing doom."

Chorus: "What cure did you discover for that sickness?"

Prometheus: "I sowed in them blind hopes."

THE WORLD CUP

The World Cup is a spectacle in the strictly Situationist sense.[1] It is a shiny display of teams, tribes, and nations in symbolic, indeed rather atavistic, national combat adorned with multiple layers of commodification, sponsorship, and the seemingly infinite commercialization— among the official FIFA sponsors are Coca-Cola, Budweiser, and McDonalds. The World Cup is an image of our age at its worst and most gaudy. But it is also something more, something bound up with difficult and recalcitrant questions of conflict, memory, history, place, social class, masculinity, violence, national identity, tribe, and group.

My first memory of the World Cup is when my dad took me to see England play Argentina at Wembley Stadium in 1966. I was six years old and this was a big deal. It was a famously tetchy, irritable 0-0 draw that went down in legend because the Argentine captain, Rattin, who had committed grievous bodily harm on a number of English players, refused to leave the pitch when he had been sent off. He clearly wasn't a gentleman. The games provided the background for three subsequent World Cup encounters between England and Argentina, in 1986 (Argentina won, with two goals from Diego Maradona, one with his hand, the famous "hand of God" incident),[2] in 1998 (Argentina won again, after a young, impetuous David Beckham had been sent off for retaliation), and 2002 (when England won and Beckham redeemed himself with a winning goal). Reflecting on

the "hand of God" incident and victory over England in 1986, Maradona said:

It was as if we had beaten a country, not just a football team. . . . Although we had said before the game that football had nothing to do with the Malvinas war, we knew they had killed a lot of Argentine boys there, killed them like little birds. And this was revenge.

Football is the continuation of war by other means.

Speaking of war, if you are not English, it is difficult to understand the way in which the memory of England's victory in the 1966 World Cup against the erstwhile West Germany still defines and distorts the present. I remember the game very clearly. Indeed, it is one of my earliest memories. England were leading 2–1 when Germany equalized and forced the match to go into extra time. England went ahead 3–2 after a Russian linesman allowed a goal that had pretty clearly not crossed the line. The fourth goal was added by hat-trick hero Geoff Hurst as England fans were flooding onto the pitch. A very common English football chant against the German fans that continues into the present is the following: "Two world wars and one world cup, do-dah, do-dah." But this one English victory in the World Cup functions like a veritable albatross around the necks of the England team. England exited the 2010 World Cup last summer with a humiliating 4–1 defeat to a younger, fitter, better, and much more imaginative German side.

It really hurt. Losing is one thing, but losing badly to a clearly superior team is awful.

My most powerful memory of the World Cup is from Mexico, in 1970. Brazil won for the third time, which meant that they got to keep the trophy. This was the team of Pelé, in his fourth World Cup, Jairzinho, Rivelino, Tostão, and Gérson. The names alone had a sort of magical power for me. I would roll them silently around my mouth as I kicked a ball against the wall, as if incanting a spell. The 1970 Brazil team was the greatest attacking team of all time and the side against which any subsequent team (the Netherlands in 1974 or France 1998) is measured. My mother has a photograph of me, aged ten, wearing a full Brazil uniform.

The World Cup, then, is about ever-shifting floors of memory and the complexity of personal and national identity. But at its best it is about *grace*. A truly great player, like Pelé, like Johan Cruyff, like Maradona, like Zidane, has grace: an unforced bodily containment and elegance of movement, a kind of discipline where long periods of inactivity can suddenly accelerate and time takes on a different dimension in bursts of controlled power. When someone like Zidane does this alone, the effect is beautiful; when four or five players do this in concert, it is breathtaking (this collective grace has been taken to a new level by the F.C. Barcelona team in the last few years). But grace is also a gift. It is the cultivation of a certain disposition, some call it faith, in the hope that grace will be dispensed.

Football is working-class ballet. It's an experience of enchantment. For an hour and a half, a different order of time unfolds and one submits oneself to it. A football game is a temporal rupture with the routine of the everyday: ecstatic, evanescent, and, most importantly, shared. At its best, football is about shifts in the intensity of experience. At times, it's like Spinoza on maximizing intensities of existence. At other times, it's more like Beckett's *Godot*, where nothing happens twice.

Let me try and make some sense of these thoughts by focusing on an exemplary artwork, which is featured in "The Sports Show": *Zidane*, by Douglas Gordon and Philippe Parreno, from 2006. The movie's subtitle is *A 21st Century Portrait* and these words have a wide range of meaning. *Zidane* is a meditation on the nature of the image and the endlessly mediated quality of reality. We begin by watching the usual flat TV images and commentary of the game before being sucked in to something else . . . but let's leave that "something else" for a moment.

At the most obvious level, *Zidane* is a portrait of the twenty-first century, where reality has an utterly mediated quality. It is a world of celebrity and commodity, a world of smooth and shiny surfaces, a hallucinatory reality, nothing more. The twenty-first century is a portrait. Everything is a portrait. Zinedine Zidane himself is a portrait, a perfect and magical fetish, a pure commodity that inspires desire, a product with rights owned by Adidas, Siemens, or his whole panoply of sponsors. Zidane is a spectacle.

Sure, you might respond. That's right. Point taken. We are all children of the Situationists and the world is a world of images. Nothing more. No more reality, as Parreno would say.

But there is more to a portrait than some Situationist thesis about the society of the spectacle. Douglas Gordon talks somewhere about the importance of silence and immobility in portraiture. This is crucial, I think. At one level, when we look at a portrait we look for something about ourselves in the image. In the interview he gave to accompany the film, Zidane recognizes this and acknowledges that people watching the film will perhaps be able to feel themselves in his place, "un petit peu" (a little bit), he adds. Such is the nature of the image at the level of identification. This is fine. But there is more.

It's the *petit peu* that counts. The paradox of Zidane as a portrait is that he is constantly in movement and engulfed in the noise of the crowd and the game. And yet, in the firmness, closedness, and severity of his face we see through the skin, through the image, to something else, what I want to call some truth, some darker truth, even some reality beyond the image. Somehow, in all the cacophonous noise and ceaseless movement of the film, there is a dark kernel of immobility and silence.

The model for this is Velázquez, and I take it that *Zidane* is a kind of homage to and reenactment of the famous portrait of Pope Innocent X. As is well known, when the far from innocent-looking pope saw Velázquez's portrait, he said

"troppo vero," too true, or too much truth. This is echoed in Zidane's remarks on his image in the movie. Firstly, he says that his face looked "un peu dure, un peu ferme" (a little hard, a little tough), but then he adds, "c'était moi quoi; voilà, c'était moi" (it was me; you see, it was me).

Zidane is a portrait in a double sense, then. On the one hand, it give us a sense of the capture of reality by commodified images in the century into which we are slowly slouching our way. But on the other hand, this portrait is true to Zidane in a way that exceeds the sensible content of the image. There is the suggestion, the adumbration, of an inaccessible interiority, a reality that resists commodification, an atmosphere, something like Orpheus looking over his shoulder as Eurydice disappears into Hades.

The film begins and returns to the phrase "an extraordinary day." Of course, Saturday, April 23, 2005, when the movie was shot and the match between Real Madrid and Villarreal was played, was a perfectly ordinary day. At halftime we get a flash sequence of images from the outside world, in a chaotic muddle of the instantly forgotten. All that counts is what takes place in the stadium, in the face of Zidane. This has something to do with abandoning oneself to chance and the flow of time. As Zidane says, he might have been injured after five minutes or sent off at the beginning rather than the end of the match. The fact is that he wasn't. It is the act of submission to the order of time that is crucial. The ninety minutes of the game provide a frame, an order of counting and accounting within which

the extraordinary can happen. Zidane keeps looking up at the clock during the match, checking the time. Such is the time of the line, of the frame, of the game. Vulgar clock-time.

But another temporal order opens up within this submission, a different experience of duration, not the linear flow of ninety minutes, but something else. In abandoning oneself completely to chance, something like necessity begins to appear, even a sense of fate. In his commentary on the film, Zidane recalls the moment—it only happened once—when he received the ball and he knew exactly what was going to happen, he knew that everything had been decided. He knew he was going to score before the ball had even touched his foot.

This bifurcation in the order of time is also found in what Zidane says about his memory of a match. You don't really remember a game, he says. It's a series of fractured images that announce a different experience of duration: episodic, random, flickering. Memory flares up and catches hold of an image and sucks out its truth. This is time as ecstasy.

In the late 1950s, in the heyday of 3-D cinema, there was an experiment in scratch-and-sniff cards that were given to moviegoers in order to intensify their experience. At a given prompt, they would scratch away at the card and sniff fresh-mown grass, gunpowder, rotting alien flesh, or whatever. I can smell this movie, Zidane.

There are two things that totally escape you when you watch football on TV: smell and sound. Football is all about smell: the crowd, the acrid

piss stink of the toilets, beefy Bovril, cigarette smoke, and meat pies. But there is also the smell of the earth, the earth that Zidane treats with such delicacy, carefully replacing divots of grass ripped out during play, or the persistent light dragging noise of Zidane's foot against the pitch. There is something nostalgic, elegiac about this smell, and when I think back to watching games with my dad when I was young or crying in the car home if Liverpool lost, then what I remember are smells, but most of all the smell of wet earth on the pitch that ascended into the terraces.

Zidane is all about sound. Zidane talks about the experience of sound when he is playing. Of being pulled in and out of the game through noises, of the vast presence of the crowd when you go onto the pitch. He has the most acute sense of hearing during a match. He can hear someone cough or whisper to his neighbor. "Il y a du son" (there is sound), he says, and adds an extraordinary phrase, "le son du bruit." The sound of noise. In many ways, this movie is about the *il y a* of the sound of noise, the sheer thereness of noise as engulfing. This is what it is to be in a crowd—sensate ecstasy.

We only know football through commentary, through largely and hugely inane commentary. There is no immediacy here. The whole experience is completely mediated and mediatized. Zidane recalls when he was a kid commenting on himself playing as he was playing. We all did this. It was as if only an act of ventriloquism and self-distancing could grant you access to

what was of utmost importance to your being (recall Bill Shankly, "Football is not a matter of life and death. It's more important than that."). The *Zidane* film gets as close as possible to the immediacy of football mainly because it is made out of sheer love of the game. But we can only get so close. Zidane recalls running and sitting as near to the TV as he could in order to watch French *Téléfoot* and listen to the voice of the commentator, Pierre Cangioni. He says—and this is fascinating—that what attracted him was not the content of Cangioni's words, but the tone, the accent, the atmosphere. It is this atmospherics that *Zidane* tries to evoke, to draw us into, the evocation of space, a heavenly sphere, the time of breath and vapor. At times, it reminds me of the cinema of Terrence Malick.

GRACE AND DESTRUCTION

At the end of his peculiar yet utterly powerful short essay "On the Puppet Theater," Heinrich von Kleist ponders the nature of grace. Given the restless nature of human consciousness, Kleist concludes that grace will only appear in bodily form in a being that "has either no consciousness at all or an infinite one, which is to say, either in the puppet or a god." Is Zidane a puppet or a god? I couldn't possibly say. What he has is grace. Which means that he could be both. It is the grace of Zidane's movement that is astonishing.

It is unclear what meaning there is—if any—to heroism in the twenty-first century.

The hero is an icon. We know that. But he is also something more. The true hero is possessed of fragility and solitude. Most of all, and here is where Zidane comes closest to the figure of the hero, he is wedded to self-ruination.

Zidane smiles once, maybe twice, in the movie. The second time is towards the end of the match when he exchanges some casual banter with the great Brazilian wingback Roberto Carlos. Real Madrid is winning after being a goal down to a stupid penalty. Zidane created the first goal ex nihilo with an extraordinary show of intelligence, power, speed, and skill. He seems happy. But it's a menacing smile. Almost a grimace.

Darkness descends, the eyes darken and he seems engulfed in a claustrophobic intensity of doubt and self-loathing. A teammate is fouled badly, but not appallingly. Zidane runs across the pitch and whacks the guy and looks like he is going to hit him again until David Beckham pulls him off. Then some kind of world of pain breaks over Zidane. He is sent off and submits to the law, reluctantly, but he submits nonetheless, like at the end of the 2006 World Cup final (when most of the civilized world was wishing that he had head-butted Marco Materazzi even harder). Heroism always leads to self-destruction and ruination. As he leaves the pitch, he knows that it is finished. He looks helpless. As Kleist says in the final words of his essay on the puppet theater, "This is the final chapter in the history of the world."

NOTES

1. Founded in 1956, the Situationist International (SI) were an artist group with members throughout the world. Guy Debord, one of the group's leaders, famously described the notion of spectacle in the book *The Society of Spectacle* (1967). Debord's argument is too complicated to summarize here, but the gist is that "everything that was directly lived has moved away into representation" (or image) within modern capitalist society.

2. Maradona scored the "hand of God" goal by hitting the ball into the goal with his left fist. In the press conference after the game, Maradona said that the goal was scored "a little with the head of Maradona and a little with the hand of God."

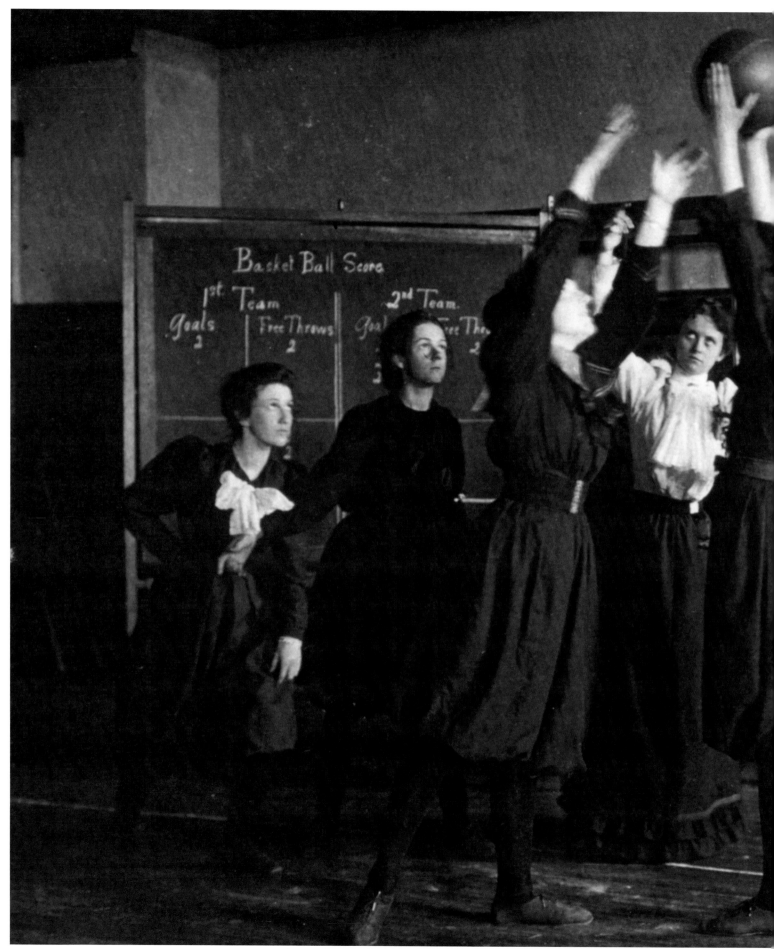

Within the image: Basket Ball Score, 1st. Team, Goals, Team, Free Throws, 2nd Team, Goal, Free Throws

Sporting
Leisure

Since the invention of photography in 1839, photographs have shaped the way we imagine and remember sports. From the nineteenth century into the early decades of the twentieth, amateurs played sports in organized clubs, schools, and informal competitions. Only a handful of professional baseball teams existed in major cities, and traveling teams barnstormed local towns for exhibition games. Other sports demarked class differences, with bare-knuckled boxing, cockfighting, and billiards popular among the lower class, and boat racing, harness racing, and golf among the upper class. Photographs at that time were taken by photojournalists and unknown casual photographers and show sports as live cultural events tied to education, local communities, and personal leisure.

THOMAS EAKINS

Study for "The Swimming Hole," c. 1883

Courtesy Fraenkel Gallery, San Francisco

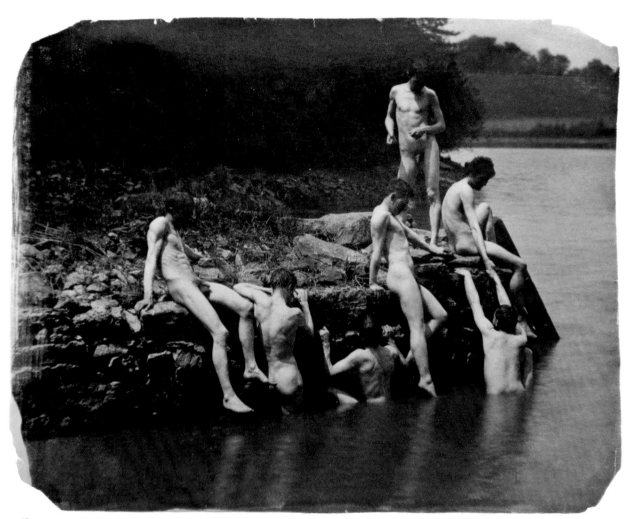

16

FRANK LLOYD WRIGHT

Girls Gym Class, 1900

The Nelson-Atkins Museum of Art, Kansas City, Missouri
Gift of Hallmark Cards, Inc., 2005.27.4534
Photo credit: Michael Lamy

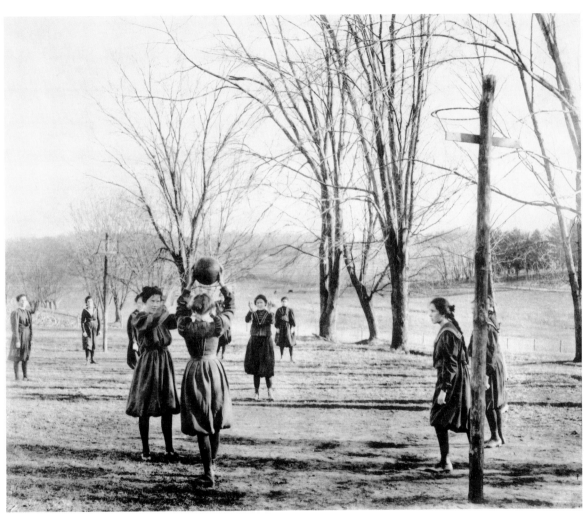

FRANCES BENJAMIN JOHNSTON

Untitled [Female students playing basketball, Western High School, Washington, D.C.], from Western High School album, c. 1899

Life magazine declared Frances Benjamin Johnston "the closest thing to an official court photographer the United States has ever had" (April 25, 1949). But Johnston also distinguished herself as the photographer of those who remained largely unrepresented and invisible, notably African Americans and women. Naked women are plentiful in all genres and styles of art, and in the late nineteenth century they appeared often under the guise of "artistic" photography. Johnston's photographs, however, show women as active participants in daily life. This picture from her *Western High School* album shows girls outfitted in athletic bloomers learning the rules of basketball, only eight years after James Naismith invented the game.

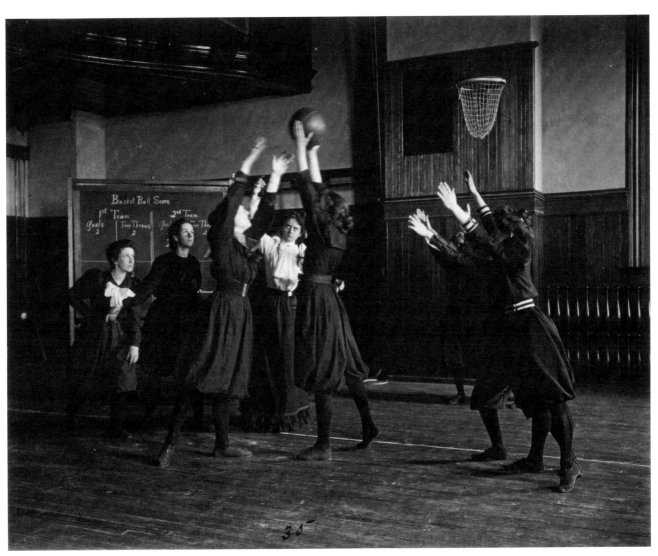

FRANCES BENJAMIN JOHNSTON

Untitled [Female students exercising in a gymnasium, Western High School, Washington, D.C.], from Western High School album, c. 1899

19

FRANCES BENJAMIN
JOHNSTON

**Untitled [Female students posing with exercise equipment
in a gymnasium, Western High School, Washington, D.C.]**,
from Western High School album, c. 1899

FRANCES BENJAMIN JOHNSTON

Untitled [Five girls lying on mat in gymnasium in front of basketball scoreboard, Western High School, Washington, D.C.], from Western High School album, c. 1899

FRANCES BENJAMIN
JOHNSTON

**Untitled [Male students playing basketball,
Western High School, Washington, D.C.]**, from
Western High School album, c. 1899

Opening day Washington–Boston in Washington,
c. 1892–1902

23

Minnesota State Fair, September 9, 1911

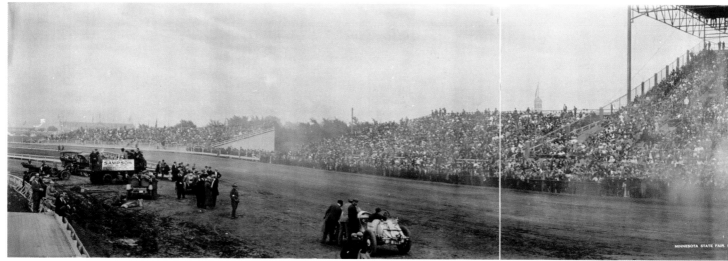

24

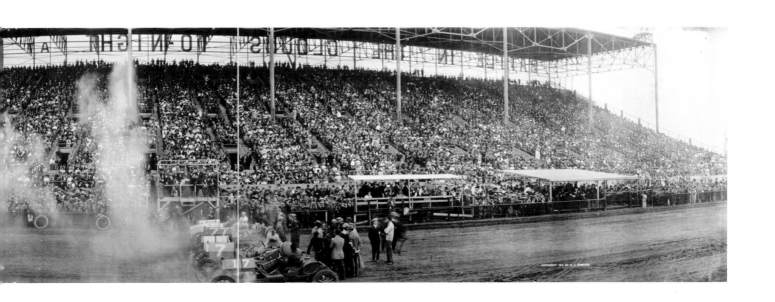

Winners of Missouri state football championship, 1920–45

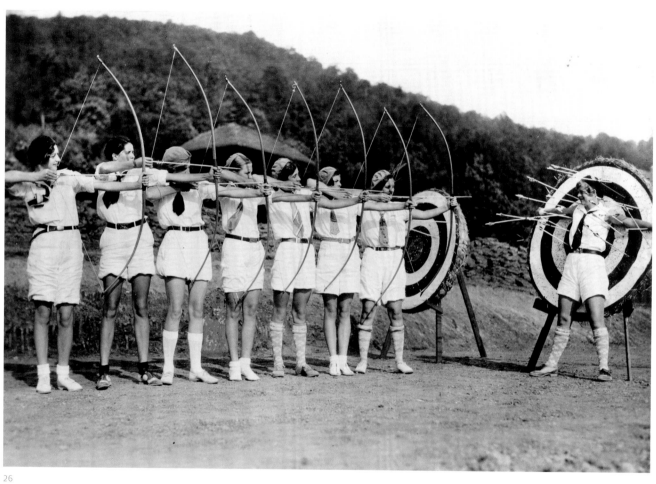

27

28

29

30

31

32

33

34

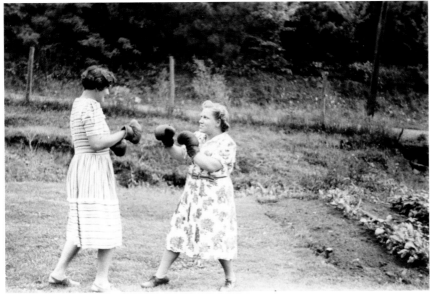

35

36

37

38 Courtesy Fraenkel Gallery, San Francisco

39

40

41

42

43

45

44

46

EADWEARD MUYBRIDGE

Animal Locomotion, plate 640, 1887

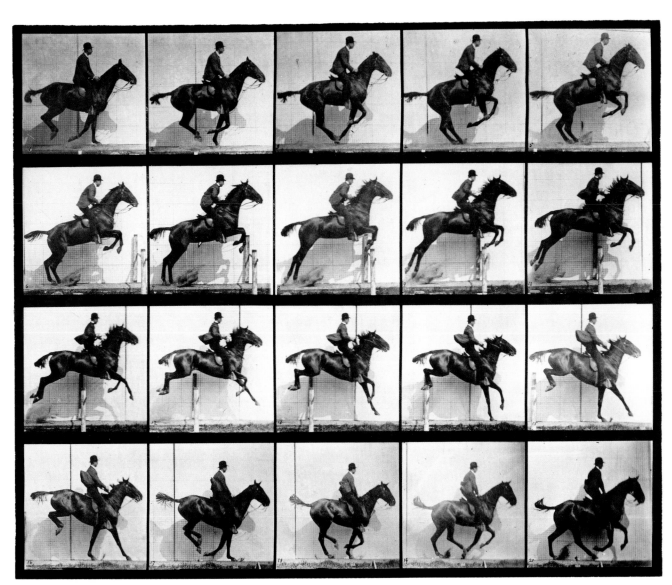

47

ALFRED STIEGLITZ

Going to the Start, 1904

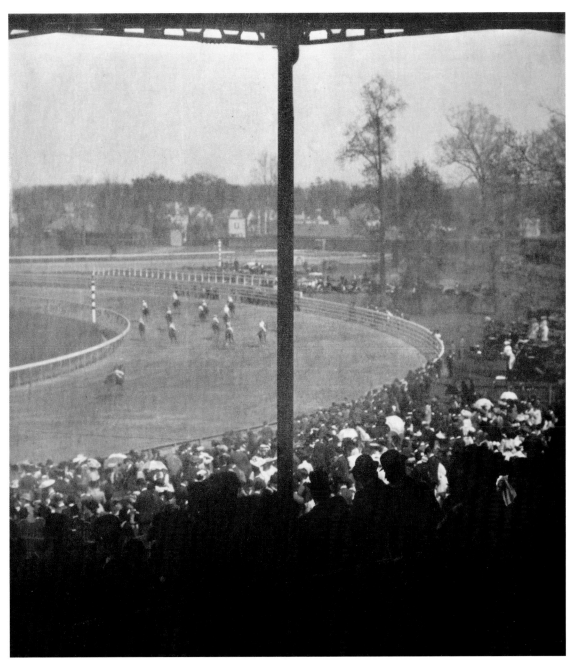

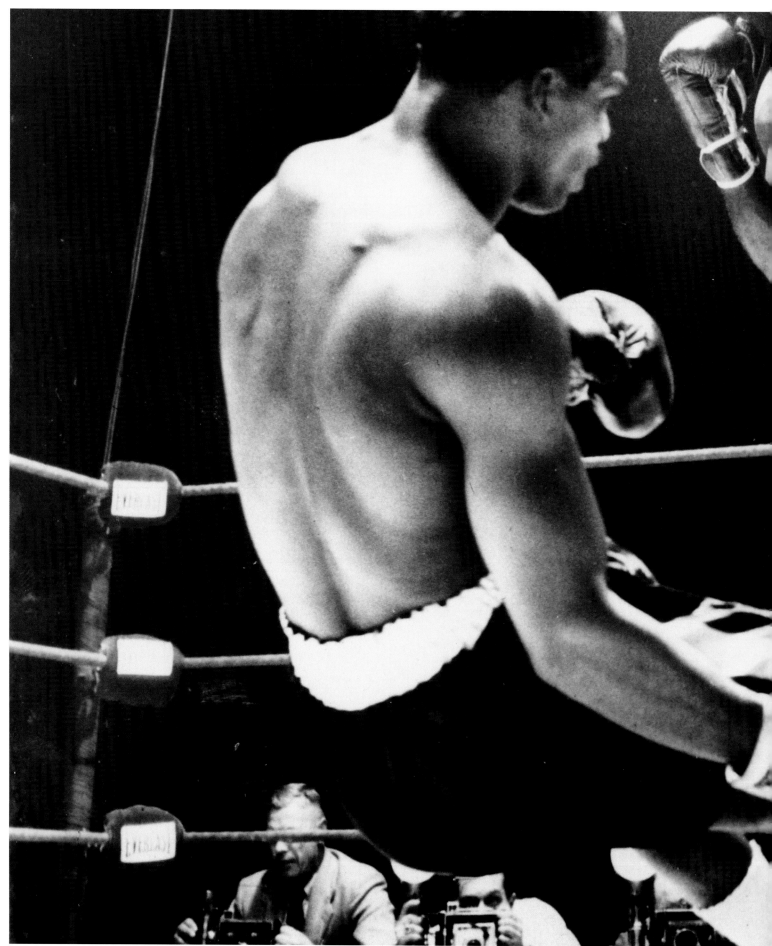

In the Game

THE MACHINE-EYE

In the 1920s, avant-garde artists used the newly invented hand-held camera with high-speed film to take photographs from steeply angled, even vertiginous, perspectives. These images gave viewers the sense of seeing through the roving eye of a machine rather than the human eye. Soviet artists such as Alexander Rodchenko linked this visual experience to the political spirit of the Russian Revolution, which emphasized the collective over the individual. Sports photographers since then have continued to employ this technique, minus the politics, to place viewers "in the game," as if they are players participating in the action.

JACQUES HENRI LARTIGUE

Grand Prix of the Automobile Club of France, 1912

The subjects of Jacques Henri Lartigue's pictures communicate a carefree sensibility, as if to say, "I don't care what I look like, I am having an adventure." Lartigue's photographs, which include some of the twentieth century's most humorous images, often feature the photographer's brothers—peeling out in race-cars, flying precarious-looking airplanes, and swimming in dress suits and silly hats. Sport becomes a metaphor for the energy and anarchy of modern life, with its adult-sized toys.

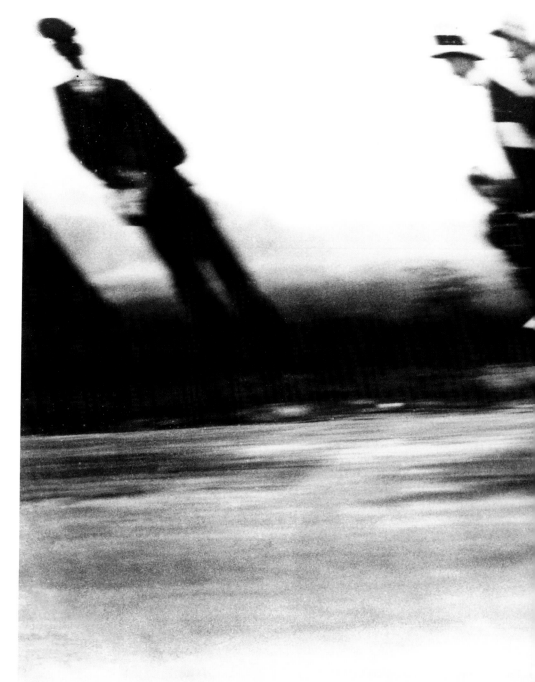

49

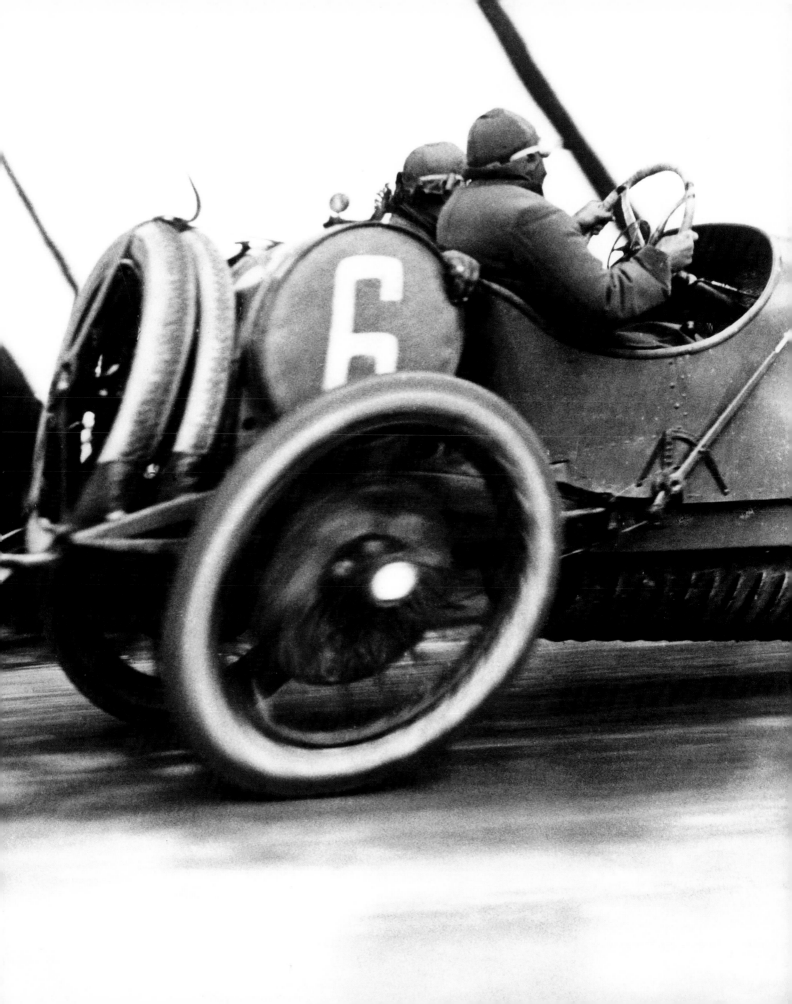

ALEXANDER RODCHENKO

Dive, 1934

Rodchenko belonged to a generation of avant-garde artists who sought to create a radically new kind of image. He used the lightweight Leica camera, which offered portability and sharper focus in less light, to make pictures that seem to emerge from the mobile camera-eye. This composition of a diver floating weightless in space with no diving board in sight, framed only by a ruler-like strip of numbers and what appears to be a raft at the top, puts viewers in the picture alongside the subject.

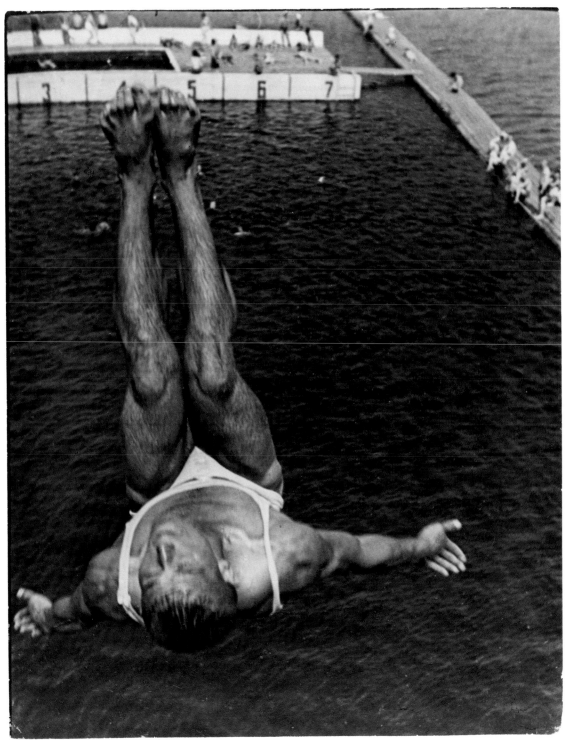

50

ALEXANDER RODCHENKO

Pole Vault, 1936

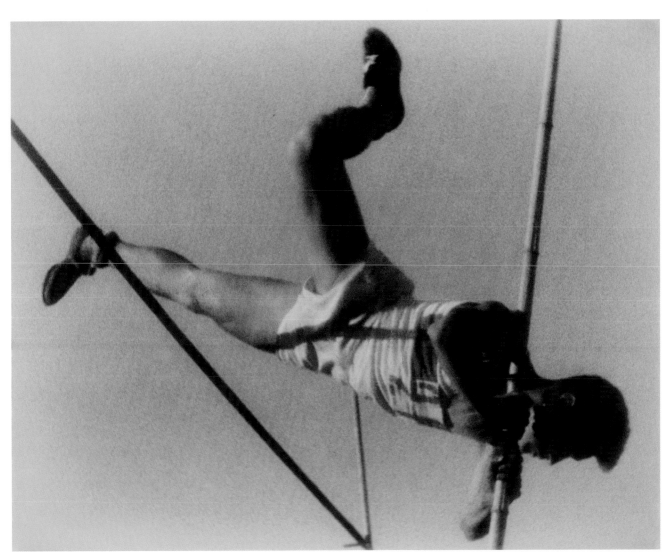

ALEXANDER RODCHENKO

Untitled [Horse race], 1935

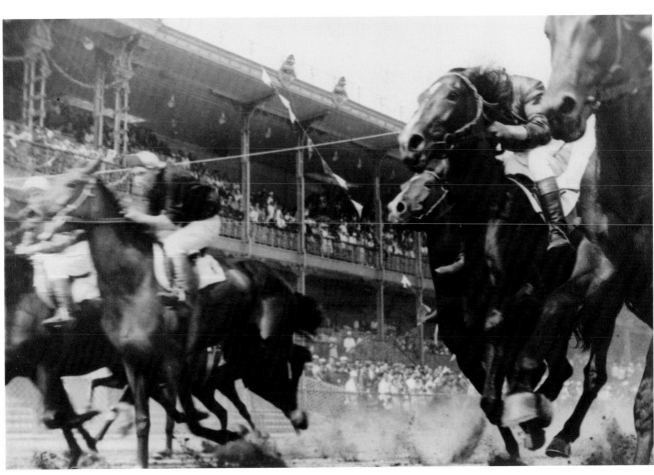

LENI RIEFENSTAHL

Jesse Owens, 1936

Leni Riefenstahl (1902–2003) was one of the most innovative sports filmmakers of the twentieth century. Using slow motion, tight close-ups, and dramatic angles, she altered the way we see and experience sports through the camera-eye. Riefenstahl introduced a number of new filmmaking techniques in *Olympia* (1938), a film commissioned by the International Olympic Committee to document the 1936 Olympics in Berlin (but lavishly funded behind the scenes by Germany's Nazi government). To film the competitions, she used multiple cameras variously positioned to capture the athletes' movements. She had holes dug under the pole vault pits so as to get an upward angle on the action; she filmed divers and swimmers underwater for the first time; and from cameras placed high above the events, she produced a bird's-eye view of the grand spectacle of sports. Riefenstahl's filmmaking achievements were undermined by her role directing propaganda films such as *Triumph of the Will* (1935) for Adolf Hitler, and her lies in later years about her involvement with the Third Reich.

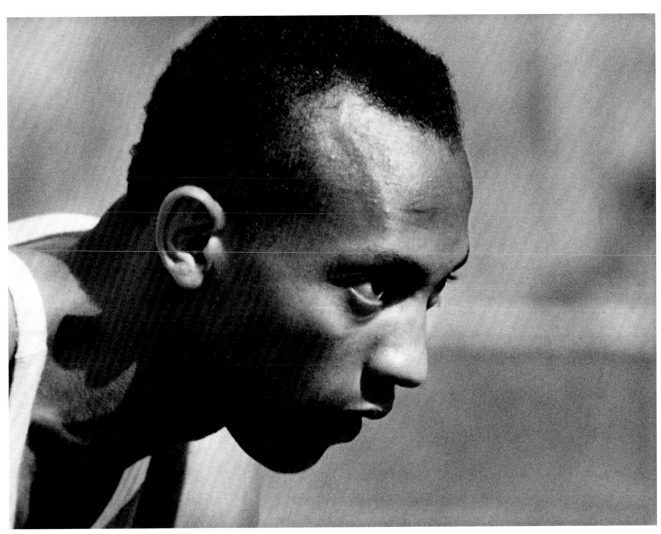

LENI RIEFENSTAHL

The Dive, 1936

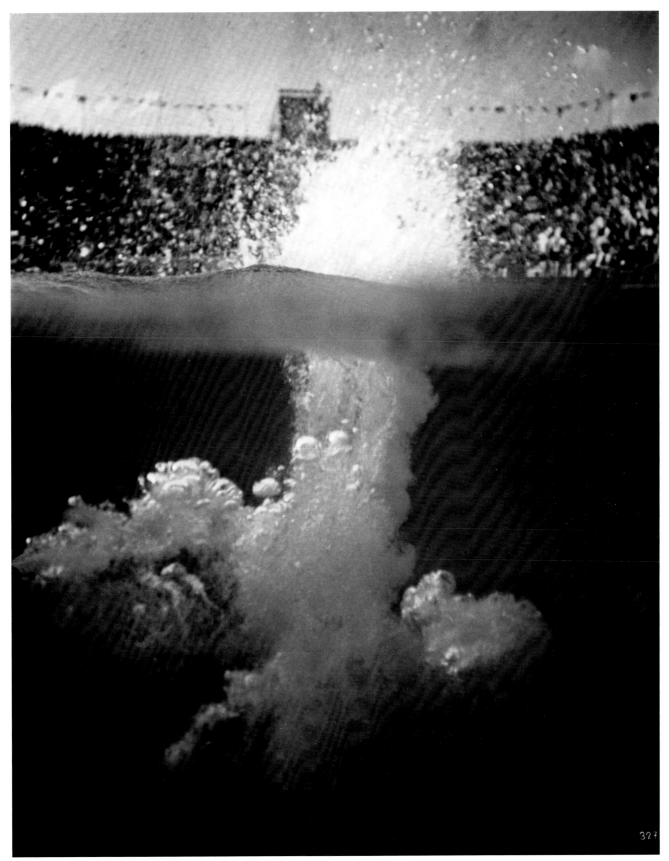

327

LENI RIEFENSTAHL

The Discus Thrower, 1936

**Eddie Miller of the New York Giants
demonstrates spiral pass**, 1940

Both images Time & Life Pictures/Getty Images

56

GJON MILI

High Jumper Clarke Mallery, 1939

Untitled [Baseball study], c. 1930s

LAURA RIBOLI

Rolls, Passages, Rotations, Walkovers (Hoop), 2009

60

JOHN GUTMANN

Czechoslovakian Gymnasts, San Francisco, 1939

EDWARD STEICHEN

Jane Fauntz (Olympic Team), n.d.

HAROLD EUGENE EDGERTON

Football Kick, 1938

Diving Day Six—14th FINA World Championships, 2011

64

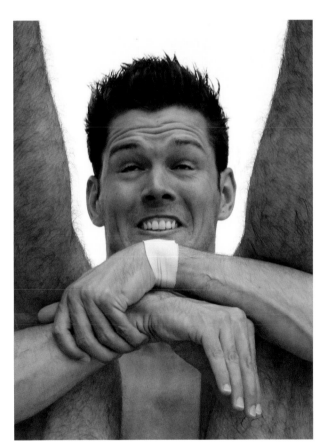

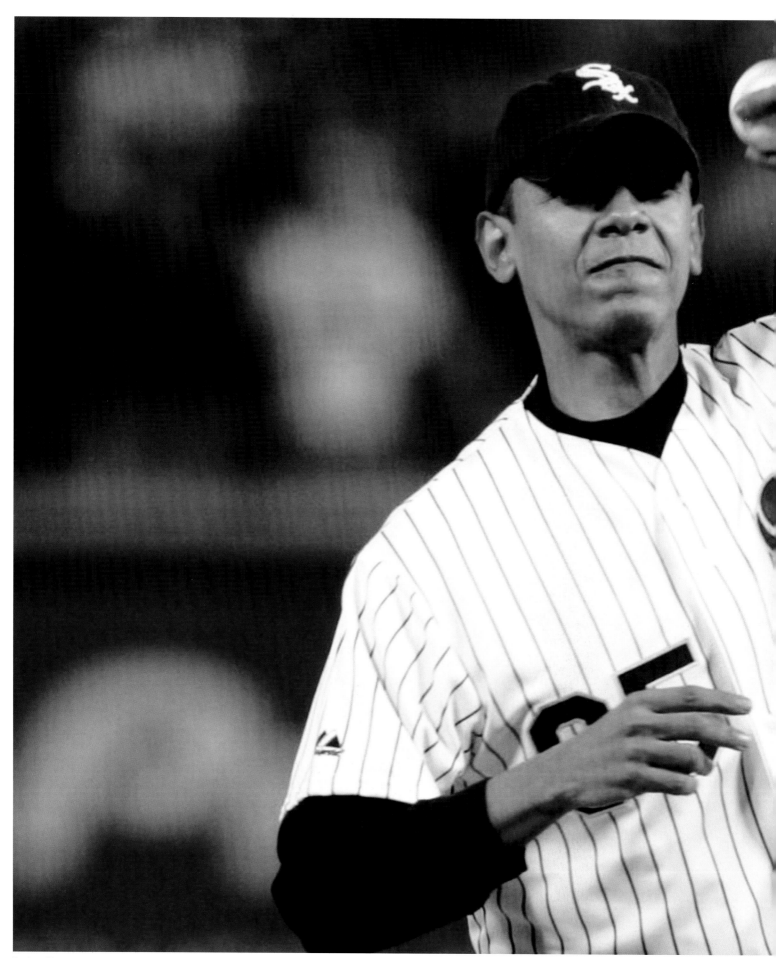

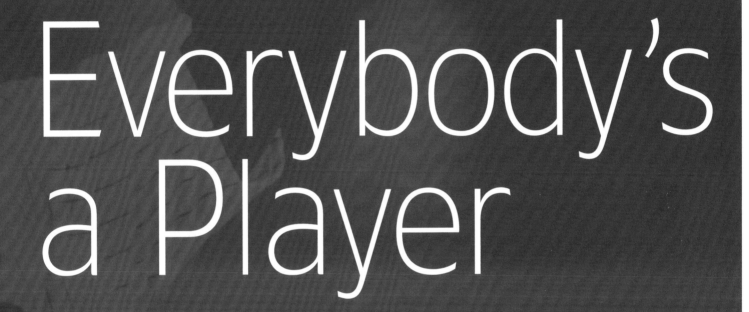

Everybody's a Player

Sports culture today promotes participation on various levels, from organized teams to weekend warriors to online gamers to professional athletes. The growth of professional sports and media has contributed to a new relationship between fans and players. Fans are now participant-observers. In the past, sports stadiums were filled with fans, mostly men, wearing business suits and stylish hats. Today men and women, families and friends, attend games, watch on television, or go to work dressed as their favorite players. We are now in a culture where everyone can be a player.

AMY ELKINS

Dan (Wing/Fullback), New Haven, CT, 2010

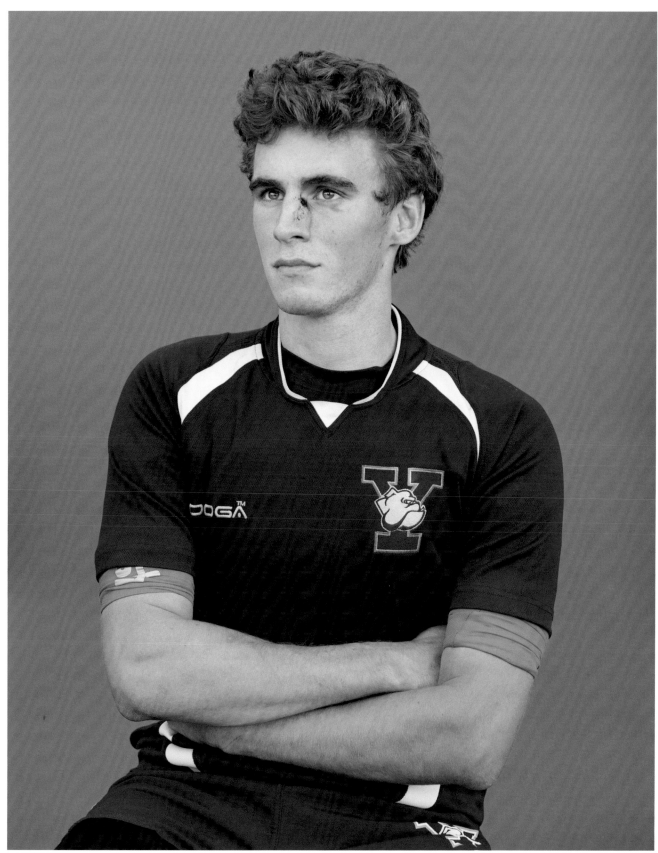

JACQUES HENRI LARTIGUE

Zissou in His Tire Boat, Chateau de Rouzat, 1911

DIANE ARBUS

**Girl with a baseball glove at Camp Lakecrest,
Dutchess County, NY**, 1968

"Everybody has that thing where they need to look one way but they come out looking another way and that's what people observe. You see someone on the street and essentially what you notice about them is the flaw. It's just extraordinary that we should have been given these peculiarities. And, not content with what we were given, we create a whole other set. Our whole guise is like giving a sign to the world to think of us in a certain way but there's a point between what you want people to know about you and what you can't help people knowing about you."

—Diane Arbus

WALLACE KIRKLAND

**The Women's Professional Baseball League:
Fort Wayne Daisies, South Bend Blue Sox, Kenosha
Comets, Grand Rapids Chicks, Rockford Peaches,
and Racine Bells**, 1945

LEON LEVINSTEIN

Handball Players, Lower East Side, NY, c. 1950s–60s

DARRYL HEIKES

President Nixon Bowling in White House Lanes, 1971

© Bettmann/CORBIS

First Pitch, Mr. President

U.S. presidents have thrown out the ceremonial first pitch for opening day since the portly William Howard Taft did so from the stands in 1910. At a Washington Senators game in 1912, Taft looked presidential wearing a tie, vest, and well-tailored suit replete with a handkerchief. Photographs of presidential first pitches since then reveal changes in styles, personalities, and fans' relationship to the game. Woodrow Wilson, Franklin D. Roosevelt, and Harry Truman wore fashionable hats. Truman threw left-handed and wore a summer suit. A hatless and relaxed John F. Kennedy threw with the confident pose of possibly America's best presidential athlete.

In the 1970s, presidents, like fans, became part of the game, wearing parts of the baseball uniform. Richard Nixon wore a glove as he threw out a first pitch. William Jefferson Clinton, in 1993, abandoned the formal presidential suit and tie for a Baltimore Orioles jacket and baseball cap. Clinton also left the stands to pitch from the mound. As the senator from Illinois, Barack Obama took attire one step further, wearing the jersey of his beloved Chicago White Sox to throw out the first pitch in 2005. Throwing the first pitch five years later as president in Washington, D.C., he played politics by wearing a Chicago White Sox hat with a Washington Nationals pullover.

71

President William Howard Taft, 1912

Associated Press; AP Photo/Brown Brothers © 1912 AP

72

President Woodrow Wilson, 1916

Associated Press; AP Photo © 1916 AP

73

Governor Franklin D. Roosevelt, 1932

© Bettmann/CORBIS

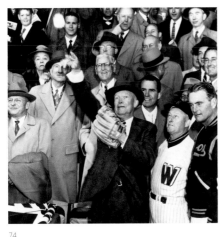

74

President Dwight D. Eisenhower, 1957

© CORBIS

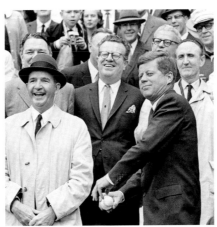

75

President John F. Kennedy, 1962

Associated Press; AP Photo © 1962 AP

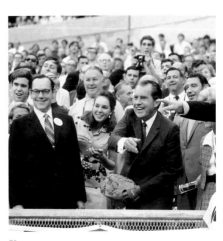

76

President Richard Nixon, 1970

© 1970 Herb Scharfman/Sports Imagery/Getty Images

77

Former President Jimmy Carter, 1992

© 1992 MLB Photos via Getty Images

78

President Ronald W. Reagan, 1988

Time & Life Pictures/Getty Images © Diana Walker

79

President Bill Clinton, 1993

Paul J. Richards, AFP/Getty Images © 1993 Getty Images

80

Senator Barack Obama, 2005

AP Photo/Ann Heisenfelt © 2005 AP

Former Presidents George W. Bush and George H. W. Bush, 2010

TIM DAVIS

The Upstate New York Olympics, 2010–11

Tim Davis's three-screen video presents an alternative version of the Olympic Games. The artist himself is the sole competitor in fifty-four absurd events, including Abandoned Building Bowling, Drive-in Movie Tennis, Lawn Jockey Leapfrog, Compost Freestyle, and Flag Pole Grapple. This "Olympics" features barns, abandoned factories, middle-class suburban homes, flooded golf courses—in short, the everyday life of upstate New York. With deadpan humor, Davis gives us an everyman's Olympics for the antihero.

CORY ARCANGEL

Masters, 2011

Choosing Sides

RIVALS, RACE, AND POLITICS

Race and politics have permeated the history of sports images, often interrupting the "games." In the United States, minority populations achieved equal treatment on the sports field long before gaining equal rights off the field. In the early twentieth century, boxing and the Olympics provided some of the first opportunities for African Americans and other minorities to compete with whites. Professional baseball, basketball, and football followed in the mid-1940s. In an odd contradiction, American sports fans often overlooked race to support an athlete competing against a political rival or enemy. Jesse Owens for example, represented democracy against fascism at the 1936 Olympics in Berlin, yet he faced racial segregation and prejudice when he returned home. Sometimes sporting events have become a stage for political conflict, as when the Middle East crisis became a reality to world audiences during the 1972 Olympics in Munich.

Untitled [John Arthur Johnson and first wife, Etta], n.d.

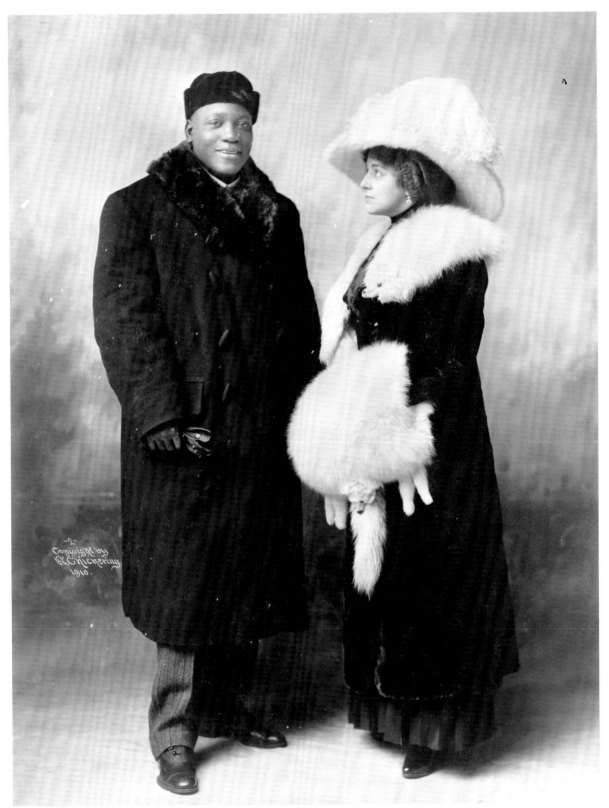

Untitled [Jack Johnson—behind wheel of auto], c. 1910

85

Jack Johnson, 1878–1946, c. 1910

86

Adolf Hitler with Boxer Max Schmeling, 1936

© Bettmann/CORBIS

87

Joe Louis and Max Schmeling Squaring Off, 1938

© Bettmann/CORBIS

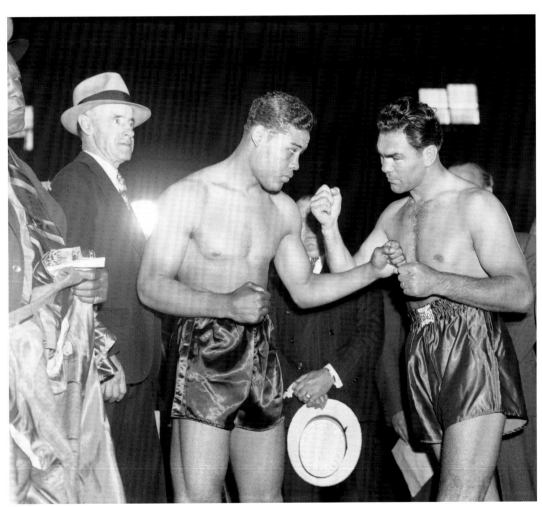

STANLEY KUBRICK

Rocky Graziano: He's a Good Boy Now, 1950
From *Look* magazine

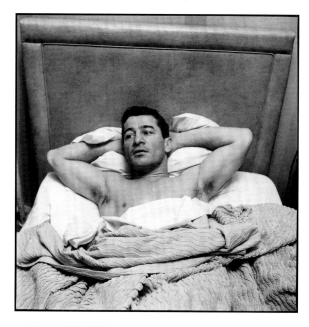

Look Magazine

1937–1971

Beginning in the 1930s, the biweekly magazine *Look* published photographic stories about American life. Its circulation peaked in 1969, at more than seven million. *Look* glorified and humanized the day's sports stars through carefully edited photographs presented as picture stories. These reflect an intimate access to the featured athletes that is rare today, when images are heavily stage-managed by athletes, sports agencies, and professional teams. *Look's* talented staff of photographers included Frank Bauman, Howard Bingham, Marvin E. Newman, Garry Winogrand, Stanley Kubrick, and many others.

Stanley Kubrick joined *Look* at the age of seventeen and stayed for five years before going on to direct films such as *2001: A Space Odyssey*, *A Clockwork Orange*, and *The Shining*. Kubrick's "Day in the Life" photo story on Rocky Graziano shows Graziano not only in the locker room preparing for a fight, but also mingling with friends, being examined by doctors, showering, and sleeping in bed. It humanizes the powerful boxer as an everyman.

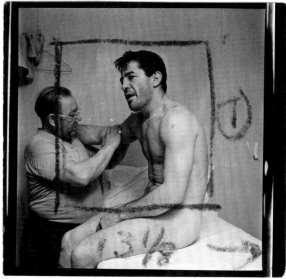

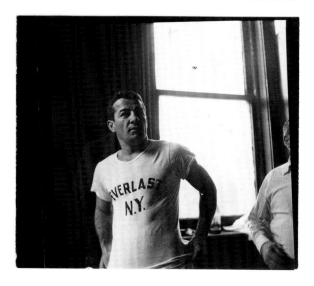

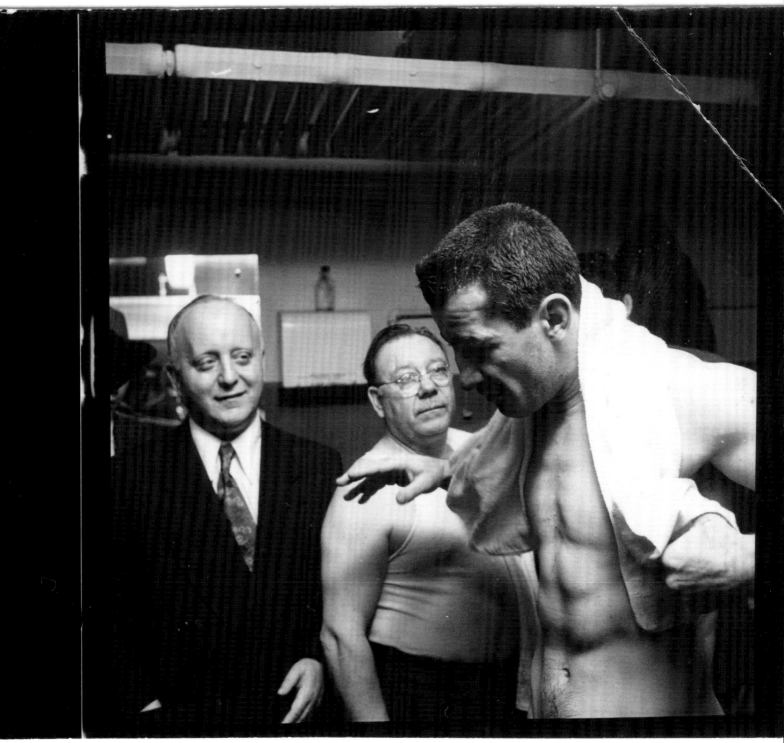

FRANK BAUMAN

Joe Louis, 1940
From *Look* magazine

90

Untitled [President Kennedy talking with Olympic Gold Medalist Wilma Rudolph, her mother, and Vice President Lyndon Johnson, April 14, 1961]

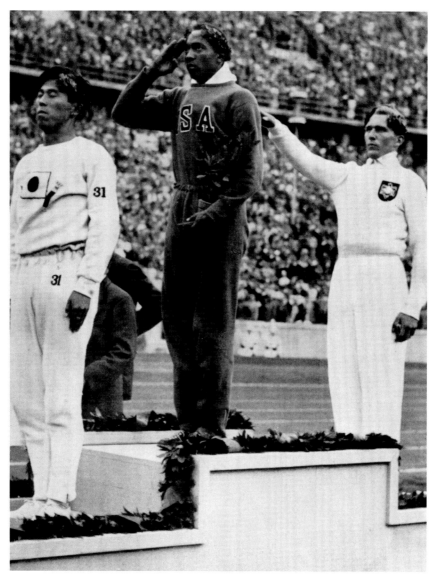

92

Untitled [American track medalists Tommie Smith and John Carlos raising black-gloved fists at the 1968 Olympic Games in Mexico City (with Peter Norman)]

Associated Press; AP Photo © 1968 AP

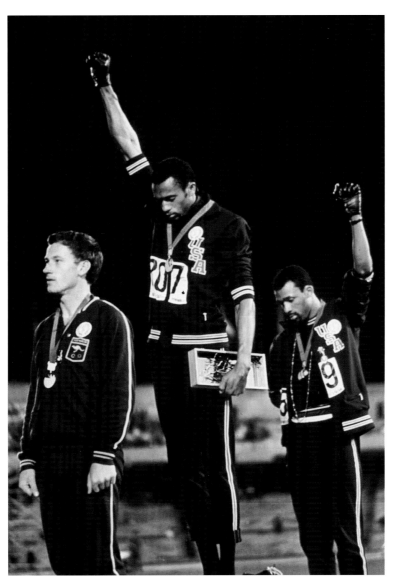

93

VIK MUNIZ

Verso (The Winner in Broad Jump, Jesse Owens), 2008

Verso is a photograph of a collage re-creation of the back of *1936 Olympic Games in Berlin* (no. 92), showing the contexts and caption for the original 1936 photograph.

Jesse Owens, America's star athlete, is crowned by the Olympic wreath of oak le
after winning the broad jump.

(Times Wide World Photos.)

MADE IN GERMANY

Jesse Owens saluting the American flag as Luz Long of Germany gave the Nazi salute in Berlin in 1936.

DI_ _ER IM WEITSPRINGEN WERDEN GEWE__ _.

#463-BERLIN--Unser Bild _eigt die Sieger__ _ng
der S_ger in Weitsprung.Jesse Owens siegte
vor _a_g Deutschland und Tajima, _pan. 36

COPYRIGHT BY PRESSE PHOTO GMBH BERLIN
Boes, 80

MAY 11 '84

THE WINNER IN BROADJUMP.

Berlin, Owens USA won the broadjump before Lutz
Long,Germany and Tajiman,Nippon.

TO THE VICTOR—In the 1936 Olympiad in Nazi Germany, with its
vaunting of "Aryan supremacy," the American Negro star, Jesse
Owens, was not cheered as a winner by the Germans in the crowd.

PUBLISHED 'N.N.Y.

SUNDAY MAY 13 '84

1936; Jesse Owens saluting the American flag as Luz
Long of Germany gave the Nazi salute.

The New York Times

Jesse Owens with wreath of victory.
He defeated Lutz Long, at right, of
Germany in the long jump in 1936
Olympics, held in Nazi Germany.

Pub. NYT
Tue., 7/14/92

POSTE

AUG 2 0 1936

EDITORIAL AUDITING

57 NOV 27 PM 6:38

94

A Guerilla (Black September guerillas kidnap Israeli athletes, Munich, September 1972)

The photograph is so unremarkable and so abstract; yet it is unforgettable and historic. A man wearing a black mask stands on an apartment balcony, his torso and head framed by the horizontal and vertical lines of the architecture. He is one of eight members of the Palestinian terrorist group Black September that took Israeli athletes and coaches hostage in the athletes' housing villages on September 5, 1972, at the Munich Olympics. The tightly fitted black mask has round openings for the eyes, which are obscured, like darkened eye sockets of a skull. The picture is gray and grainy. The man is utterly anonymous. This is a sports photograph and a historical document. It stands for the tragic events that would follow: the deaths of eleven Israelis, five Palestinians, and a German policeman.

GARRY WINOGRAND

**Muhammad Ali–Oscar Bonavena Press Conference,
New York**, 1970

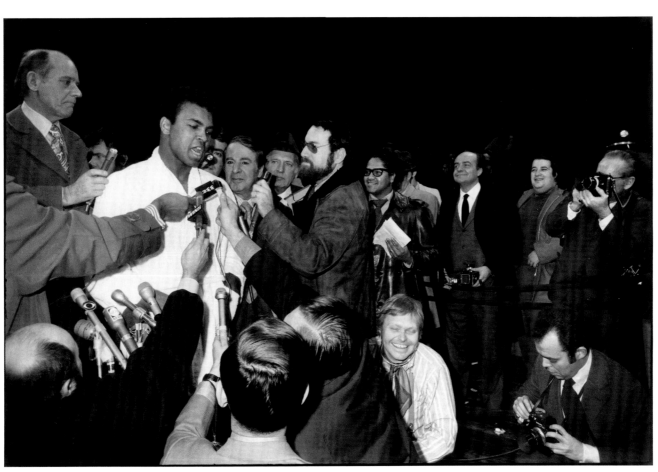

Pop Icons

UP CLOSE AND VERY PERSONAL

Since photography's beginnings, star players have had their pictures taken, and by the 1860s their images were being used to advertise products. The reproduction and distribution of photographic images made local and regional athletes into national stars with whom audiences could identify. The growth of broadcast media after the 1960s transformed athletes from stars into larger-than-life icons. With the spread of television, millions watched sports in their living rooms, and charismatic athletes like Muhammad Ali became international pop icons. Today, networks and athletes often collaborate on exclusive media coverage, with keen attention to the athlete's image as a popular and saleable commodity. This feeds audiences' desire to be "up close and personal" with players.

Honus Wagner, from White Borders, c. 1909–11

Designed and issued by the American Tobacco Company, the T206 Honus Wagner baseball card is an early example of how major baseball stars were marketed through images. (The card is a color lithograph based on a photograph.) Wagner was in the first class inducted into the Baseball Hall of Fame and is considered one of the five best baseball players of all time. His T206 card is the most valuable baseball card ever produced, having sold for $2.8 million in 2007. It is rare, with only 60 to 200 originally in circulation. When it was published in 1909, Wagner requested that it be pulled—whether because he didn't want his image distributed to children through cigarette sales or because he wanted more money for his image has been debated. In either case, this is an early instance of an athlete recognizing the value of his image and seeking to control it.

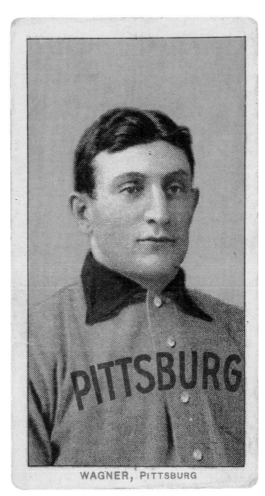

WAGNER, PITTSBURG

97

EDWARD STEICHEN

Paul Robeson, 1930

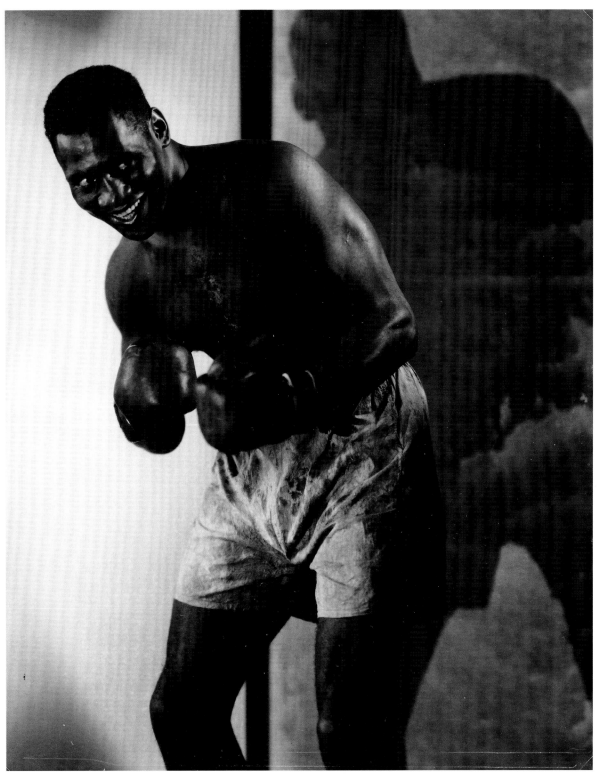

JAMES VAN DER ZEE

Joe Louis, c. 1930s

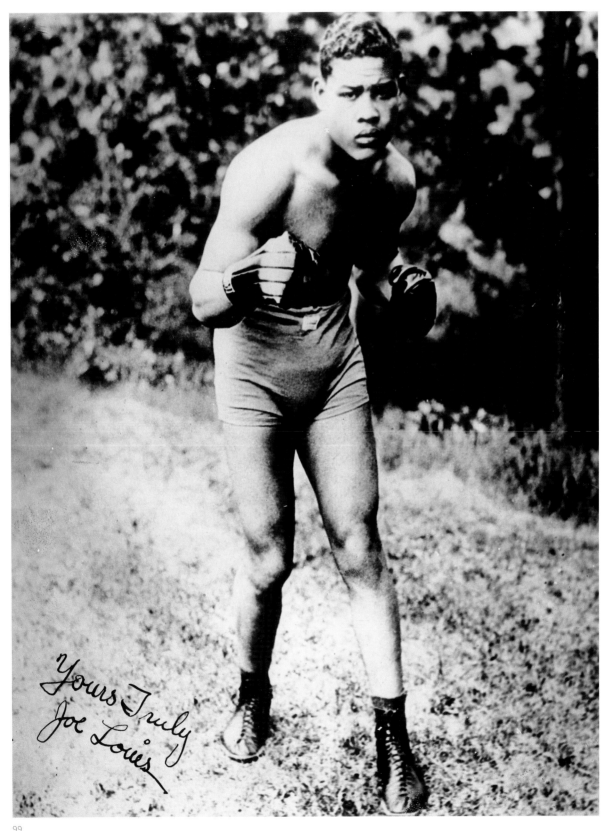

Yours Truly
Joe Louis

99

Untitled [Jim Thorpe, sitting at desk], n.d.

NAT FEIN

The Babe Bows Out by Nat Fein, 1948

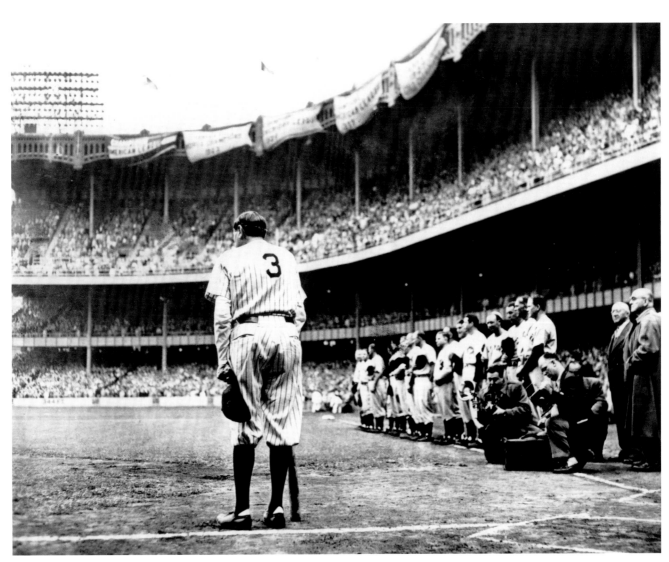

Babe Ruth "The Sultan of Swat," n.d.

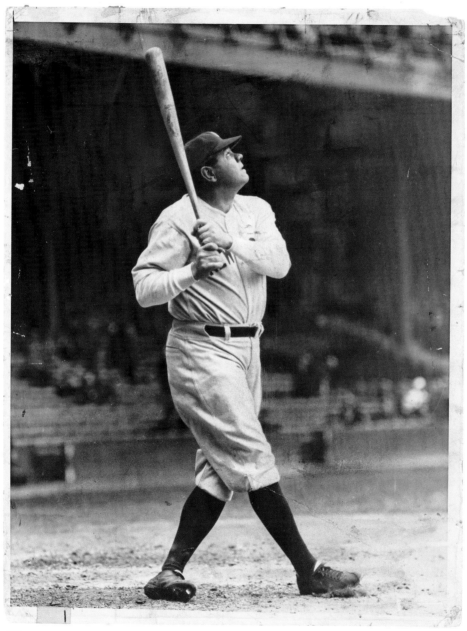

102

Babe Ruth, the Greatest Slugger of Them All, 1927

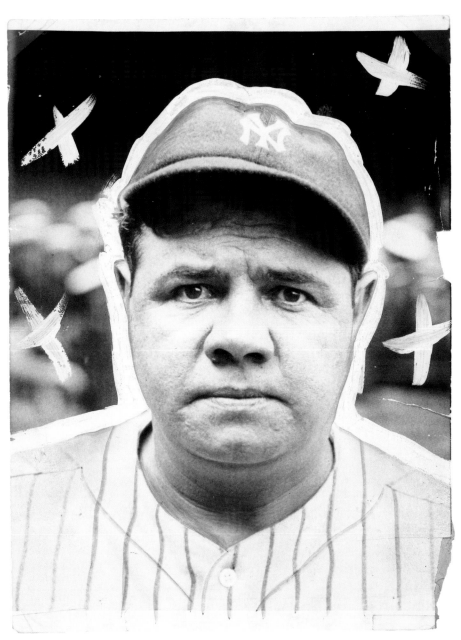

GEORGE STROCK

**Satchel Paige [Baseball player Satchel Paige playing
a game of pool]**, 1941

Time & Life Pictures/Getty Images

Jackie Robinson acquired by Dodgers, "It was announced that the Brooklyn club had purchased the Negro from its farm team," 1947

105

THE DODGERS ACQUIRE A NEW INFIELDER

Jackie Robinson being congratulated by Clay Hopper, manager of the Montreal Royals, at Ebbets Fie yesterday after it was announced that the Brooklyn club had purchased the Negro from its farm team.

Associated Pre

Clay Hopper, left, Montreal manager, congratulating Jackie Robinson on his promotion to Brooklyn Dodgers in 1947.

GJON MILI

Ted Williams—"Easy Ball Batting," 1941

Time & Life Pictures/Getty Images

106

GJON MILI

**Studio shot of Boston Red Sox star Ted Williams
demonstrating his batting technique**, 1941

Both images Time & Life Pictures/Getty Images

107

108

Roger Bannister breaks four-minute mile (3:59.4), 1954

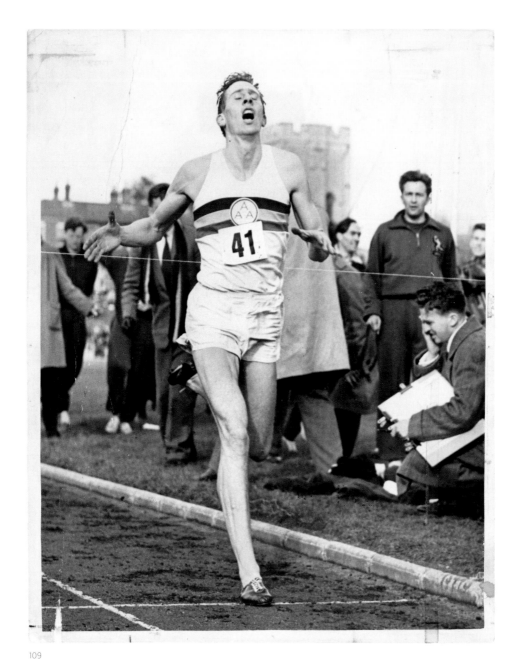

109

Roger Bannister hits the tape in 3 minutes 59.4 seconds

What Roger Bannister did for track and field, he did also for all sports. Even John Wooden, the former basketball coach at the University of California, Los Angeles, often referred to Bannister's feat. Wooden said it gave ath-

Roger Bannister:
'What he did for
track and field, he
did also for
ll sports.'

Keystone Press
Roger Bannister rested for four
days before running his historic
sub-four-minute mile in 1954.

TIME: 3:59.4—Roger Bannister finishes his history-making run (top) and has to be supported. "Real pain overtook me," he declared.

53-671

GORDON PARKS

Muhammad Ali (face sweating), 1970

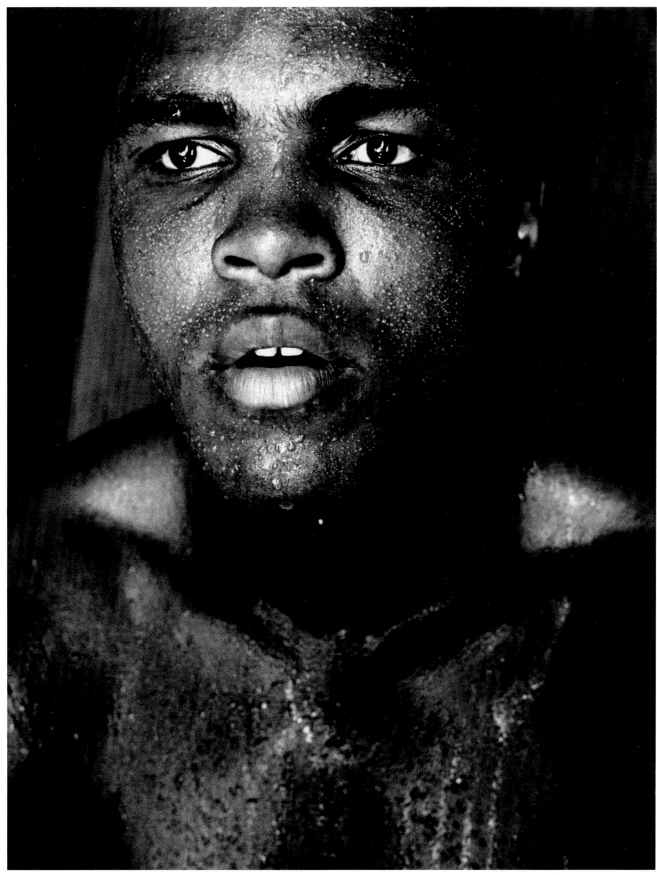

GORDON PARKS

Close-up of Muhammad Ali's fists, his knuckles cut, after match against Henry Cooper, 1966

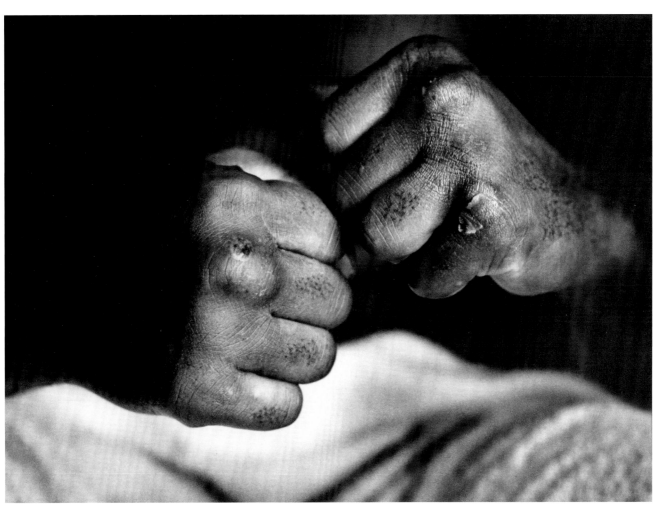

RICHARD AVEDON

Lew Alcindor, basketball player, 61st Street and
Amsterdam Avenue, New York, May 2, 1963

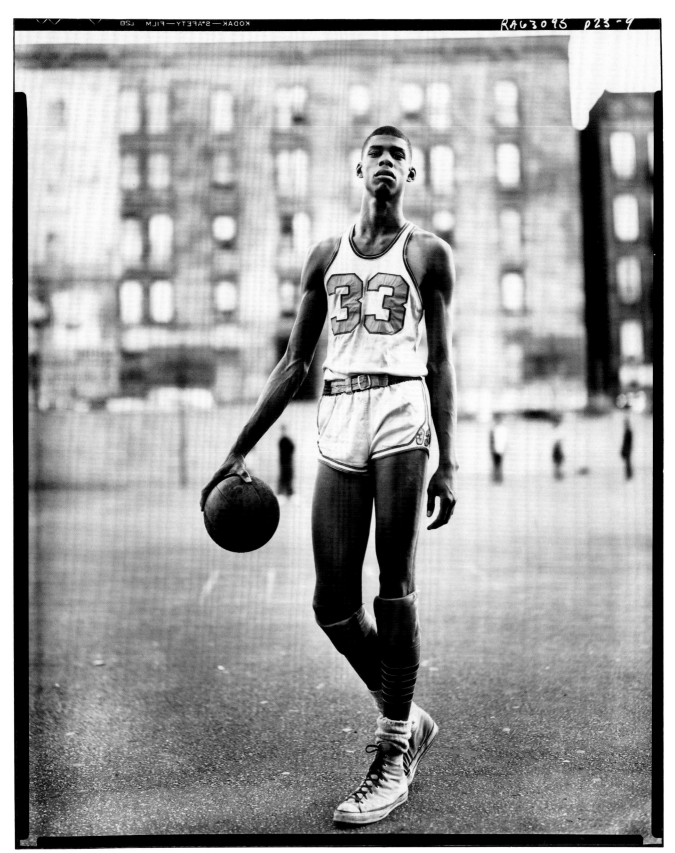

ANDY WARHOL

Jack Nicklaus, 1977

113

114

115

116

ANDY WARHOL

Wayne Gretzky, 1983

117

118

119

120

ROBERT MAPPLETHORPE

Arnold Schwarzenegger, 1976

Robert Mapplethorpe's portrait accentuates the muscular body of Arnold Schwarzenegger, Mr. Olympia seven times during his bodybuilding career. Framed within a carefully staged composition of simple structural elements—plain wooden floor, stark white background, and flowing curtain—Schwarzenegger looks out self-consciously at the camera, arms behind his back and legs in a semi-squat to accent his muscles. An aspiring actor, the much photographed Schwarzenegger later became an international movie star, the thirty-eighth governor of California, and part of the celebrated Kennedy family.

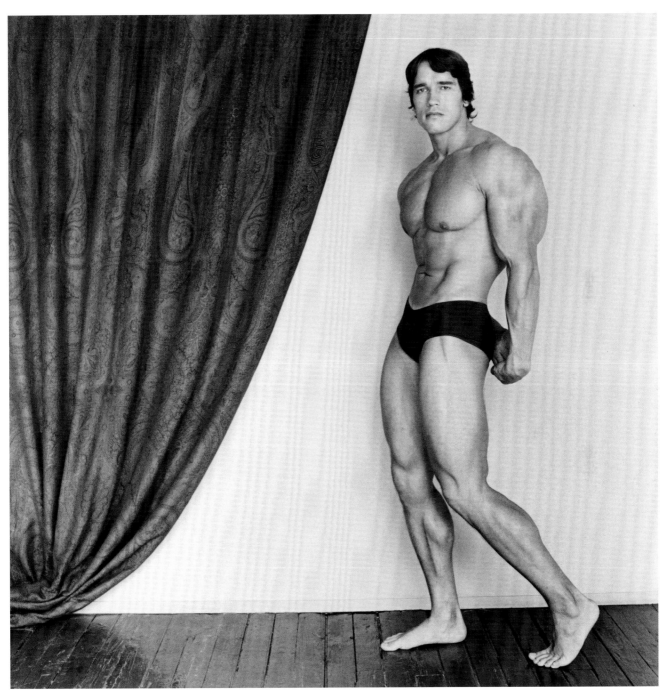

STEPHEN SHORE

Sparky Lyle's locker, Ft. Lauderdale, Florida, 1978

HANK WILLIS THOMAS

Smokin' Joe Ain't J'mama, 1978/2006

Captions connect the dots. In newspapers, they are meant to be descriptive and objective. In advertising, they are brief and catchy. With photographs, they can tell stories. Hank Willis Thomas's work, however, suggests that captions also hide stories. In the series *Unbranded: Reflections in Black by Corporate America, 1968–2008*, Thomas digitally removed advertising captions, leaving us to contemplate how an advertising image speaks on its own. In viewing this photograph of the boxer Joe Frazier, the first thought that comes to mind is, Muhammad Ali would never have been in a picture like this. Outfitted in a blue bonnet, Frazier sits at a table with a stack of pancakes and tub of margarine in front of him. Willis's title, *Smokin' Joe Ain't J'mama*, alludes to the Aunt Jemima trademark for pancake mix, a female image with roots in black minstrel shows. Frazier is shown as an updated version of a black stereotype.

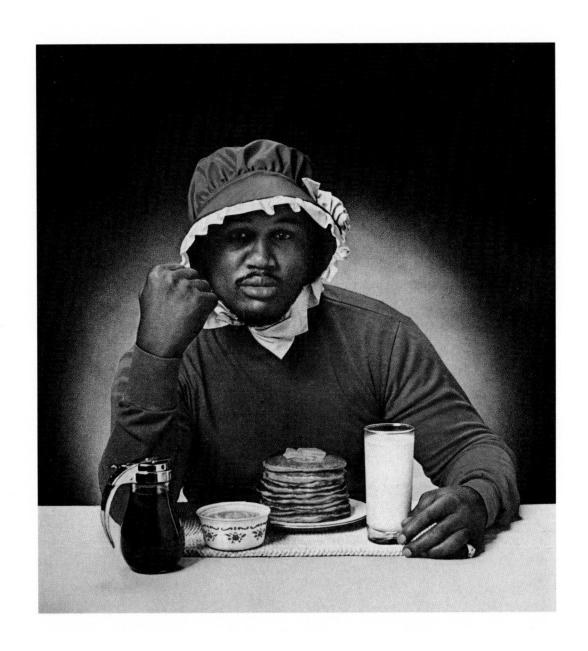

HANK WILLIS THOMAS

Gotten, 1996/2007

ANNIE LEIBOVITZ

Kirby Puckett, Orlando, Florida, 1988

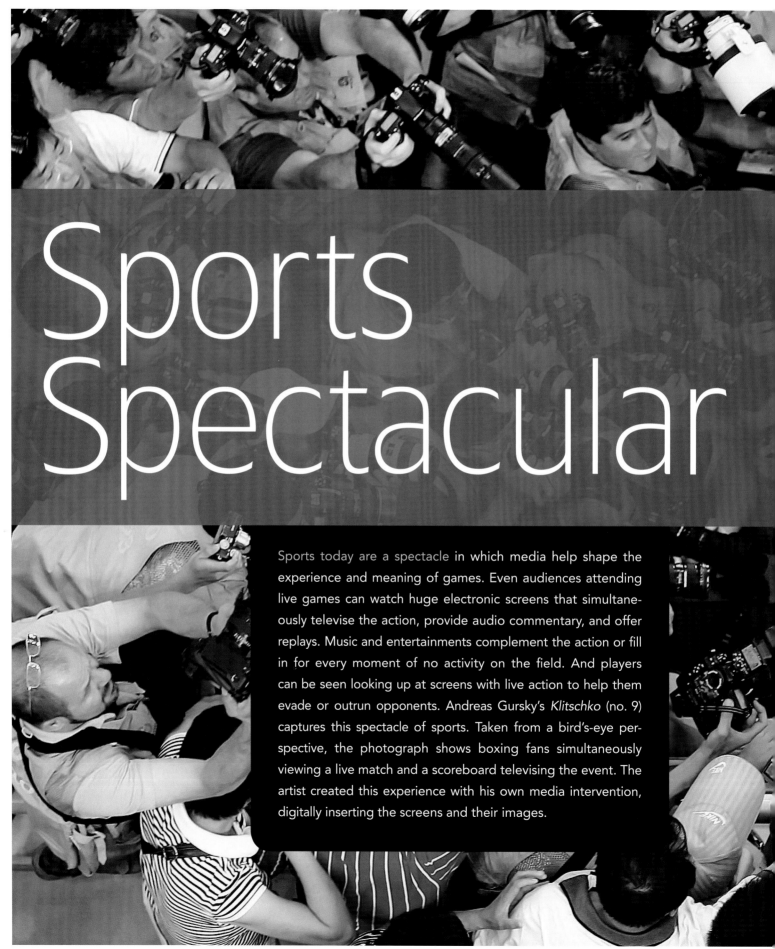

Sports Spectacular

Sports today are a spectacle in which media help shape the experience and meaning of games. Even audiences attending live games can watch huge electronic screens that simultaneously televise the action, provide audio commentary, and offer replays. Music and entertainments complement the action or fill in for every moment of no activity on the field. And players can be seen looking up at screens with live action to help them evade or outrun opponents. Andreas Gursky's *Klitschko* (no. 9) captures this spectacle of sports. Taken from a bird's-eye perspective, the photograph shows boxing fans simultaneously viewing a live match and a scoreboard televising the event. The artist created this experience with his own media intervention, digitally inserting the screens and their images.

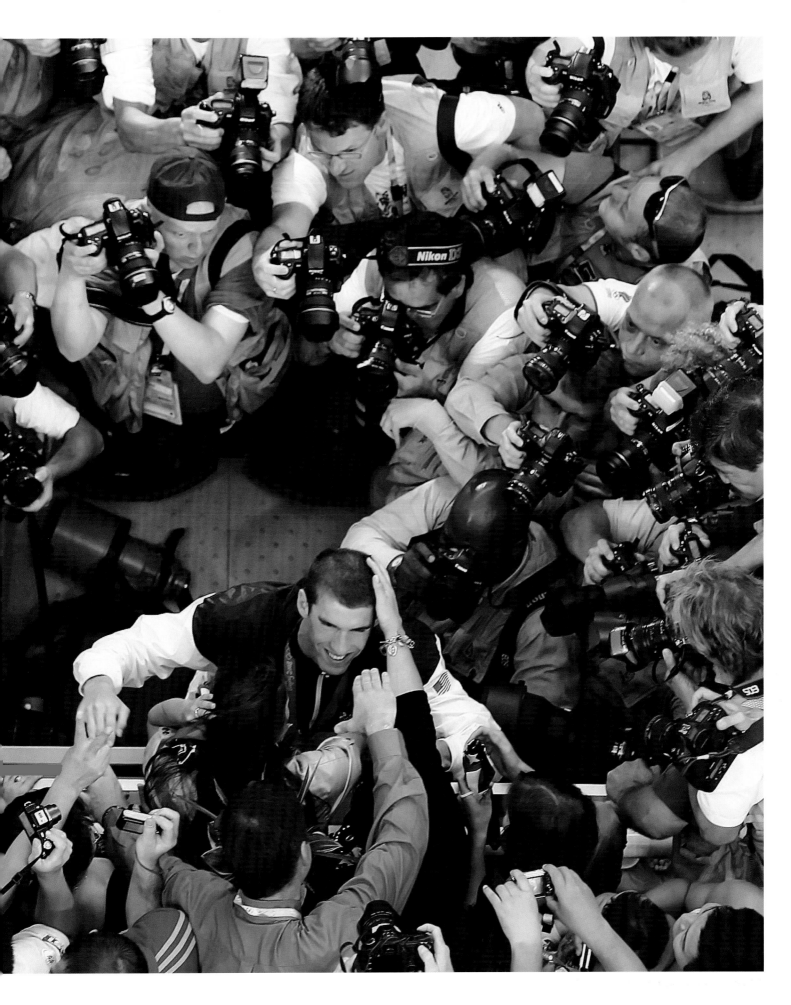

MARTIN MUNKACSI

Spectators at a Sports Event, from the series Crowd, 1933

HENRI CARTIER-BRESSON

**This Fan Listens to a Distant Ball Game While
Watching Another**, 1957

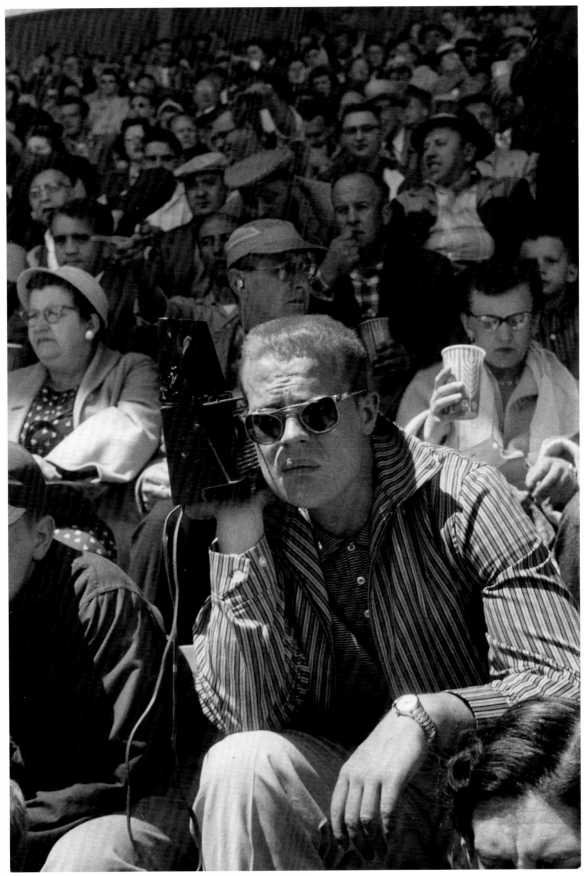

LEE FRIEDLANDER

Baltimore, 1962

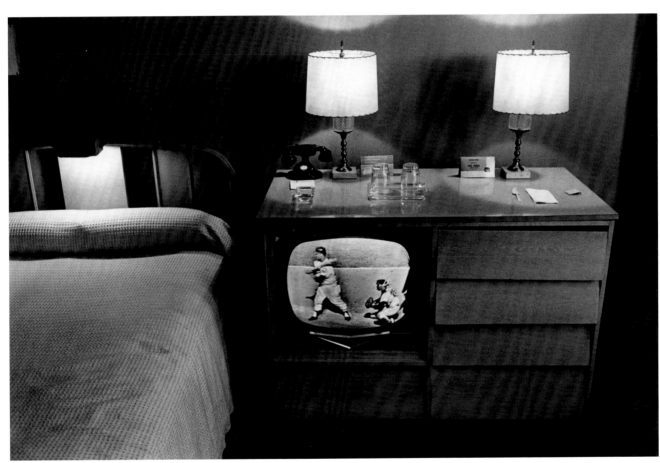

TOBY OLD

KO'd on TV, New York City, from Boxing series, 1983

TOD PAPAGEORGE

**Cotton Bowl (Notre Dame vs. Texas), Cotton Bowl
Stadium, Dallas, January 1, 1971**

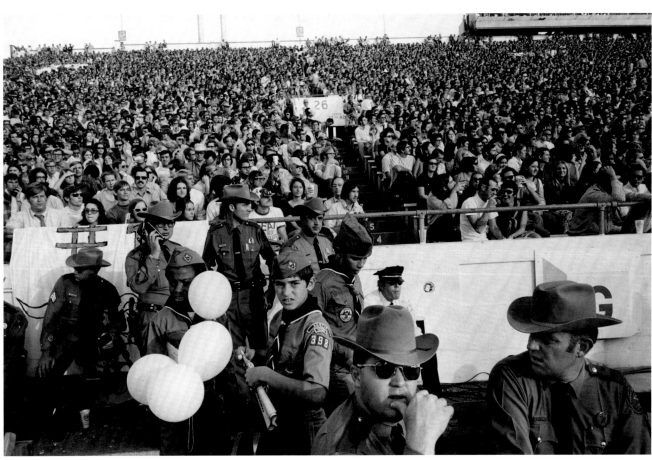

TOD PAPAGEORGE

Iron Bowl (Auburn vs. Alabama), Legion Field,
Birmingham, Alabama, November 28, 1970

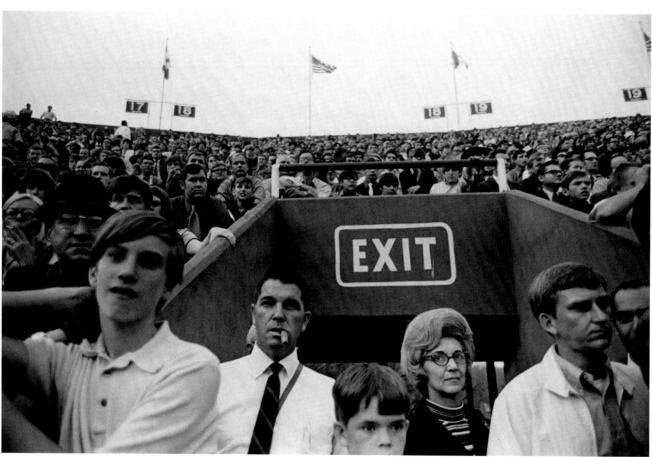

132

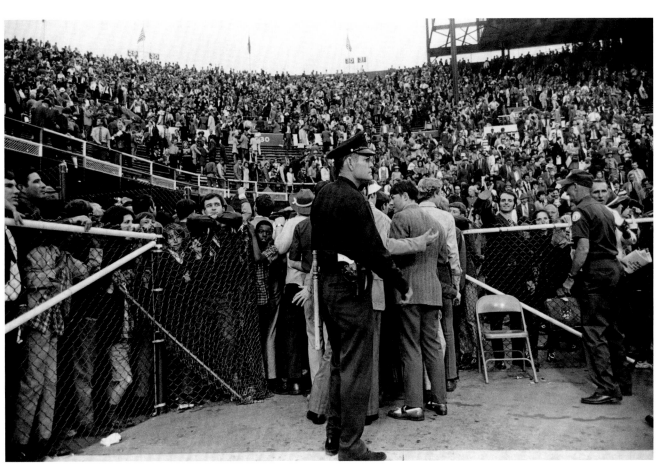

TOD PAPAGEORGE

**Opening Day (Boston vs. New York), Yankee Stadium,
New York, April 7, 1970**

TOD PAPAGEORGE

Belmont Stakes, Belmont Park, New York, June 6, 1970

135

TOD PAPAGEORGE

**Little League World Series, Lamade Stadium,
Williamsport, Pennsylvania, August 26, 1970**

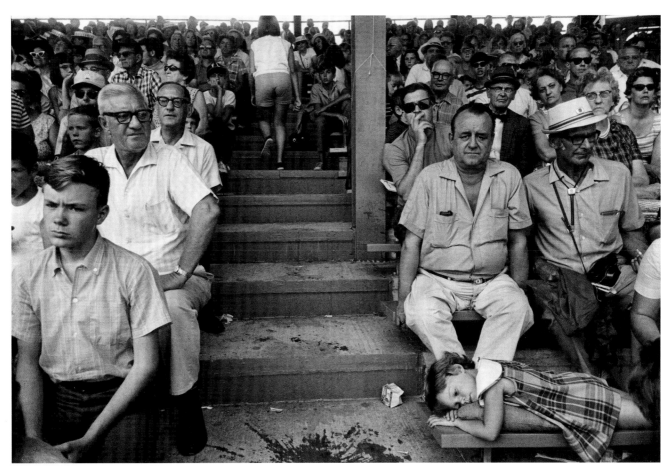

Iron Bowl (Auburn vs. Alabama), Legion Field,
Birmingham, Alabama, November 28, 1970

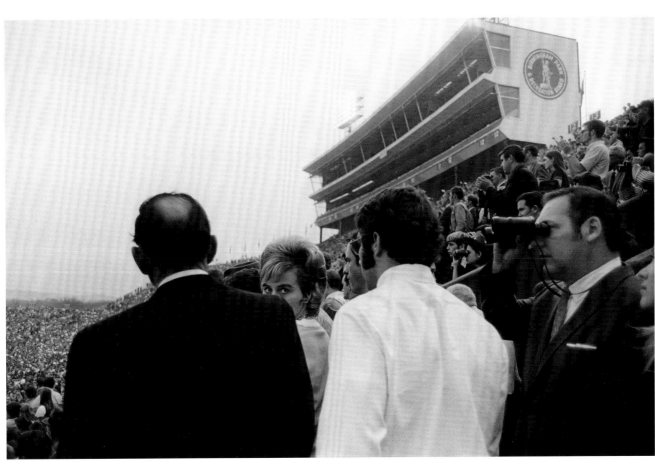

ANDREAS GURSKY

Tour de France, 2007

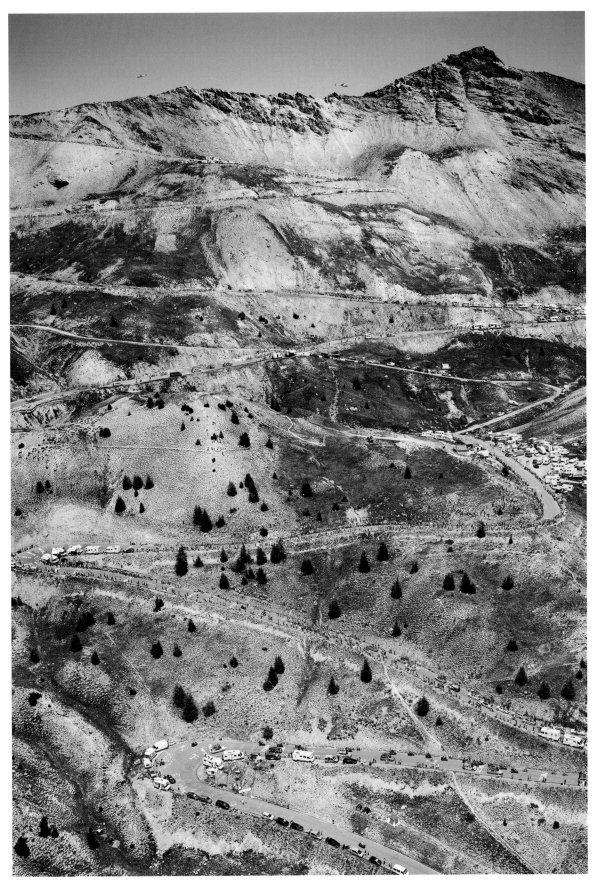

ANDREAS GURSKY

Bahrain I, 2005

© The Museum of Modern Art/Licensed by SCALA/Art Resource,
New York

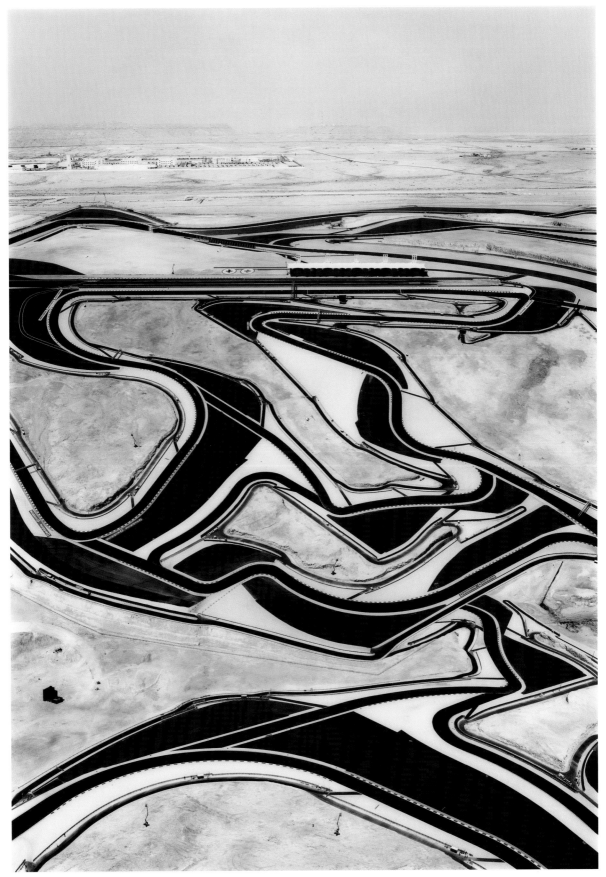

SHARON LOCKHART

Goshogaoka Girls Basketball Team:
Group III: (a) Chihiro Nishijima; (b) Sayaka Miyamoto and
Takako Yamada; (c) Kumiko Shirai and Eri Hashimoto;
(d) Kumiko Kotake, 1997

140

SHARON LOCKHART

Goshogaoka Girls Basketball Team:
Group IV: (a) Ayako Sano, 1997

KOTA EZAWA

Brawl, 2008

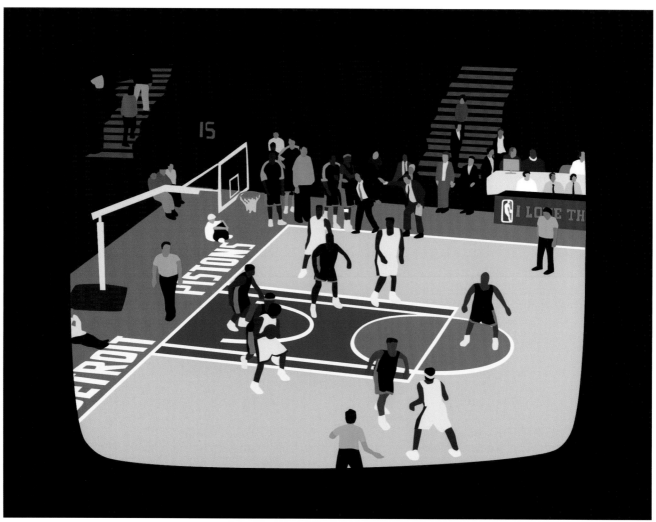

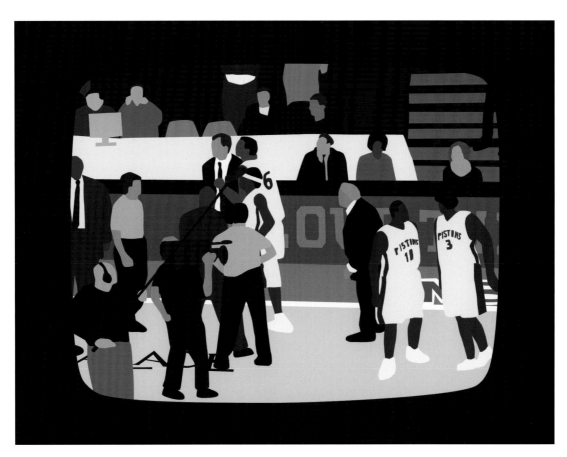

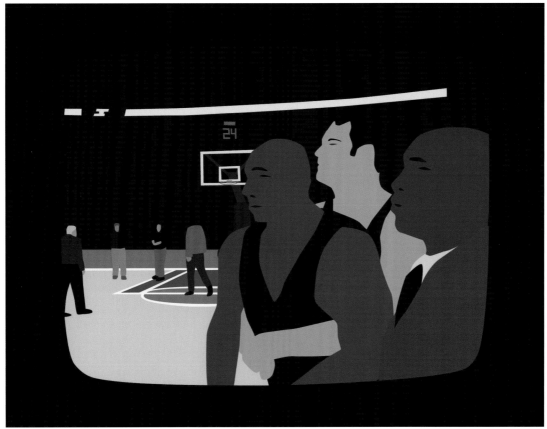

ROGER WELCH

The O. J. Simpson Project

In the mid-1970s, O. J. Simpson was the most famous football player in America, breaking records, appearing as a celebrity guest on prime-time television, and making the cover of many magazines. Fans admired his charismatic personality as much as his athletic prowess. Simpson's legend was so enduring that at his trial, twenty years later, undaunted fans wore T-shirts proclaiming, "O.J. is still my hero."

To explore Simpson's views about fame and charisma, I conducted a videotaped interview in December 1976 addressing him on a wide range of topics, from politics to sports mythology and competition to show business. O.J. was casual and gracious throughout, easygoing, affable, and humorous.

A few days later, I directed multiple film cameras on Simpson in a game between the Buffalo Bills and the New York Jets at Buffalo's Rich Stadium. Other cameras captured the reactions of the audience. The resulting film was later transferred to video.

The completed work occupies one large exhibition space with three wall-size projections and two television monitors, all playing continuously. A two-screen panorama on one side presents the crowd in the stands audibly cheering or jeering at the spectacle. The screen on the opposite side silently displays Simpson's athletic performance during the game. This projection is flanked by two video monitors simultaneously showing Simpson's interview.

While in Buffalo, I stayed at Hallwalls, an alternative art space then run by Cindy Sherman, Robert Longo, and Charles Clough. Robert made a drawing for me, which I still have, of a football player waking me up for the early-morning interview. Luckily, aside from the drawing, he also gave me an alarm clock.

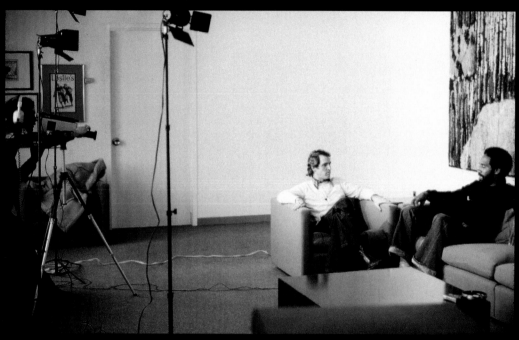

143

ROGER WELCH

O. J. Simpson

INTERVIEW BY ROGER WELCH (1976)

The following excerpts from Roger Welch's interview with O. J. Simpson on December 6, 1976, for *The O. J. Simpson Project* (1977) have been edited for clarity, and Welch's interview questions, some of which were edited out of the installation video, are included.

OJ: When I first came out of school, you know, they pay you a lot of money for appearances, and it was kind of hard for me to justify not making those appearances. But appearances are just like the game of football—as long as I'm popular and I'm gaining yards on the football field, I can go do an appearance and pick up seven fifty, a thousand, I mean ten thousand dollars or so. And people say, how can you not do an appearance for that amount of money? Well, I consider that invested in my future. I try to save my time on the off-season for movies in case an interesting project comes up that I have the available time to go wherever, I have to go to do it. As I said, I want to be an actor and to work in that line, so I have something to fall [back] onto when I finish the game of football.

RW: Are there any commercials or films that you wouldn't do?

OJ: Oh, yeah, there are types of movies I read the script and first I try to find out my . . . gauge thus far in my development as an actor. Well, first, who is the director? Secondly, who are the other actors? And thirdly, what is my part in all of this? Is it a meaningful part? Does it have anything to progress the story? Is the character there just to be a [guest star]? . . . You see these [movies] *Two-Minute Warning* [1976] and *Earthquake* [1974] and they've just got guys coming in and out and nobody has anything to do with the story line, so I realize I have a long way to go as an actor. I've been offered leads in movies but, hey, I knew they

were exploiting me. So what I wanted to do was work with good actors—people I can learn from and good directors who can direct me 'cause sometimes you're lost out there. You don't know exactly how you should play certain characters and I've been fortunate in that I've worked with some pretty good directors.

RW: Did you ever think of writing and acting and directing in a film yourself?

OJ: Oh yeah, I've thought of all of it. On writing and producing, I'd like to be a producer. . . . I was in Europe this fall doing a movie and . . . Rod Steiger was on his way to Israel to do a movie and we got together for a couple of days and had a meal together, and just during the conversation with his talking about our experiences, I thought of what I thought would be a pretty good movie. So, I went and wrote my critique down on it—a little description of a thing I would like to do with him. He was interested in it and I had to register it with the writers so nobody could steal the story line. I haven't done much with it since then, but hopefully someday I'll be able to have a good writer work on it and I think . . . it's a pretty good idea for a movie.

OJ: I went to Africa to do a movie that was called *The Diamond Mercenaries* [1975]. They changed it to *Killer Force* [1976] and we went and made a different movie than we thought we were going to make. You know, you read a script, and I just did a movie that came out pretty good

called *The Cassandra Crossing* [1976]. But I noticed that there were a few things that were cut totally different than the idea that I had in mind or the idea that the other actors had in mind when we were doing the part shooting the particular scene. So, yes, a lot has to do with the director and probably more important, so much has to do with the editor because they can cut a scene up or cut you completely out of a movie. It's interesting how it happens.

OJ: At the time, I just asked my agent, hey, I read this book and there's a character in it I'd like to play if they ever make a movie. Find out who has the rights to the book. . . . At one point, I thought maybe I could get the rights to the book. But, unfortunately it had been long gone . . . since I had read it.

RW: I read *Ragtime* [by E. L. Doctorow, 1976] and I was imagining you playing the part of Coalhouse Walker in a movie. You've expressed interest in being cast for the role and it seemed a good match for you. There was something about the character. All I could think of was determination, not bending under any pressure. You have some of those qualities, so the role seems to fit you well.

OJ: Yes, the guy took a moral stand. He would only be treated as a man. I've always tried to use that as my philosophy and, as I said I felt myself, when I was reading the character, I saw a lot of myself in the character. Of course, I wasn't as

old as maybe the character was supposed to be, but I didn't see this as any problem either. I am getting older and the way they've been hitting me in the head this year, I'm getting to look older [*laugh*].

RW: Muhammad Ali has a remarkable ability to keep his mythology going. Anytime it seems like he's slipping from the public eye, he turns things around to keep his heroic image alive. Do you feel any pressure, in some way, that people always expect you to be the hero?

OJ: I found . . . I thought that maybe my problem would be that I would have to tear that down. I would have to . . . I had a certain image that I found I was becoming entrapped . . . getting trapped within the image other people have of me. You know, my image was dictating what I did and who I was. I even had a manager at one point. I was going to do something and he said, you can't do that. O. J. Simpson would never do that. I said, hey, wait . . . wait a minute. I'm O. J. Simpson [*laugh*], and I'm going to do it. I'm growing a mustache . . . a beard here. I'm growing a beard for no particular reason. I'm just tired of shaving every day and with all the anxieties I've been having this year [*laugh*] you know, it's a little rest for my face . . . not shaving. But you know, you're getting letters from people. Hey you can't grow a beard, there're kids that look up to you. You're supposed to be clean-shaven. I said, wait a minute, I am me. I am O.J. and I'm going to do what's right, first of all,

for me and my family and [if] someone finds that something they would like to emulate, hey, fine. I'm glad of that. But I have to be true to myself first. So, I thought going into acting that my biggest problem would be tearing down the good guy O. J. Simpson, to play something else. I did a movie called *The Klansmen* [1974] and . . . all the people close to me said you can't do that. You can't be shooting people and killing people and everything. And I said, now wait a minute. Now I'm playing a part in a movie and I don't want to be on the screen O. J. Simpson. I want to be whatever character the people are looking at and I got good reviews for it and I was glad I did it. And I thought maybe I would have to play more of those kinds of parts. The guy was not a bad guy. He was sort of an antihero, but more of those type of characters to kind of get rid of . . . not to get rid of the good-guy image but when people see me on the screen not to see, hey, [it's] O. J. Simpson, 'cause if I'm playing a nice guy, a good guy, the image people have of me—it's going to be pretty tough for them to decipher hey, O. J. from whoever that guy is.

OJ: For the most part guys are being realistic about things. They're not saying what people want to hear and they're not living their lives the way people think they're supposed to live their lives. Ah . . . guys are being real they're trying to say an athlete is just like anybody else, they smoke, they drink, some of them are into drugs and they go out after women and you name it [*laugh*].

RW: Have you ever considered getting involved in politics?

OJ: I try to stay out of politics even though it's getting increasingly difficult to do that. You know, I find that all these politicians are after me all the time. . . . They think I have some influence on people's . . . you know and I don't know. I didn't know what I was going to do in this last election and people are after me all the time trying to find out who I was going to vote for and everything and I said, who am I? I'm not that qualified and that versed in politics to have anybody take seriously who I think is a good candidate. I mean, I'm not that polished in it and I'm not that educated in it to really know. . . . I've had a lot of pressure on me to go into politics—guys say I should start gearing myself for politics but, I think if I went into politics today, I would probably have to be a socialist and all my enemies would call me a communist [*laugh*] you know, so, I say I better stay out of politics [*laugh*].

RW: We were in school about the same time and I remember at that time there was a lot of political activity, especially in the late sixties it really hit. Did you feel a pressure to get involved in it, but because you were playing football you couldn't do that?

OJ: No, I had my goals. . . . I wanted to get into professional football. I wanted to get some financial security for my family. So, I had what I wanted to accomplish first before I even start

even thinking about changing the world, changing the way things were run. I still have a few things that I feel that I had personally—my ego must satisfy—I must feed it before I'm able to sit back and start worrying about what's happening to everybody else in the world. I'm not qualified yet to do it, and I have a few more things that I have to find out about myself before I have to worry about it. Now, when I was in school I was part of the whole generation, I grew up in Haight Ashbury right when the thing hit in '62 and '63 and everything. And I feel I'm in tune with what's going on with my generation and I think our generation has influenced maybe the world more so than any generation, in the last fifty or sixty years, but . . . I'm not ready for it yet. I'm not ready for politics. I didn't avoid it intentionally. I was pulled into it once or twice in the Black movement when I was in school. But I was able to handle it then and ever since then, I haven't had any real run-ins with politics or socially or racially or whatever.

RW: Yeah, because I think someone would like you to be a spokesman.

OJ: All the time.

OJ: Well, racially, now in those days, racially they were trying to use the athletes as the platform, as the pedestal, racially. And as far as the Black community was concerned, . . . many people felt that, hey, the only person that they would listen to were athletes, especially on campuses.

You can be you know, "Joe Dokes," and you can get up there with all the knowledge and 180 IQ. Being black it didn't mean anything. But if the Heisman Trophy candidate—if you had him standing up there with you. Hey, somebody would listen to you. So, I think they tried to use us and in many cases it hurt guys. It hurt . . . I feel that even with Harry Edwards in San Jose. It hurt Tommie Smith. It hurt Lee Evans. It hurt John Carlos—it hurt those guys. Ah . . . standing on his platform I felt they should have been standing on their own platform. They should have found out, hey, what Tommie Smith is all about before they got up there and, you know, Harry Edwards, no one would have ever heard of him if he hadn't had those guys standing up there with him. And of course Harry had had some very pertinent things to say then. And I'm sure he had some things [to say] now. But Harry Edwards is doing fine at Berkeley. Now I mean, he has money, he's driving big fancy cars and Tommie Smith and these other guys, they're looking for work. . . . Guys had come to me trying to use me in that respect but as I said, I had goals and my thoughts that I wanted to try to develop. And I said, if I stand on the platform I'm going to be speaking for O.J. [*laugh*].

OJ: No, I can't handle it. It's hard for me to be an ambassador for football right now. I love the game. I know there's pitfalls in the game. I think it's a great game. I've read that some guys have had bitter experiences in the game. . . . You read Pete Gent's books [*North Dallas Forty*],

hey but I think some of those guys got into the game sort of idealistically. They weren't realists and I've always considered myself, first of all, a realist, and I recognize that football does have its faults but, hey, I love the game. I play the game, the game has allowed me to attain just about everything that I have materially and even spiritually, not religiously, but inside. That helped me find out things about myself and I realize there's a price you have to pay for everything and if the price is listening to some idiot trying to control your life, hey, if you're strong enough you're going to overcome that and you get what you can. The positive things you can get from the game. I mean I think my father had it tough. He was a custodian at the Federal Reserve Bank and there's people working on the assembly lines and they got to swallow an awful lot of pride.

OJ: I see kids look at me and they like the way you do your thing, you say, if I was in his position I'd do it just like him or guys that you work with say, hey, I want him to get it. He deserves it. And by getting that spirit, by getting that feeling, they go out and perform better themselves too, you know, they, I don't know, they relate it to one guy for some reason, like in Buffalo, they relate to me. Dave Foley, he was in New York and they cut him. Mike Motley, they traded him in from New England. These guys were kind of floating around, but we got together and we got a common goal and spirit with each other and we're able to get and do those things. They kind of rally around me because my name is in the

paper because of knocking guys down, but what for whatever reason, that's charisma.

RW: I see a tackle as a guy who sets up obstacles, and then the runner is the guy who goes through them. In some ways it makes the runner a more romantic kind of hero figure and it seems that runners are more likely to be heroes than the tackles. Do you think that's true?

OJ: Oh yeah, that has been true. It's the glamour position. I think that everybody would like to be a runner. I have a true feeling that inside everybody would like to be the great runner more than any other position on the football field. I think they're the most respected by the players on the team, good runners. Because we get hit more than anybody else and it takes a certain toughness inside, mental toughness to be a running back—a good running back and . . . quarterbacks don't get hit. Some of them are not great athletes. They have good arms. They can throw the ball . . . but I would say on the football field then, more than any other position, the running back has to be maybe as tough as anybody on the field. He has to be probably just about the best athlete on the field, and mentally he has to be the most determined guy on the field. And when we work together, when you work with linemen all the time, the play don't go when it's going. But they know what I'm doing behind them because we've played well together and I can set guys up and make their jobs easier and, of course,

that makes my job easier. But I don't know if I answered whatever question was asked [*laugh*]. But I like being a running back, and I don't think there's any other position on the field I'd prefer to play other than that.

OJ: If it wasn't for Jim Brown, if it wasn't for Freddy Williamson, I may have come out and hey hand me this script "Willie Dynamite" you're the lead. I would have taken it. But I've seen how their careers progressed and I say, well, that's not the way I want to do it. What have they done wrong—not that they feel that they've done anything wrong. I don't know. I see a certain way their careers have gone that I don't want mine to go. So, I've studied them, saw what they've done, and say, well wait a minute, I don't want to do that. I don't want to be a lead just yet. Let me work with good actors. Let me work with good directors, and let me develop along the lines of a . . . Dustin Hoffman [*wink to the camera, laugh*]. But I've learned from them. I've learned from their experiences. Just like his [Jim Brown's] records are out there for me to go after. He put them out there, he established excellence and in acting he established a level, yeah, that I'm trying to shoot above that level.

RW: Before you ran for the rushing record in Detroit, you spoke about how you get so physically tuned in to the game that you can sense tacklers before you see them. Did you feel like that in the Detroit game? [Simpson set a then NFL rushing record against the Detroit Lions on

November 2, 1976, running for 273 yards and two touchdowns. The Minnesota Vikings' Adrian Peterson now holds the record after rushing for 296 yards against the San Diego Chargers on November 4, 2007.]

OJ: Oh yeah, well certain days you're on. I was pretty on that day. So some days you're on and you know some days you are thinking too much . . . you get out there and you're trying to outthink the guys who are over there, and there are some days you're just lost into the game and that's why I mean more and more that I have to get alone. I have to sit on that bench by myself at the beginning of the game to get totally into the game where I'm just feeling the game. And I'm not thinking about what he may do . . . what they do in this situation. I'm just reacting spontaneously to whatever's happening. That day I was really on. And Sunday I was on that way. In the beginning of the season, you're out of shape. You're thinking about your conditioning. You're thinking about what defense they may be in and all that. . . . It's all physical . . . in anything you do. I think even if you're just into debating. If you go out and get your body in shape and everything, hey, it's going to kind of take over and once you get to cookin', Jack you're just cookin'.

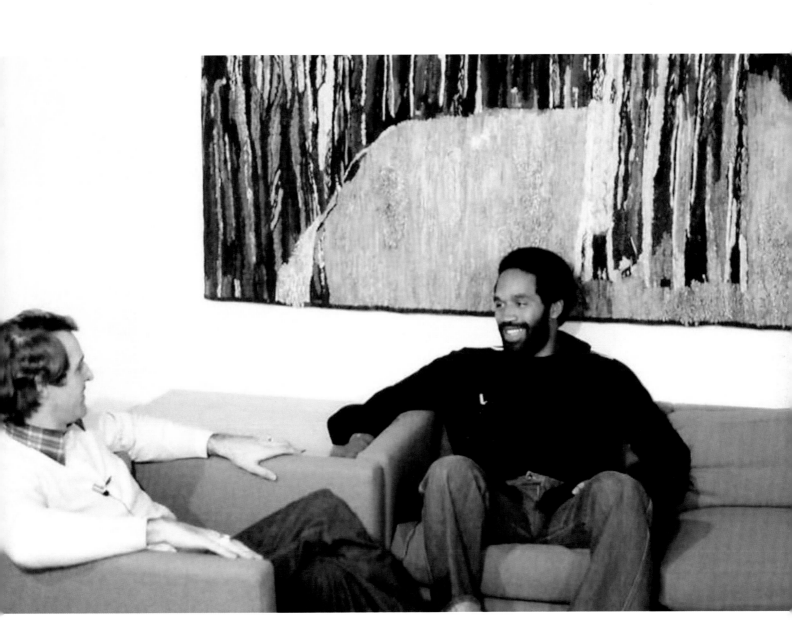

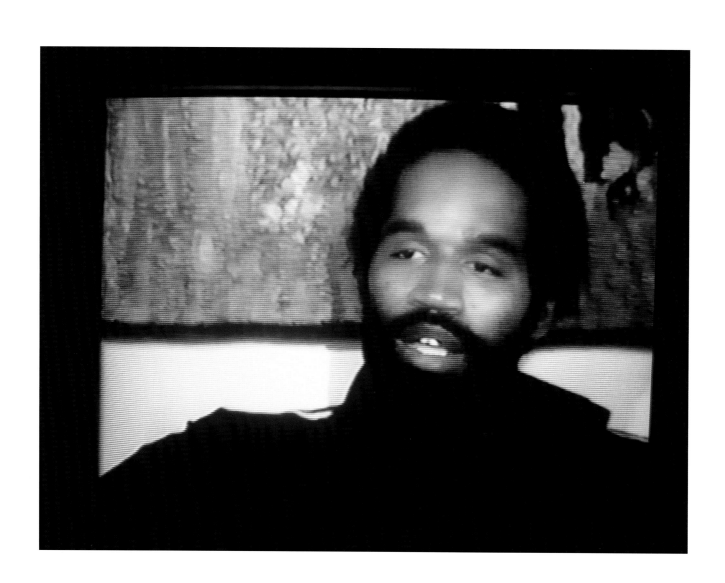

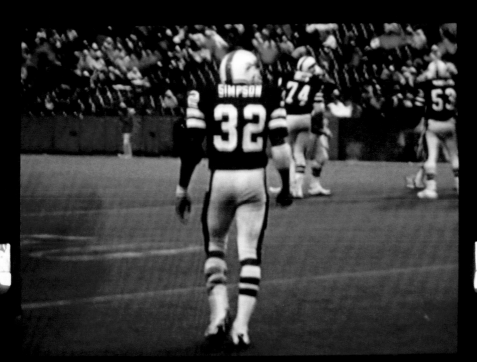

JOYCE CAROL OATES

On Boxing

It's a terrible sport, but it's a sport . . . the fight for survival is the fight.

—**Rocky Graziano**
former middleweight champion of the world

They are young welterweight boxers so evenly matched they might be twins, though one has a redhead's pallor and the other is a dusky-skinned Hispanic. Circling each other in the ring, beneath the glaring lights, trying jabs, tentative left hooks, right crosses that dissolve in mid-air or turn into harmless slaps. How to get inside! How to press an advantage, score a point or two, land a single punch! It seems they have forgotten all they've been trained to do and the Madison Square Garden fight crowd is getting noisy, derisive, impatient. Time is running out. "Those two—what'd they do, wake up this morning and decide they were boxers?" a man behind me says in disgust. (He's dark, nattily dressed, neat-trimmed moustache and tinted glasses. A sophisticated fight fan. Knows all the answers. Two hours later he will be screaming, "Tommy! Tommy! Tommy!" over and over in a paroxysm of grief as, on the giant closed-circuit television screen lowered over the ring, middle-weight champion Marvelous Marvin Hagler batters his brash challenger Thomas Hearns into insensibility.)

The young welterweights are surely con-scious of the chorus of jeers, boos, and catcalls in this great cavernous space reaching up into the cheap twenty-dollar seats in the balconies amid the constant milling of people in the aisles, the commingled smells of hotdogs, beer,

cigarette and cigar smoke, hair oil. But they are locked desperately together in their futile match—circling, "dancing," jabbing, slapping, clinching—now a flurry of light blows, clumsy footwork, yet another sweaty stumbling despairing clinch into the ropes that provokes a fresh wave of derision as the referee helps them apart. Why are they here in the Garden of all places, each fighting, it seems, his first professional fight? Neither wants to hurt the other—neither is angry at the other. When the bell sounds at the end of the fourth and final round the crowd boos a little louder. The Hispanic boy, silky yellow shorts, damp frizzy floating hair, strides about his corner of the ring with his gloved hand aloft—not in defiance of the boos which increase in response to his gesture, or even in acknowledgment of them. It's just something he's doing, something he has seen older boxers do, he's saying *I'm here, I made it. I did it.*

When the decision is announced as a draw the crowd's derision increases in volume. "Get out of the ring!" "Assholes!" "Go home!" Contemptuous male laughter follows the boys up the aisle in their robes, towels about their heads, sweating, breathless. Why had they thought they were boxers?

How can you enjoy so brutal a sport, people sometimes ask me.

Or pointedly don't ask.

And it's too complex to answer. In any case I don't "enjoy" boxing in the usual sense of the word, and never have; boxing isn't invariably "brutal"; and I don't think of it as a "sport."

Nor can I think of boxing in writerly terms as a metaphor for something else. No one whose interest began as mine did in childhood—as an offshoot of my father's interest—is likely to think of boxing as a symbol of something beyond itself, as if its uniqueness were merely an abbreviation, or iconographic; though I can entertain the proposition that life is a metaphor for boxing—for one of those bouts that go on and on, round following round, jabs, missed punches, nothing determined, again the bell and again and you and your opponent so evenly matched it's impossible not to see that your opponent *is* you: and why this struggle on an elevated platform enclosed by ropes as in a pen beneath hot crude pitiless lights in the presence of an impatient crowd?—that sort of hellish-writerly metaphor. Life *is* like boxing in many unsettling respects. But boxing is only like boxing.

For if you have seen five hundred boxing matches you have seen five hundred boxing matches and their common denominator, which certainly exists, is not of primary interest to you. "If the Host is only a symbol," as the Catholic writer Flannery O'Connor once remarked, "I'd say the hell with it."

Like a dancer, a boxer "is" his body, and is totally identified with it. And the body is identified with a certain weight:

Heavyweight—no weight limit
Cruiserweight—not over 195 pounds
Light heavyweight—not over 175 pounds
Middleweight—not over 160 pounds
Junior middleweight—not over 154 pounds
Welterweight—not over 147 pounds
Junior welterweight—not over 140 pounds
Lightweight—not over 135 pounds
Junior lightweight—not over 130 pounds
Featherweight—not over 126 pounds
Junior featherweight—not over 122 pounds
Bantamweight—not over 118 pounds
Flyweight—not over 112 pounds

Though the old truism "A good big man will always beat a good little man" has been disproved any number of times (most recently by Michael Spinks in his victory over Larry Holmes) it is usually the case that a boxer invites disaster by fighting out of his weight division: he can "move up" but very likely he can't "bring his punch with him." Where at one time the distinctions between weight were fairly crude (paralleling life's unfairness—the mismatches of most

battles outside the ring) boxing promoters and commissions have created a truly Byzantine hierarchy of weights to regulate present-day fights. In theory, the finely calibrated divisions were created to prevent mismatches; in practice, they have the felicitous effect of creating many more "champions" and many more lucrative "title" shots. So it is, an ambitious boxer in our time hopes not only to be a champion but to be a great champion—an immortal; he may try for multiple titles, like Sugar Ray Robinson (world welter- and middleweight champion who tried, and failed, to win the light-heavyweight title from Joey Maxim), Sugar Ray Leonard (world welter- and junior-middleweight champion), Roberto Durán (world light-, welter- and light-middleweight champion who tried, and failed, to move up to middleweight), Alexis Arguello (world featherweight, junior lightweight, and lightweight champion who hoped for a junior welterweight title before his recent retirement).

In order to make his weight the boxer may resort to fasting or vigorous exercise so close to fight time that he risks serious injury: like, most recently, WBA bantam-weight champion Richie Sandoval who lost ten pounds in a short period of time and, in his match with Gaby Canizales

in March 1986, nearly lost his life as a consequence. When Michael Spinks made boxing history in September 1985 by becoming the first light-heavyweight to win the heavyweight title, as much excited media attention was paid to Spinks's body as to his boxing. For Spinks had accomplished what constituted a *tour de force* of the physical—with the help of his trainer and nutritionist he had created for himself a true heavyweight's body: two hundred pounds of solid muscle. And though his opponent Larry Holmes outweighed him by twenty-odd pounds it scarcely mattered since Spinks had not merely gained weight, he had become a "new" body. And he sustained this remarkable new body for his title defense against Holmes, which he also won. Boxing's fanaticism can go no further.

Why are you a boxer, Irish featherweight Champion Barry McGuigan was asked. He said: "I can't be a poet. I can't tell stories . . ."

Each boxing match is a story—a unique and highly condensed drama without words. Even when nothing sensational happens: then the drama is "merely" psychological. Boxers are there to establish an absolute experience, a public accounting of the outermost limits of their beings; they will know, as few of us can know of ourselves, what physical and psychic power they possess—of how much, or how little, they are capable. To enter the ring near-naked and to risk one's life is to make of one's audience voyeurs of a kind: boxing is so intimate. It is to ease out of sanity's consciousness and into another, difficult to name. It is to risk, and sometimes to realize, the agony of which *agon* (Greek, "contest") is the root.

In the boxing ring there are two principal players, overseen by a shadowy third. The ceremonial ringing of the bell is a summoning to full wakefulness for both boxers and spectators. It sets into motion, too, the authority of Time.

The boxers will bring to the fight everything that is themselves, and everything will be exposed—including secrets about themselves they cannot fully realize. The physical self, the maleness, one might say, underlying the "self." There are boxers possessed of such remarkable intuition, such uncanny prescience, one would think they were somehow recalling their fights, not fighting them as we watch. There are boxers who perform skillfully, but mechanically, who cannot improvise in response to another's alteration of strategy; there are boxers performing at the peak of their talent who come to realize, mid-fight, that it will not be enough; there are boxers—including great champions—whose careers end abruptly, and irrevocably, as we watch. There has been at least one boxer possessed of an extraordinary and disquieting

awareness not only of his opponent's every move and anticipated move but of the audience's keenest shifts in mood as well, for which he seems to have felt personally responsible—Cassius Clay/Muhammad Ali, of course. "The Sweet Science of Bruising" celebrates the physicality of men even as it dramatizes the limitations, sometimes tragic, more often poignant, of the physical. Though male spectators identify with boxers no boxer behaves like a "normal" man when he is in the ring and no combination of blows is "natural." All is style.

Every talent must unfold itself in fighting. So Nietzsche speaks of the Hellenic past, the history of the "contest"—athletic, and otherwise—by which Greek youths were educated into Greek citizenry. Without the ferocity of competition, without, even, "envy, jealousy, and ambition" in the contest, the Hellenic city, like the Hellenic man, degenerated. If death is a risk, death is also the prize—for the winning athlete.

In the boxing ring, even in our greatly humanized times, death is always a possibility—which is why some of us prefer to watch films or tapes of fights already past, already defined as history. Or, in some instances, art. (Though to prepare for writing this mosaic-like essay I saw tapes of two infamous "death" fights of recent times: the Lupe Pintor–Johnny Owen bantamweight match of 1982, and the Ray Mancini–Duk Koo-Kim lightweight match of the same year. In both instances the boxers died as a consequence of their astonishing resilience and apparent indefatigability—their "heart," as it's known in boxing circles.) Most of the time, however, death in the ring is extremely unlikely; a statistically rare possibility like your possible death tomorrow morning in an automobile accident or in next month's headlined airline disaster or in a freak accident involving a fall on the stairs or in the bathtub, a skull fracture, subarachnoid hemorrhage. Spectators at "death" fights often claim afterward that what happened simply seemed to happen—unpredictably, in a sense accidentally. Only in retrospect does death appear to have been inevitable.

If a boxing match is a story it is an always wayward story, one in which anything can happen. And in a matter of seconds. Split seconds! (Muhammad Ali boasted that he could throw a punch faster than the eye could follow, and he may have been right.) In no other sport can so much take place in so brief a period of time, and so irrevocably.

Because a boxing match is a story without words, this doesn't mean that it has no text or no language, that it is somehow "brute," "primitive," "inarticulate," only that the text is improvised in action; the language a dialogue between the boxers of the most refined sort (one might say, as much neurological as psychological: a dialogue of split-second reflexes) in a joint response to the mysterious will of the audience which is always that the fight be a worthy one so that the crude paraphernalia of the setting—ring, lights, ropes, stained canvas, the staring onlookers themselves—be erased, forgotten.

(As in the theater or the church, settings are erased by way, ideally, of transcendent action.) Ringside announcers give to the wordless spectacle a narrative unity, yet boxing as performance is more clearly akin to dance or music than narrative.

To turn from an ordinary preliminary match to a "Fight of the Century" like those between Joe Louis and Billy Conn, Joe Frazier and Muhammad Ali, Marvin Hagler and Thomas Hearns is to turn from listening or half-listening to a guitar being idly plucked to hearing Bach's *Well-Tempered Clavier* perfectly executed, and that too is part of the story's mystery: so much happens so swiftly and with such heart-stopping subtlety you cannot absorb it except to know that something profound is happening and it is happening in a place beyond words.

I try to catch my opponent on the tip of his nose because I try to punch the bone into his brain.

—**Mike Tyson**

Boxing's claim is that it is superior to life in that it is, ideally, superior to all accident. It contains nothing that is not fully willed.

A boxer meets an opponent who is a dream-distortion of himself in the sense that his weaknesses, his capacity to fail and to be seriously hurt, his intellectual miscalculations—all can be interpreted as strengths belonging to the Other; the parameters of his private being are nothing less than boundless assertions of the Other's self. This is dream, or nightmare: my strengths are not fully my own, but my opponent's weaknesses; my failure is not fully my own, but my opponent's triumph. He is my shadow-self, not my (mere) shadow. The boxing match as "serious, complete, and of a certain magnitude"—to refer to Aristotle's definition of tragedy—is an event that necessarily subsumes both boxers, as any ceremony subsumes its participants. (Which is why one can say, for instance, that the greatest fight of Muhammad Ali's career was one of the few fights Ali lost—the first heroic match with Frazier.)

The old boxing adage—a truism surely untrue—that you cannot be knocked out if you see the blow coming, and if you will yourself not to be knocked out, has its subtler, more daunting significance: nothing that happens to the boxer in the ring, including death—"his" death—is not of his own will or failure of will. The suggestion is of a world-model in which we are humanly responsible not only for our own acts but for those performed against us.

Which is why, though springing from life, boxing is not a metaphor for life but a unique, closed, self-referential world, obliquely akin to those severe religions in which the individual is both "free" and "determined"—in one sense possessed of a will tantamount to God's, in

another totally helpless. The Puritan sensibility would have understood a mouth filling with blood, an eye popped out of its socket—fit punishment for an instant's negligence.

A boxing trainer's most difficult task is said to be to persuade a young boxer to get up and continue fighting after he has been knocked down. And if the boxer has been knocked down by a blow he hadn't seen coming—which is usually the case—how can he hope to protect himself from being knocked down again? and again? The invisible blow is after all—invisible.

"Normal" behavior in the ring would be unbearable to watch, deeply shameful: for "normal" beings share with all living creatures the instinct to persevere, as Spinoza said, in their own being. The boxer must somehow learn, by what effort of will non-boxers surely cannot guess, to inhibit his own instinct for survival; he must learn to exert his "will" over his merely human and animal impulses, not only to flee pain but to flee the unknown. In psychic terms this sounds like magic. Levitation. Sanity turned inside out, "madness" revealed as a higher and more pragmatic form of sanity.

The fighters in the ring are time-bound—surely nothing is so excruciatingly long as a fiercely contested three-minute round—but the fight itself is timeless. In a sense it becomes all fights, as the boxers are all boxers. By way of films, tapes, and photographs it quickly becomes history for us, even, at times, art. Time, like the possibility of death, is the invisible adversary of which the boxers—and the referee, the

seconds, the spectators—are keenly aware. When a boxer is "knocked out" it does not mean, as it's commonly thought, that he has been knocked unconscious, or even incapacitated; it means rather more poetically that he has been knocked out of Time. (The referee's dramatic count of ten constitutes a metaphysical parenthesis of a kind through which the fallen boxer must penetrate if he hopes to continue in Time.) There are in a sense two dimensions of Time abruptly operant: while the standing boxer is *in time* the fallen boxer is *out of time*. Counted out, he is counted "dead"—in symbolic mimicry of the sport's ancient tradition in which he would very likely be dead. (Though, as we may recall, the canny Romans reserved for themselves as spectators the death blow itself: the triumphant gladiator was obliged to wait for a directive from outside the arena before he finished off his opponent.)

If boxing is a sport it is the most tragic of all sports because more than any human activity it consumes the very excellence it displays—its drama is this very consumption. To expend oneself in fighting the greatest fight of one's life is to begin by necessity the downward turn that next time may be a plunge, an abrupt fall into the abyss. *I am the greatest* says Muhammad Ali. *I am the greatest* says Marvelous Marvin Hagler. You always think you're going to win, Jack Dempsey wryly observed in his old age, otherwise you couldn't fight at all. The punishment—to the body, the brain, the spirit—a man must endure to become even a moderately good

boxer is inconceivable to most of us whose idea of personal risk is largely ego-related or emotional. But the punishment as it begins to show in even a young and vigorous boxer is closely gauged by his rivals, who are waiting for him to slip. (After junior-welterweight champion Aaron Pryor won a lackluster fight last year a younger boxer in his weight division, interviewed at ringside, said with a smile: "My mouth is watering." And there was twenty-nine-year-old Billy Costello's bold statement—"If I can't beat an old man [of thirty-three] then I should retire"—shortly before his bout with Alexis Arguello, in which he was knocked out in an early round.)

In the ring, boxers inhabit a curious sort of "slow" time—amateurs never box beyond three rounds, and for most amateurs those nine minutes are exhausting—while outside the ring they inhabit an alarmingly accelerated time. A twenty-three-year-old boxer is no longer young in the sense in which a twenty-three-year-old man is young; a thirty-five-year-old is frankly old. (Which is why Muhammad Ali made a tragic mistake in continuing his career after he had lost his title for the second time—to come out of retirement, aged thirty-eight, to fight Larry Holmes; and why Holmes made a similar mistake, years later, in needlessly exposing himself to injury, as well as professional embarrassment, by meeting with the light-heavyweight champion Michael Spinks. The victory of the thirty-seven-year-old Jersey Joe Walcott over the thirty-year-old Ezzard Charles, for the heavyweight title in 1951, is sui generis. And

Archie Moore is sui generis.) All athletes age rapidly but none so rapidly and so visibly as the boxer.

So it is, the experience of watching great fighters of the past is radically different from having seen them perform when they were reigning champions. Jack Johnson, Jack Dempsey, Joe Louis, Sugar Ray Robinson, Rocky Marciano, Muhammad Ali, Joe Frazier—as spectators we know not only how a fight but how a career ends. The trajectory not merely of ten or fifteen rounds but that of an entire life . . .

Everything that man esteems
Endures a moment or a day.
Love's pleasure drives his love away,
The painter's brush consumes his dreams;
The herald's cry, the soldier's tread
Exhaust his glory and his might:
Whatever flames upon the night
Man's own resinous heart has fed.

—William Butler Yeats,
from "The Resurrection"

When I see blood, I become a bull.

—**Marvin Hagler**

I have no difficulty justifying boxing as a sport because I have never thought of it as a sport.

There is nothing fundamentally playful about it; nothing that seems to belong to daylight, to pleasure. At its moments of greatest intensity it seems to contain so complete and so powerful an image of life—life's beauty, vulnerability, despair, incalculable and often self-destructive courage—that boxing *is* life, and hardly a mere game. During a superior boxing match (Ali–Frazier I, for instance) we are deeply moved by the body's communion with itself by way of another's intransigent flesh. The body's dialogue with its shadow-self—or Death. Baseball, football, basketball—these quintessentially American pastimes are recognizably sports because they involve play: they are games. One *plays* football, one doesn't *play* boxing.

Observing team sports, teams of adult men, one sees how men are children in the most felicitous sense of the word. But boxing in its elemental ferocity cannot be assimilated into childhood. (Though very young men box, even professionally, and many world champions began boxing in their early or mid-teens. By the time he was sixteen Jack Dempsey, rootless and adrift in the West, was fighting for small sums of money in unrefereed saloon fights in which—in

the natural course of things—he might have been killed.) Spectators at public games derive much of their pleasure from reliving the communal emotions of childhood but spectators at boxing matches relive the murderous infancy of the race. Hence the occasional savagery of boxing crowds—the crowd, largely Hispanic, that cheered as the Welshman Johnny Owen was pounded into insensibility by the Mexican bantamweight champion Lupe Pintor, for instance—and the excitement when a man begins to seriously bleed.

Marvelous Marvin Hagler, speaking of blood, is speaking, of course, of his own.

Considered in the abstract the boxing ring is an altar of sorts, one of those legendary spaces where the laws of a nation are suspended: inside the ropes, during an officially regulated three-minute round, a man may be killed at his opponent's hands but he cannot be legally murdered. Boxing inhabits a sacred space predating civilization; or, to use D. H. Lawrence's phrase, before God was love. If it suggests a savage ceremony or a rite of atonement it also suggests the futility of such gestures. For what possible atonement is the fight waged if it must shortly be waged again . . . and again? The boxing match is the very image, the more terrifying for being so stylized, of mankind's collective aggression; its ongoing historical madness.

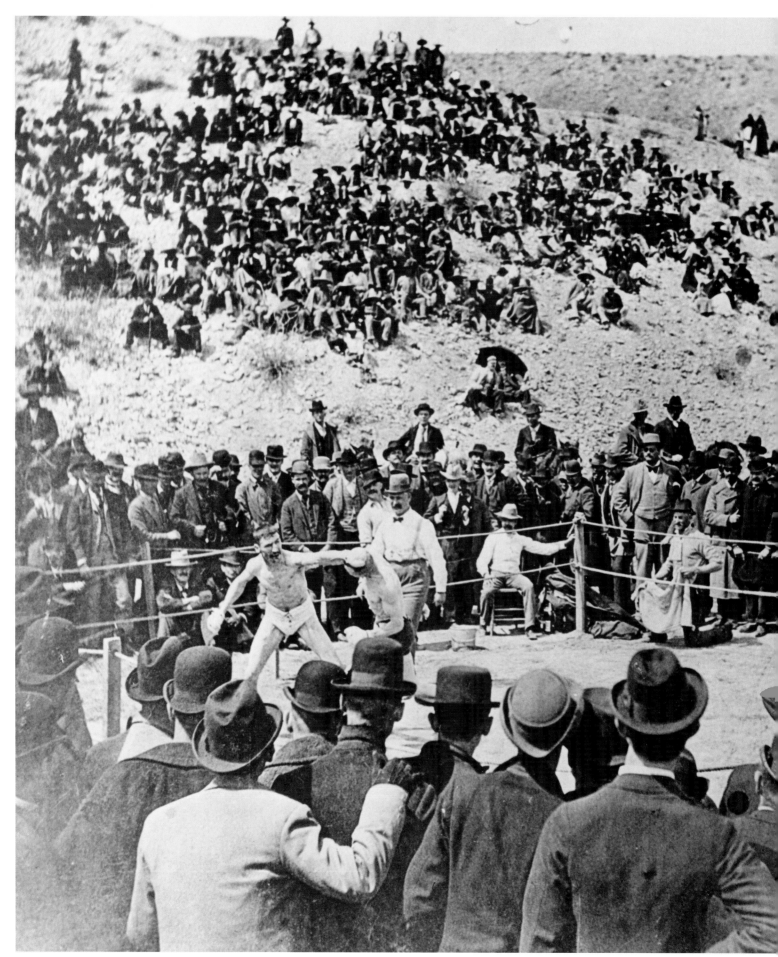

144 **Fight between Bob Fitzsimmons and Peter Maher** (detail), 1896. The J. Paul Getty Museum, Los Angeles

Knockout

THE BODY IN PAIN

Sports are filled with exhilarating moments that photographs memorialize: baseball's home run, football's leaping catch for a touchdown, swimming's winning touch, track and horseracing's finishing line, and basketball's dunk. Most pictures, however, fail to capture the excitement of live action. Boxing photographs are different. Few moments in sports are as spectacular, final, and horrific as the knockout punch. The camera reveals the equalizing effect of the knockout on even the most muscular bodies and resilient men. In the pictures here, postures and gestures are repeated. When the body is in pain, it retreats into a few powerless poses. The conscious mind shuts down and limbs go limp as the body falls toward the mat for the ten-second count.

GJON MILI

**Joe Walcott Knocks Joe Louis to the Canvas,
Championship Match**, 1947

Time & Life Pictures/Getty Images

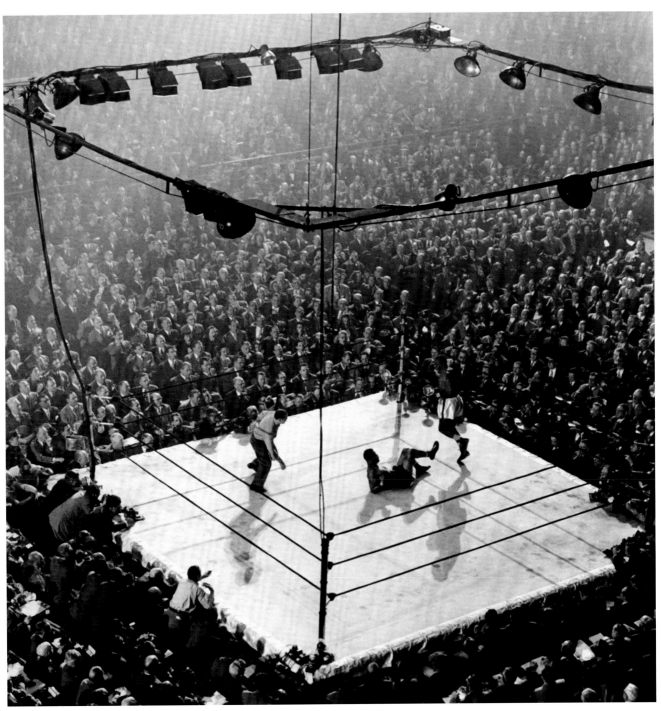

Untitled [Floyd Patterson knocking out opponent],
c. 1950s

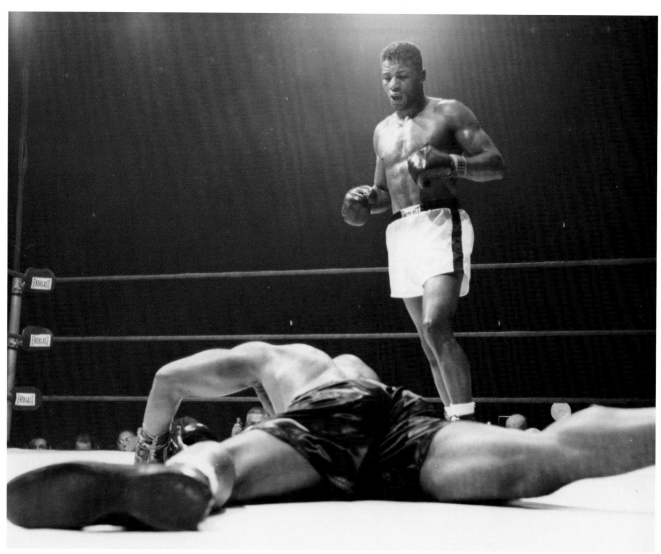

146

Untitled [Floyd Patterson knocking out opponent],
c. 1950s

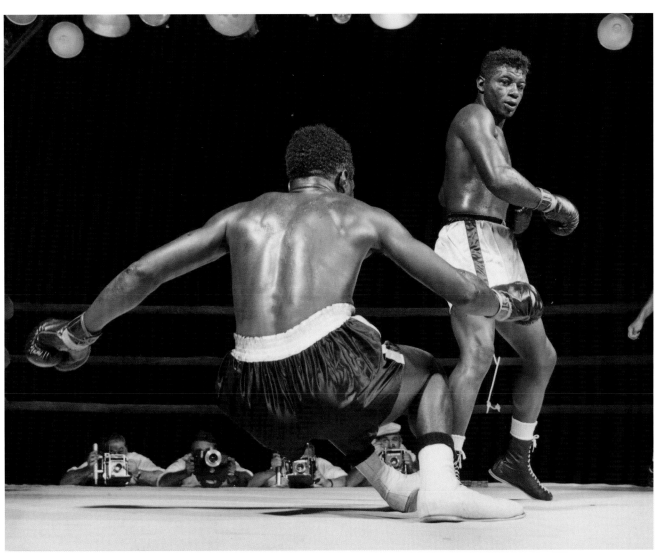

Untitled [Two boxers in the ring, one with a bloody eye],
c. 1950s

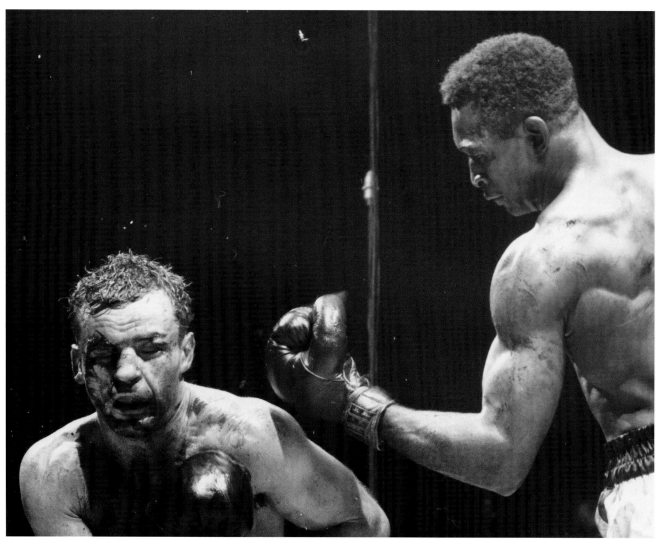

148

Untitled [Boxer with referee in the ring], c. 1950s

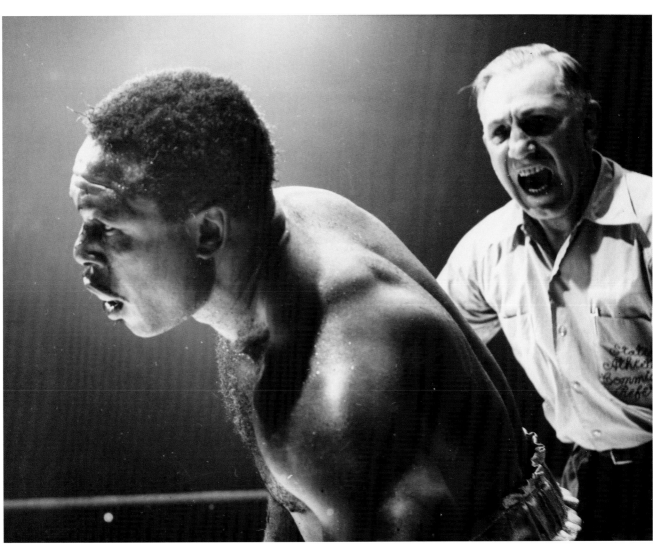

Untitled [Two boxers in the ring, one being restrained by the referee], c. 1950s

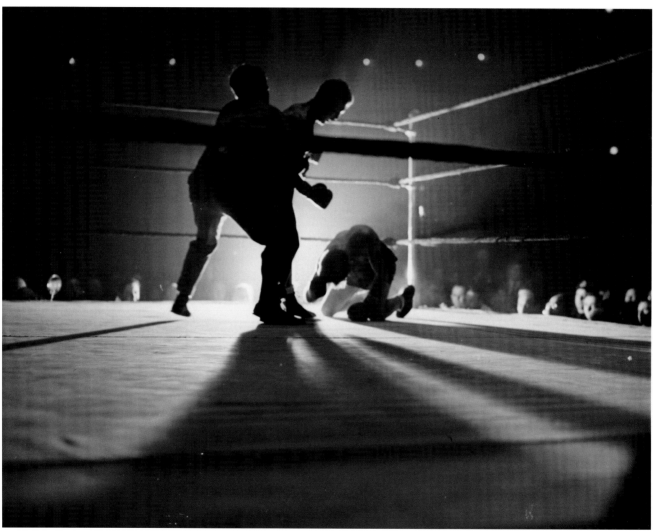

Untitled [Joe Louis knocking opponent to the canvas],
c. late 1930s–40s

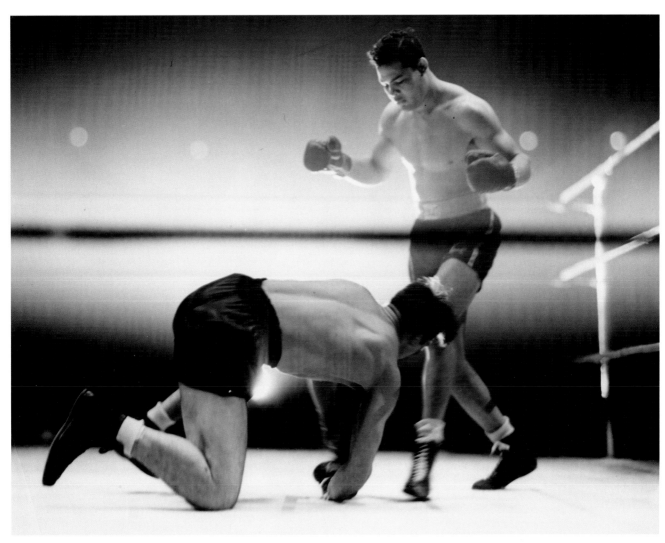

Untitled [Two boxers in the ring, one falling to canvas],
c. 1940s

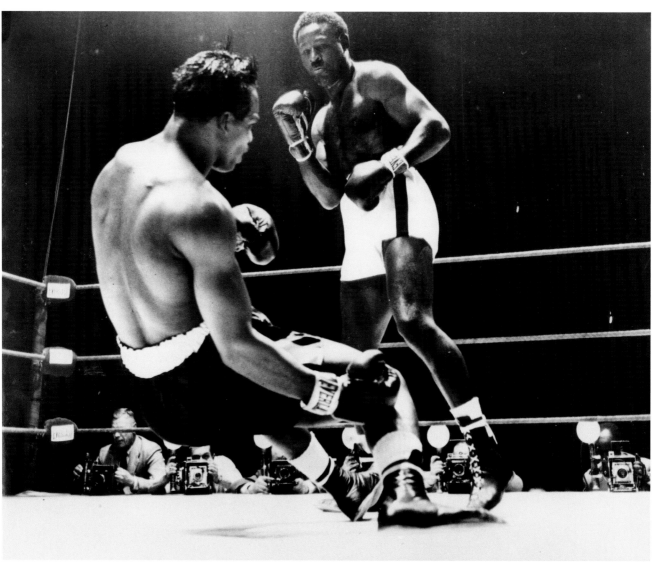

152

Untitled [Boxer knocked out on the canvas], c. 1940s

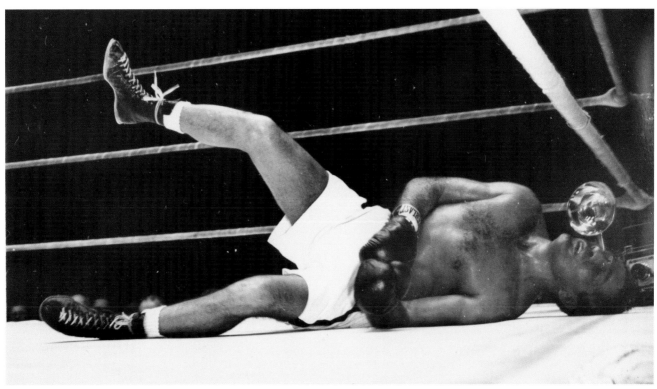

CHARLES HOFF

Unidentified Boxers (Golden Gloves), c. 1950s

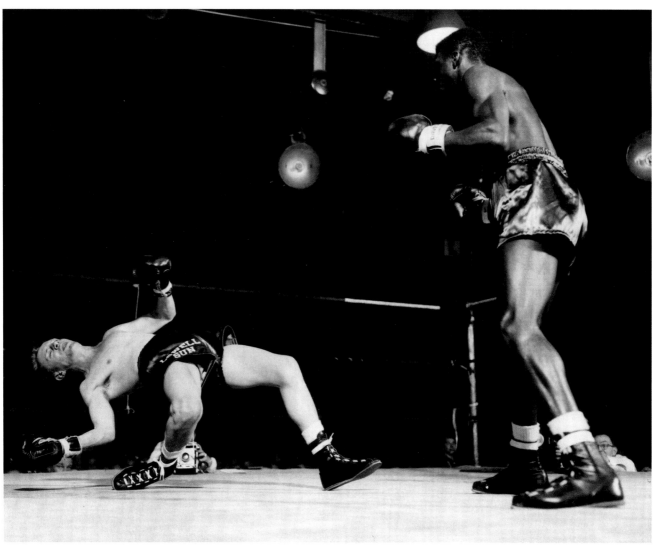

154

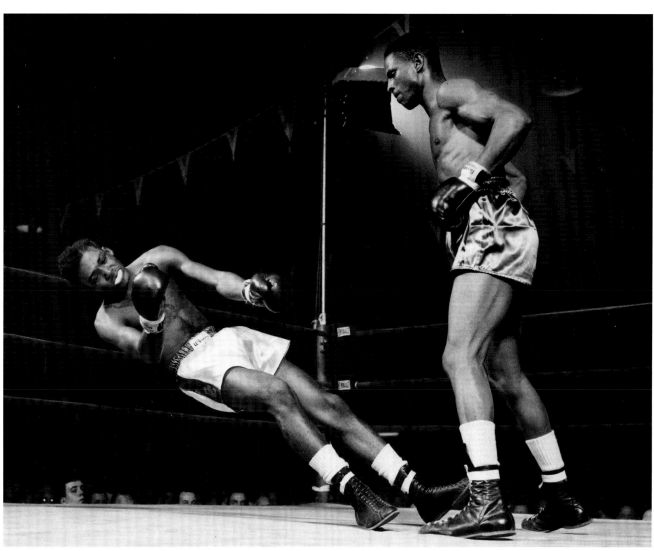

155

TOM ARNDT

Sports Camera Technology

Changes in camera technology since the late nineteenth century have radically altered the image quality and creative possibilities of sports photography. In general, technological advances in film–based (or analogue) photography allowed photographers to take clear photographs in low–light environments such as enclosed stadiums, create sharp close–up images of sports action from greater distances, and adjust to sports action with mobile and lighter cameras. More recent developments with digital photography permit photographers to produce a greater number of images with greater speed, instantly adjust picture quality on a computer with Adobe Photoshop technology, and transmit the images from the camera to their final location instantaneously. Several cameras stand out as landmark developments in technology.

Graflex (1898). This bulky single-lens camera with shutter speeds up to one thousandth of a second was one of the first cameras used for sports photography. With the Graflex, photographers could take stop-action images that made athletes' movements appear spontaneous and unposed. Sports photographers often customized the camera with a telephoto lens of 30 inches or longer to capture intimate close-ups even from great distances.

Time & Life Pictures/Getty Images

Leica (1925). Small, fast, and lightweight, the Leica revolutionized photojournalism and sports photography with its dynamic images. It had flexible design features such as interchangeable lenses, 35-millimeter movie film, and a quiet shutter. Photographers including Alexander Rodchenko and Leni Riefenstahl used the Leica to take close-ups from oblique angles that made viewers feel right in the middle of the action.

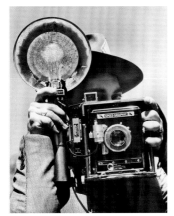

Speed Graphic (1912; popular in 1930s and 1940s). Designed as a press camera with bellows that could be extended to use telephoto lenses, the Speed Graphic was a lightweight camera with a sports finder (a wire frame attached to the top that let photographers compose an image without looking at the viewfinder), which allowed for fast work. Its 4 x 5-inch negative made high-quality, detailed prints for newspaper reproduction. The Speed Graphic used sheet film, so photographers had to be highly selective in the shots they took. (Today's digital cameras can store thousands of images.)

© Getty Images

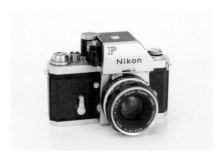

Nikon F (1959). This professional camera had interchangeable viewfinders and many lens options to accommodate varied distances from the sports action. A motor drive (for multiple images) and other components made the Nikon F a real breakthrough. The motor drive permitted long sequences of images, such as a batter swinging or a quarterback throwing. The finder showed 100 percent of the image, so photographs could be composed with precision.

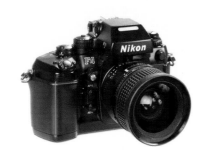

Nikon F4 (1988) and Canon Eos 1 (1989).

These cameras pioneered autofocus, which enabled photographers to keep up with the fast pace of a game and capture action that would otherwise have been missed. Faster lenses allowed photographers to produce natural-looking pictures of sporting events even at low light levels and with long lenses. Today's digital single-lens reflex cameras are built around the autofocus chassis developed by Canon and Nikon and employ advanced versions of multipoint autofocus systems developed for their film cameras.

COMPILED BY NICOLE SOUKUP

Time Line of Sports, Media, and Culture

1700s–1800s

1733
The *Boston Gazette* publishes the first sports story in an American newspaper, on a boxing match.

1820
The first American magazines dedicated to sports begin to appear between 1820 and 1835.

1839
Invention of photography

1853
The *New York Clipper* employs the first American sportswriter, Henry Chadwick, called "the father of the game" for his efforts to popularize baseball.

1861–65
American Civil War

1869
The first professional baseball teams are established.

1883
Joseph Pulitzer, owner of the *New York World*, creates the first newspaper sports department for a New York daily.

1895
William Randolph Hearst creates the first newspaper sports section, in the *New York Journal*.

1896
First women's intercollegiate basketball game, University of California–Berkeley versus Stanford University.

The Olympic Games are reborn in Athens, Greece, with 245 athletes representing fourteen countries.

1898
Lizzie Arlington becomes the first woman to sign with a minor league baseball team.

1900s

1900
Female athletes compete in the Olympics for the first time at the Games of the II Olympiad, in Paris.

1903
The Boston Americans defeat the Pittsburgh Pirates five games to three to win the first World Series.

1908
Jack Johnson (1878–1946) becomes the first African American world heavyweight champion, defeating Tommy Burns, a Canadian, in fourteen rounds.

1910s

1912
Photo finish and electronic timing devices first used at the Games of the V Olympiad, in Stockholm.

Jim Thorpe wins Olympic gold medals in the pentathlon and decathlon, only to have his medals, titles, and records stripped the following year because he had previously played semiprofessional baseball. (The medals were restored in 1983.)

1920s

1914–18
World War I

1919
"Black Sox" scandal: eight Chicago White Sox players are banned for life from professional baseball for intentionally losing two games against the Cincinnati Reds during the 1919 World Series.

1920
Harlem Renaissance

Babe Ruth is sold to the New York Yankees for $100,000 to finance a Broadway play produced by Boston Red Sox owner Harry Frazee.

Fritz Pollard and Bobby Marshall become the first African Americans to sign with the American Professional Football Association, later called the National Football League (NFL).

1921
First live radio broadcast of a sporting event, on Westinghouse station KDKA in Pittsburgh: a ten-round, no decision prizefight between Johnny Dundee and Johnny Ray.

1924
William DeHart Hubbard becomes the first African American to win an Olympic gold medal in an individual event (the long jump), at the Games of the VIII Olympiad, in Paris.

1925
Leica introduces a handheld camera that revolutionizes sports photography.

1928
University of Notre Dame football coach Knut Rockne delivers his "Win one for the Gipper" halftime speech, resulting in a comeback win for the Fighting Irish against Army.

1929
Beginning of Great Depression

1930s

1933
The first Major League Baseball All-Star Game is organized by the *Chicago Tribune*'s sports editor, Arch Ward.

1934
The first College All-Star Football Game is organized by Arch Ward.

Ford Motor Company pays $100,000 to sponsor the World Series radio broadcasts on NBC, CBS, and Mutual Broadcasting Company.

1930s

1936
American athlete Jesse Owens takes gold medals in the 100-meter dash, 200-meter dash, long jump, and 4 x 100-meter relay at the Games of the XI Olympiad, held in Berlin after Hitler and the Nazi party had come to power in Germany.

German heavyweight boxer Max Schmeling knocks out Joe Louis in the twelfth round of a sold-out fight at Yankee Stadium. The fight is seen as a battle between America and the emerging Nazi regime.

1938
Joe Louis avenges himself against Max Schmeling, knocking out Schmeling in less than two minutes. The fight, held at Yankee Stadium, has a gate of $1,015,012, and approximately two-thirds of Americans listen to the broadcast.

1939
Gillette Safety Razor Company begins a thirty-two-year sponsorship of the World Series.

First televised baseball game, on New York station W2XBS (later WNBC-TV), Columbia University and Princeton at Baker Field.

1940s

1941
Pearl Harbor attacked. United States enters World War II.

Joe DiMaggio establishes a fifty-six-game hitting streak that has never been broken.

1943
All-American Girls Professional Baseball League premieres.

1944
Gillette company signs deal to sponsor Madison Square Garden's weekly fight telecasts.

1945
World War II ends.

1946
Kenny Washington and Woody Strode play for NFL's Los Angeles Rams, becoming the league's first black players.

1947
Brooklyn Dodger Jackie Robinson steps onto Ebbets Field, becoming the first black major league ballplayer.

1948
Olympic Games televised for the first time.

Marie Provaznikova, president of the Women's Technical Committee of the International Gymnastics Federation, defects from Czechoslovakia following the Games of the XIV Olympiad, in London—the first political defection at the Olympics.

1950s

1950
All but two members of the U.S. Military Academy's varsity football team are dismissed for cheating.

Earl Lloyd, Chuck Cooper, and Nat "Sweetwater" Clifton become the first African American players in the National Basketball Association (NBA).

1951
New York District Attorney Frank Hogan accuses thirty-two players from seven college teams of "point shaving" between 1947 and 1951.

"The Giants win the pennant! The Giants win the pennant!" (Russ Hodges, WMCA-AM). The New York Giants take the Brooklyn Dodgers 5–4 after Bobby Thomson's three-run home run, also known as "the shot heard 'round the world."

1954
Launching of *Sports Illustrated*, a weekly publication dedicated to sports.

U.S. Supreme Court decision in *Brown v. Board of Education of Topeka* ends segregation in public schools.

Roger Bannister breaks the four-minute mile, running 3:59.4.

1956
Rocky Marciano retires from boxing undefeated, with a record of 49-0.

1960
Olympic Games are seen on more than a hundred television channels in eighteen countries.

Olympic Games air for the first time on American television.

1961
ABC launches *Wide World of Sports*.

1962
CBS agrees to a $4.5 million a year contract with the NFL. (Two years later, NFL commissioner Pete Rozelle renegotiates for $14 million.)

Wilt Chamberlain scores 100 points in a basketball game.

1964
Civil Rights Act of 1964 signed into law.

Cassius Clay defeats Sonny Liston to become world heavyweight champion. He joins the Nation of Islam and changes his name to Muhammad Ali.

1965
U.S. ground troops enter Vietnam War.

1966
England defeats West Germany's soccer team 4-2 in the FIFA World Cup final in front of 98,000 fans at Wembley Stadium.

First all-black basketball team, Texas Western College of El Paso, beats University of Kentucky 72-65 to win the National Collegiate Athletic Association (NCAA) basketball tournament.

1967
Muhammad Ali is found guilty of draft evasion and stripped of his world heavyweight title after refusing, for religious reasons, to serve in the military.

1968
First AFL–NFL World Championship Game. NFL's Green Bay Packers defeat the American Football League's Kansas City Chiefs 35-10.

Tommie Smith and John Carlos raise their fists in a Black Power salute during the 200-meter medal ceremony at the Olympic Games, resulting in their suspension from the U.S. team and expulsion from the Olympic Village.

University of Houston Cougars defeat the UCLA Bruins 71–69 in the "game of the century," the first NCAA regular-season basketball game broadcast nationwide during prime time.

1970
ABC airs *Monday Night Football* and revolutionizes sports broadcasting with instant replays and slow motion.

1971
Basketball player Lew Alcindor changes his name to Kareem Abdul-Jabbar.

1972
Title IX of the 1964 Civil Rights Act amended to prohibit sex discrimination in schools and collegiate athletic programs that receive federal funding.

At the Games of the XX Olympiad, in Munich, Palestinian terrorists from the Black September group kidnap and kill eleven Israelis and one West German police officer. ABC broadcaster Jim McKay announces to an international audience, "Our worst fears have been realized tonight. . . . They're all gone."

American swimmer Mark Spitz wins seven gold medals at the Olympics.

1973
Secretariat wins horse racing's Triple Crown.

U.S. military forces leave Vietnam.

1974
Muhammad Ali knocks out George Foreman in the eighth round of the "Rumble in the Jungle," in Kinshasa, Zaire (now Democratic Republic of the Congo).

Henry Aaron of the Atlanta Braves supplants New York Yankees great Babe Ruth as home-run king, with 715.

1975
Muhammad Ali defeats Joe Frazier in the fourteenth round of the "Thrilla in Manila," in the Philippines, the third and final fight between the two great heavyweights (Ali won 2, Frazier 1).

1976
Billy Jean King defeats Bobby Riggs 6-4, 6-3, 6-3 in the "Battle of the Sexes" tennis match at the Houston Astrodome.

Nadia Comaneci, a fourteen-year-old Romanian, becomes the first gymnast to score a perfect 10 in the Olympics.

1979
Cable station ESPN is launched and premieres the daily sports news show *SportsCenter*.

USA Network signs a three-year, $1.5 million agreement with the NBA.

1980
"Miracle on Ice": Team USA defeats the Soviet hockey team 4-3, going on to win the gold medal at the XIII Olympic Winter Games. ABC's Al Michaels immortalizes the moment with the phrase "Do you believe in miracles?"

Bjorn Borg defeats John McEnroe in a 3-hour 53-minute match at Wimbledon—one of the greatest tennis matches of all time.

1982
NFL has contracts with three major networks, worth an estimated $2 billion. (Major League Baseball's network contracts in the 1980s are estimated at $1.1 billion over six years.)

1984
Michael Jordon is picked third in the NBA draft.

1986
The United States Football League files an antitrust lawsuit against the NFL.

Diego Maradona leads Argentina's soccer team against England in the 1986 FIFA World Cup with the "hand of God" goal.

1987
ESPN awarded NFL's first cable contract.

1989
ESPN and Major League Baseball reach a four-year agreement, to begin in 1990.

Pete Rose, baseball's all-time hit leader, is banned from baseball for gambling. (He has not been inducted into the Hall of Fame.)

1991
Minnesota Twins win the World Series, beating the Atlanta Braves 4 games to 3.

All-Star basketball player Ervin "Magic" Johnson announces he has the AIDS virus and will retire from the NBA.

1992
Mike Tyson is convicted of raping Desiree Washington.

1994
O. J. "the Juice" Simpson is arrested for the murders of Nicole Brown Simpson and Ronald Goldman.

2001
September 11: Al Qaeda terrorists fly hijacked planes into the World Trade Center and the Pentagon.

2002
NBA finalizes a $4.6 billion contract with television networks ESPN, ABC, and TNT.

ESPN becomes the first network to televise all four major professional sports: NFL, NHL, MLB, and NBA.

2004
Former Arizona Cardinals safety Pat Tillman, a U.S. Army Ranger, is killed in Afghanistan. The Army reports he died from enemy fire, but later it comes to light he died from friendly fire. Tillman is awarded the Silver Star.

The Boston Red Sox win the World Series for the first time in eighty-six years. This ends the so-called Curse of the Bambino, which began when Sox ownership sold Babe Ruth to the Yankees in 1919.

2005
U.S. House Government Reform Committee begins hearings into use of steroids in Major League Baseball.

2006
NFL signs television contracts totaling $20.4 billion with CBS, NBC, Fox, and ESPN.

2008
Michael Phelps of the United States wins eight gold medals in swimming at the Games of the XXIX Olympiad in Beijing, the record for most medals at a single Olympics.

Usain Bolt of Jamaica wins three Olympic medals in sprinters' events (100 m, 200 m, and 4 x 100-m relay), setting world records in all three.

2009
Tiger Woods, winner of fourteen Grand Slam tournaments, announces a leave from golf after admitting to infidelities but returns to competition twenty weeks later.

2010
Professional soccer player Didier Drogba appears with musician Lady Gaga and former president Bill Clinton on the cover of *Time* magazine's "100 Most Influential People in the World" issue.

2011
Super Bowl XLV averaged 111 million viewers, making it the most-viewed American television broadcast.

CATALOGUE AND EXHIBITION IMAGE LIST

Images that are not in "The Sports Show" exhibition are indicated by a bullet (•).

01
Unknown photographer
Untitled [Women boxing], n.d.
Photograph
3¼ x 2⅜ inches
Collection of Peter J. Cohen

02
Unknown photographer
Untitled [Women boxing], n.d.
Photograph
3¼ x 2⅜ inches
Collection of Peter J. Cohen

03
Unknown photographer
Untitled [Women boxing], n.d.
Photograph
3⁵⁄₁₆ x 2⅜ inches
Collection of Peter J. Cohen

04
Eadweard Muybridge
American (born England), 1830–1904
Animal Locomotion, plate 344, 1887
Collotype
6¾ x 17⅜ inches
Minneapolis Institute of Arts
Gift of Samuel C. Gale, William H.
Hinkle, Albert Loring, Charles M.
Loring, Charles J. Martin, and
Charles Alfred Pillsbury, 81.76.40

05
Unknown photographer
Babe Ruth, 1919
Glass negative
4 x 5 inches or smaller
Library of Congress Prints
and Photographs Division,
LC-DIG-npcc-00316

06
(Five photographs)
Unknown photographer
• **Untitled [Chief Paris (Sequoia Green Feather)]**, c. 1936–37
Glass negatives
4 x 5 inches
Harry E. Winkler Collection of Boxing
Photographs, Hesburgh Libraries of
Notre Dame

07
Lourdes Grobet
Mexican, born 1940
Untitled [Masked wrestler reading letter], 1983
Chromogenic print
14 x 11 inches
San Francisco Museum of Modern Art
Gift of Larry and Jane Reed
© Lourdes Grobet

08
Wolfgang Tillmans
German, born 1968
Heptathlon, 2009
Inkjet print
82 x 54½ inches
Courtesy of the artist and
Andrea Rosen Gallery, New York
© Wolfgang Tillmans

09
Andreas Gursky
German, born 1955
Klitschko, 1999
Chromogenic print
81¹⁵⁄₁₆ x 103 inches framed
Collection Walker Art Center,
Minneapolis
Gift of Charles J. Betlach II, 2009
© 2011 Andreas Gursky/Artists
Rights Society (ARS), New York/VG
Bild-Kunst, Bonn

10
(Three images)
Paul Pfeiffer
American, born 1966
The Saints, 2007
17-channel sound installation
Size variable
© Paul Pfeiffer
Courtesy Paula Cooper Gallery,
New York

11
Andy Warhol
American, 1928–1987
Pelé, 1977
Polaroid Polacolor Type 108
4¼ x 3⅜ inches
Collection of the Andy Warhol
Museum, Pittsburgh
© 2011 The Andy Warhol Foundation
for the Visual Arts, Inc./Artists Rights
Society (ARS), New York

12
Andy Warhol
American, 1928–1987
Pelé, 1977
Polaroid Polacolor Type 108
4¼ x 3⅜ inches
Collection of the Andy Warhol
Museum, Pittsburgh
© 2011 The Andy Warhol Foundation
for the Visual Arts, Inc./Artists Rights
Society (ARS), New York

13
Andy Warhol
American, 1928–1987
Pelé, 1977
Polaroid Polacolor Type 108
4¼ x 3⅜ inches
Collection of the Andy Warhol
Museum, Pittsburgh
© 2011 The Andy Warhol Foundation
for the Visual Arts, Inc./Artists Rights
Society (ARS), New York

14
Andy Warhol
American, 1928–1987
Pelé, 1977
Polaroid Polacolor Type 108
4¼ x 3⅜ inches
Collection of the Andy Warhol
Museum, Pittsburgh
© 2011 The Andy Warhol Foundation
for the Visual Arts, Inc./Artists Rights
Society (ARS), New York

15
(Two images)
Douglas Gordon
Scottish, born 1966
Philippe Parreno
Algerian, born 1964
Zidane: A 21st Century Portrait, 2007
Video
Size variable
Courtesy of Gagosian Gallery
Film stills courtesy Anna Lena
Films/Naflastrengir

16
Thomas Eakins
American, 1844–1916
Study for "The Swimming Hole,"
c. 1883
Platinum print
8¾ x 11 inches
Courtesy Fraenkel Gallery,
San Francisco

17
Frank Lloyd Wright
American, 1867–1959
Girls Gym Class, 1900
Callotype
7⅝ x 9⅛ inches
The Nelson-Atkins Museum of Art,
Kansas City, Missouri
Gift of Hallmark Cards, Inc.,
2005.27.4534
Photo credit: Michael Lamy
© 2011 Frank Lloyd Wright Foundation,
Scottsdale, Ariz./Artists Rights Society
(ARS), New York

18
Frances Benjamin Johnston
American, 1864–1952
**Untitled [Female students playing
basketball, Western High School,
Washington, D.C.]**, from Western
High School album, c. 1899
Cyanotype
Library of Congress Prints
and Photographs Division,
LC-USZ62-71237

19
Frances Benjamin Johnston
American, 1864–1952
• **Untitled [Female students exercising
in a gymnasium, Western High
School, Washington, D.C.]**, from
Western High School album, c. 1899
Cyanotype
Library of Congress Prints
and Photographs Division,
LC-USZ62-130222

20
Frances Benjamin Johnston
American, 1864–1952
• **Untitled [Female students posing
with exercise equipment in a
gymnasium, Western High School,
Washington, D.C.]**, from Western
High School album, c. 1899
Cyanotype
Library of Congress Prints
and Photographs Division,
LC-USZC4-9677

21
Frances Benjamin Johnston
American, 1864–1952
• **Untitled [Five girls lying on mat in
gymnasium in front of basketball
scoreboard, Western High School,
Washington, D.C.]**, from Western
High School album, c. 1899
Cyanotype
Library of Congress Prints
and Photographs Division,
LC-USZ62-89961

22
Frances Benjamin Johnston
American, 1864–1952
• **Untitled [Male students playing
basketball, Western High School,
Washington, D.C.]**, from Western
High School album, c. 1899
Cyanotype
Library of Congress Prints
and Photographs Division,
LC-USZ62-30192

23
Unknown photographer
**Opening day Washington–Boston
in Washington**, c. 1892–1902
Gelatin silver print
15 x 47 inches
Courtesy of Claire Lozier and
Andrew Smith Gallery

24
Unknown photographer
**Minnesota State Fair,
September 9, 1911**
Gelatin silver print
10 x 58½ inches
Library of Congress Prints
and Photographs Division, PAN
SUBJECT-Events no. 18 (F size)

25
Unknown photographer
**Winners of Missouri state football
championship**, 1920–45
Gelatin silver print
Library of Congress Prints
and Photographs Division,
LC-USZ62-92261

26
Unknown photographer
**Seven young women aiming
arrows at target, with another
young woman standing in front
of the target, at Camp Greystone,
Tuxedo, North Carolina**, c. 1920–30
Gelatin silver print
Library of Congress Prints
and Photographs Division,
LC-USZ62-106063

27
Unknown photographer
**Mouse-trap armor for caddies—
here is the newest safety device
seen on California links**, c. 1950
Gelatin silver print
Library of Congress Prints
and Photographs Division,
LC-USZ62-85750

28
Unknown photographer
Softball or ballet? 1955
Gelatin silver print
Library of Congress Prints
and Photographs Division,
LC-DIG-ppmsca-18795

29
Unknown photographer
**Untitled [Woman shooting bow
and arrow in swimsuit]**, n.d.
Gelatin silver print
4⅝ x 3¼ inches
Collection of Peter J. Cohen

30
Unknown photographer
**Untitled [Woman shooting bow
and arrow]**, n.d.
Gelatin silver print
4⅝ x 2¾ inches
Collection of Peter J. Cohen

31
Unknown photographer
**Miss Katharine Harley, former
champion of the U.S. won at
Chevy Chase**, 1908
Gelatin silver print
Library of Congress Prints
and Photographs Division,
LC-DIG-ppmsca-19494

32
Unknown photographer
Untitled [Man on swimming dock],
n.d.
Gelatin silver print
4⁹⁄₁₆ x 3¼ inches
Collection of Peter J. Cohen

33
Unknown photographer
Field Day, 1919
Gelatin silver print
3½ x 5⅜ inches
Collection of Peter J. Cohen

34
Unknown photographer
• **Woman in aeroplane ready for swimming, Pittsburgh**, 1910
Bain News Service, publisher
Glass negative
5 x 7 inches or smaller
Library of Congress Prints and Photographs Division,
LC-DIG-ggbain-04525

35
Unknown photographer
Untitled [Women boxing in garden], n.d.
Gelatin silver print
3¼ x 4⅝ inches
Collection of Peter J. Cohen

36
Unknown photographer
Jewels, c. 1920
Gelatin silver print
Library of Congress Prints and Photographs Division,
LC-USZ62-64466

37
Unknown photographer
Untitled [Woman posed with shotgun for trapshooting], 1914
Gelatin silver print
Library of Congress Prints and Photographs Division,
LC-USZ62-113557

38
Unknown photographer
Untitled [Boxing man], n.d.
Gelatin silver print
4½ x 2⅜ inches
Courtesy Fraenkel Gallery,
San Francisco

39
Unknown photographer
Untitled [Woman golfing], n.d.
Gelatin silver print
5⁷⁄₁₆ x 3¼ inches
Collection of Peter J. Cohen

40
Unknown photographer
Ball Club Tokyo, 1930
Gelatin silver print
4½ x 6⁷⁄₁₆ inches
Collection of Peter J. Cohen

41
Unknown photographer
Untitled [Football player], n.d.
Gelatin silver print
5⁷⁄₁₆ x 3⁷⁄₁₆ inches
Collection of Peter J. Cohen

42
Unknown photographer
Untitled [Boy at bat with catcher and umpire behind], n.d.
Gelatin silver print
3⅜ x 2¹¹⁄₁₆ inches
Collection of Peter J. Cohen

43
Unknown photographer (French)
The Oldest Baseball Bat, c. 1937
Gelatin silver print
4 x 6 inches
San Francisco Museum of Modern Art,
Foto Forum purchase

44
Unknown photographer
Untitled [Man catching baseball], n.d.
Gelatin silver print
4⅝ x 2⅞ inches
Collection of Peter J. Cohen

45
Unknown photographer (French)
Untitled [Women racing], c. 1915
Gelatin silver print
3⅜ x 5⅜ inches
San Francisco Museum of Modern Art
Gift of Scott Tolmie

46
Unknown photographer
One way to make a living—Bee Kyle making her 286th 100-foot dive into a 5-foot tank at Ocean View, Va., c. 1930–50
Gelatin silver print
Library of Congress Prints and Photographs Division,
LC-USZ62-90295

47
Eadweard Muybridge
American (born England), 1830–1904
Animal Locomotion, plate 640, 1887
Collotype
9¹⁵⁄₁₆ x 12¹⁄₁₆ inches
Minneapolis Institute of Arts
Gift of Samuel C. Gale, William H. Hinkle, Albert Loring, Charles M. Loring, Charles J. Martin, and Charles Alfred Pillsbury, 81.76.73

48
Alfred Stieglitz
American, 1864–1946
Going to the Start, 1904
Photogravure
8⅜ x 7½ inches
Minneapolis Institute of Arts
The William Hood Dunwoody Fund,
64.34.12.3

49
Jacques Henri Lartigue
French, 1894–1986
Grand Prix of the Automobile Club of France, 1912
Gelatin silver print (printed 1972)
6¹¹⁄₁₆ x 9¹⁄₁₆ inches
Minneapolis Institute of Arts
The Kate and Hall J. Peterson Fund,
72.118.8
© Ministère de la Culture—France/
AAJHL

50
Alexander Rodchenko
Russian, 1891–1956
• **Dive**, 1934
Gelatin silver print
11¹¹⁄₁₆ x 9¼ inches
Museum of Modern Art, New York,
Thomas Walther Collection. Purchase,
1826.2001
© Estate of Alexander Rodchenko/
RAO, Moscow/VAGA, New York, N.Y.

51
Alexander Rodchenko
Russian, 1891–1956
Pole Vault, 1936
Gelatin silver print
9⅜ x 11⅞ inches
The J. Paul Getty Museum,
Los Angeles
© Estate of Alexander Rodchenko/
RAO, Moscow/VAGA, New York, N.Y.

52
Alexander Rodchenko
Russian, 1891–1956
Untitled [Horse race], 1935
Gelatin silver print
11¹¹⁄₁₆ x 17 inches
The J. Paul Getty Museum,
Los Angeles
© Estate of Alexander Rodchenko/
RAO, Moscow/VAGA, New York, N.Y.

53
Leni Riefenstahl
German, 1902–2003
Jesse Owens, 1936
Gelatin silver print
8 11/16 x 11 1/4 inches
© Archiv LRP

54
Leni Riefenstahl
German, 1902–2003
The Dive, 1936
Gelatin silver print
8 11/16 x 11 1/4 inches
© Archiv LRP

55
Leni Riefenstahl
German, 1902–2003
The Discus Thrower, 1936
Gelatin silver print
8 11/16 x 11 1/4 inches
© Archiv LRP

56
Gjon Mili
American (born Albania), 1904–1984
**Eddie Miller of the New York
Giants demonstrates spiral pass**,
1940
Gelatin silver print
9 7/8 x 12 7/8 inches
Courtesy of Howard Greenberg Gallery
Time & Life Pictures/Getty Images

57
Gjon Mili
American (born Albania), 1904–1984
**Eddie Miller of the New York
Giants demonstrates spiral pass**,
1940
Gelatin silver print
10 x 13 inches
Courtesy of Howard Greenberg Gallery
Time & Life Pictures/Getty Images

58
Gjon Mili
American (born Albania), 1904–1984
High Jumper Clarke Mallery, 1939
Gelatin silver print
12 7/8 x 10 inches
Courtesy of Howard Greenberg Gallery
Time & Life Pictures/Getty Images

59
Unknown photographer (French)
Untitled [Baseball study], c. 1930s
Gelatin silver print
8 1/16 x 10 1/16 inches
San Francisco Museum of Modern Art
Gift of the Buhl Foundation

60
(Three images)
Laura Riboli
American, born 1973
**Rolls, Passages, Rotations,
Walkovers (Hoop)**, 2009
Color HD video, 5 min. looped
Size variable
Courtesy of the artist and Wallspace,
New York

61
John Gutmann
German, 1905–1998
**Czechoslovakian Gymnasts,
San Francisco**, 1939
Gelatin silver print
9 1/2 x 7 1/2 inches
San Francisco Museum of Modern Art
Bequest of John Gutmann, 2000.329
© 1998 Center for Creative Photography,
Arizona Board of Regents

62
Edward Steichen
American (born Luxembourg),
1879–1973
Jane Fauntz (Olympic Team), n.d.
Gelatin silver print
9 1/4 x 7 5/8 inches
Minneapolis Institute of Arts
Bequest of Edward Steichen by
direction of Joanna T. Steichen and
George Eastman House, 82.28.50
Permission of the Estate of
Edward Steichen

63
Harold Eugene Edgerton
American 1903–1990
Football Kick, 1938
Dye transfer print (printed 1985)
16 3/4 x 14 inches
Minneapolis Institute of Arts
Gift of the Harold and Esther Edgerton
Family Foundation, 96.149.32.1
© Harold & Esther Edgerton Foundation,
2012, courtesy of Palm Press, Inc.

64
(Four photographs)
Ezra Shaw
American, born 1974
**Diving Day Six—14th FINA World
Championships**, 2011
Gelatin silver print
Size variable
© 2011 Getty Images

65
Amy Elkins
American, born 1979
**Dan (Wing/Fullback), New Haven,
CT**, 2010
Inkjet print
16 x 20 inches
© Amy Elkins
Courtesy of the artist and Yancey
Richardson Gallery, New York

66
Jacques Henri Lartigue
French, 1894–1986
**Zissou in His Tire Boat,
Chateau de Rouzat**, 1911
Gelatin silver print (printed 1972)
9 1/16 x 6 3/4 inches
Minneapolis Institute of Arts
The Kate and Hall J. Peterson Fund,
72.118.6
© Ministère de la Culture—France/
AAJHL

67
Diane Arbus
American, 1923–1971
**Girl with a baseball glove at
Camp Lakecrest, Dutchess County,
NY**, 1968
Gelatin silver print
20 x 16 inches (sheet)
Courtesy Fraenkel Gallery,
San Francisco
© The Estate of Diane Arbus, LLC

68
Wallace Kirkland
American, 1891–1979
**The Women's Professional Baseball
League: Fort Wayne Daisies,
South Bend Blue Sox, Kenosha
Comets, Grand Rapids Chicks,
Rockford Peaches, and Racine
Bells**, 1945
Gelatin silver print
10 9/16 x 13 1/4 inches
The Museum of Fine Arts, Houston
Gift of an anonymous donor in honor
of Audrey Jones Beck

69
Leon Levinstein
American, 1910–1988
Handball Players, Lower East Side, NY, c. 1950s–60s
Gelatin silver print
12¹⁵⁄₁₆ x 10⅜ inches
The Horace W. Goldsmith Foundation Fund, through Joyce and Robert Menschel, 1987 (1987.1064)
The Metropolitan Museum of Art, New York, N.Y., U.S.A.
Image copyright © The Metropolitan Museum of Art/Art Resource, New York
© Howard Greenberg Gallery

70
Darryl Heikes
American
• **President Nixon Bowling in White House Lanes**, 1971
Gelatin silver print
Size variable
© Bettmann/CORBIS

71
Unknown photographer
• **Untitled [President William Howard Taft throws out the first ball at a baseball game in Washington in 1912]**
Gelatin silver print
Size variable
Associated Press; AP Photo/Brown Brothers
© 1912 AP

72
Unknown photographer
• **Untitled [President Woodrow Wilson throws out the first ball at a baseball game in Washington in 1916]**
Gelatin silver print
Size variable
Associated Press; AP Photo
© 1916 AP

73
Unknown photographer
• **Untitled [Governor Franklin D. Roosevelt at World Series, October 1932]**
Gelatin silver print
Size variable
© Bettmann/CORBIS

74
Unknown photographer
• **President Dwight D. Eisenhower Throws First Pitch**, 1957
Gelatin silver print
Size variable
© CORBIS

75
Unknown photographer
• **Untitled [President John F. Kennedy starts windup for the pitch which opens the American League baseball season in Washington, April 8, 1962]**
Gelatin silver print
Size variable
Associated Press; AP Photo
© 1962 AP

76
Herb Scharfman
American, 1912–1998
• **Untitled [President Richard Nixon throws out first pitch at 1970 All-Star Game]**
Gelatin silver print
Size variable
© 1970 Herb Scharfman/Sports Imagery
Getty Images

77
Unknown photographer
MLB Photos/Stringer
• **Untitled [Former President Jimmy Carter throws out the first pitch at 1992 World Series]**
Gelatin silver print
Size variable
© 1992 MLB Photos via Getty Images

78
Diana Walker
American
• **Untitled [President Ronald W. Reagan with Chicago Cubs in September 1988]**
Gelatin silver print
Size variable
Time & Life Pictures/Getty Images
© Diana Walker

79
Paul J. Richards
American
• **Untitled [President Bill Clinton warms up in the Orioles dugout]**, 1993
Gelatin silver print
Size variable
AFP/Getty Images
© 1993 Getty Images

80
Ann Heisenfelt
American
• **First Fan [Senator Barack Obama, D-Ill., throws out the ceremonial first pitch before game 2 of the American League Championship Series between the Chicago White Sox and the Los Angeles Angels at the U.S. Cellular Field in Chicago on Oct. 12, 2005]**
Gelatin silver print
Size variable
AP Photo/Ann Heisenfelt; © 2005 AP

81
Elsa/Getty Images
• **Untitled [Former President George W. Bush, with former President George H. W. Bush, throws out the first pitch for game 4 of 2010 World Series]**
Gelatin silver print
Size variable
© 2010 Getty Images

82
(Two images)
Tim Davis
American (born Malawi), born 1961
The Upstate New York Olympics, 2010–11
Video—3 screens, 50 mch HD
Edition 1 of 3, 3 DVDs
Courtesy of Greenberg Van Doren Gallery, New York

83
Cory Arcangel
American, born 1978
Masters, 2011
Hacked Qmotions Indoor Golf Simulator, PlayStation video game console, Tiger Woods '99 PGA Tour Golf game disk, golf clubs, and artificial grass
Dimensions variable
Collection of Beth and Richard Marcus

84
Unknown photographer
Untitled [John Arthur Johnson and first wife, Etta], n.d.
Gelatin silver print
8 x 10 inches
Library of Congress Prints and Photographs Division, LC-USZ62-28040

85
Unknown photographer
Untitled [Jack Johnson—behind wheel of auto], c. 1910
Gelatin silver print
4 x 5 inches
Library of Congress Prints and Photographs Division,
LC-USZ62-35868

86
Unknown photographer
Jack Johnson, 1878–1946, c. 1910
Gelatin silver print
4 x 5 inches
Library of Congress Prints and Photographs Division,
LC-USZ62-79738

87
Unknown photographer
• **Adolf Hitler with Boxer Max Schmeling**, 1936
Gelatin silver print
Size variable
© Bettmann/CORBIS

88
Unknown photographer
• **Joe Louis and Max Schmeling Squaring Off**, 1938
Gelatin silver print
Size variable
© Bettmann/CORBIS

89
(Four photographs)
Stanley Kubrick
American, 1928–1999
Rocky Graziano: He's a Good Boy Now, 1950
Contact sheet
Museum of the City of New York,
LOOK Collection

90
(Five photographs)
Frank Bauman
American, 1914–1974
• **Joe Louis**, 1940
Photographic negatives
2¼ x 2¼ inches
Museum of the City of New York,
LOOK Collection

91
Unknown photographer
• **Untitled [President Kennedy talking with Olympic Gold Medalist Wilma Rudolph, her mother, and Vice President Lyndon Johnson, April 14, 1961]**
Gelatin silver print
Size variable
© CORBIS

92
Unknown photographer
• **1936 Olympic Games in Berlin**
Gelatin silver print
Size variable
Popperfoto/Getty Images

93
Unknown photographer
Untitled [American track medalists Tommie Smith and John Carlos raising black-gloved fists at the 1968 Olympic Games in Mexico City (with Peter Norman)]
Gelatin silver print
Size variable
Associated Press; AP Photo
© 1968 AP

94
Vik Muniz
Brazilian, born 1961
Verso (The Winner in Broad Jump, Jesse Owens), 2008
Mixed media
6¾ x 9⅛ inches
Courtesy of the artist and
Sikkema Jenkins & Co.
© Vik Muniz/Licensed by VAGA,
New York, N.Y.

95
(Front and back of photo shown)
Unknown photographer
United Press International Press Photograph, New York Times Press Archive
A Guerilla (Black September guerillas kidnap Israeli athletes, Munich, September 1972)
Gelatin silver print
8 x 10⅛ inches (sheet)
Private collection

96
Garry Winogrand
American, 1928–1984
Muhammad Ali–Oscar Bonavena Press Conference, New York, 1970
Gelatin silver print (printed c. 1980)
12¼ x 18½ inches
© The Estate of Garry Winogrand
Courtesy Fraenkel Gallery,
San Francisco

97
Unknown photographer
• **Honus Wagner, from White Borders**, c. 1909–11
Commercial color lithography
2⅝ x 1⁷⁄₁₆ inches (sheet)
Gift of Jefferson R. Burdick (Burdick 246, T206).
The Metropolitan Museum of Art,
New York, N.Y., U.S.A.
Image copyright © The Metropolitan Museum of Art/Art Resource,
New York

98
Edward Steichen
American (born Luxembourg),
1879–1973
Paul Robeson, 1930
Gelatin silver print
9⁹⁄₁₆ x 7⅝ inches
Minneapolis Institute of Arts
Bequest of Edward Steichen by direction of Joanna T. Steichen and George Eastman House, 82.28.55
Permission of the Estate of Edward Steichen

99
James Van Der Zee
American, 1886–1983
Joe Louis, c. 1930s
Gelatin silver print
9¼ x 7¹⁄₁₆ inches
Minneapolis Institute of Arts
Anonymous gift, 91.164.7

100
Unknown photographer
Untitled [Jim Thorpe, sitting at desk], n.d.
Gelatin silver print
Size variable
Library of Congress Prints and Photographs Division,
LC-USZ62-11598

101
Nat Fein
American, 1914–2000
The Babe Bows Out by Nat Fein, 1948
Gelatin silver print
10¹⁄₁₆ x 12⅞ inches
The Museum of Fine Arts, Houston
Gift of Alfred C. Glassell III in honor of Alfred C. Glassell, Jr., at "One Great Night in November, 1995"
© The Estate of Nat Fein

102
Unknown photographer
New York Times Press Photograph
Babe Ruth "The Sultan of Swat," n.d.
Gelatin silver print
9⅛ x 7 inches (sheet)
Private collection

103
Unknown photographer
World Wide Photos, New York Times
Press Archive
**Babe Ruth, the Greatest Slugger
of Them All**, 1927
Gelatin silver print
8⅛ x 6 inches (sheet)
Private collection

104
George Strock
American
**Satchel Paige [Baseball player
Satchel Paige playing a game of
pool]**, 1941
Gelatin silver print
10¾ x 10½ inches
Time & Life Pictures/Getty Images
Courtesy of Howard Greenberg Gallery

105
(Front and back of photo shown)
Unknown photographer
New York Times Press Photo
**Jackie Robinson acquired by
Dodgers, "It was announced that
the Brooklyn club had purchased
the Negro from its farm team,"** 1947
Gelatin silver print
7³/₁₆ x 9 inches (sheet)
Private collection

106
Gjon Mili
American (born Albania), 1904–1984
Ted Williams—"Easy Ball Batting,"
1941
Gelatin silver print
12 x 10 inches
Courtesy of Howard Greenberg Gallery
Time & Life Pictures/Getty Images

107
Gjon Mili
American (born Albania), 1904–1984
**Studio shot of Boston Red Sox
star Ted Williams demonstrating
his batting technique**, 1941
Gelatin silver print
12 x 9⅞ inches
Courtesy of Howard Greenberg Gallery
Time & Life Pictures/Getty Images

108
Gjon Mili
American (born Albania), 1904–1984
**Studio shot of Boston Red Sox
star Ted Williams demonstrating
his batting technique**, 1941
Gelatin silver print
12 x 9⅞ inches
Courtesy of Howard Greenberg Gallery
Time & Life Pictures/Getty Images

109
(Front and back of photo shown)
Unknown photographer
New York Times Press Photograph
**Roger Bannister breaks four-
minute mile (3:59.4)**, 1954
Gelatin silver print
10⅛ x 8 inches (sheet)
Private collection

110
Gordon Parks
American, 1912–2006
Muhammad Ali (face sweating),
1970
Gelatin silver print (printed later)
14 x 11 inches
Courtesy of Howard Greenberg Gallery
© The Gordon Parks Foundation

111
Gordon Parks
American, 1912–2006
**Close-up of Muhammad Ali's fists,
his knuckles cut, after match
against Henry Cooper**, 1966
Gelatin silver print
7⅝ x 13½ inches
Courtesy of Howard Greenberg Gallery
© The Gordon Parks Foundation

112
Richard Avedon
American, 1923–2004
**Lew Alcindor, basketball player,
61st Street and Amsterdam
Avenue, New York, May 2, 1963**
Gelatin silver print
13¹³/₁₆ x 11 ⅛ inches
Minneapolis Institute of Arts
The Alfred and Ingrid Lenz Harrison
Purchase Fund and gift of The
Richard Avedon Foundation, 2011.15
© The Richard Avedon Foundation

113
Andy Warhol
American, 1928–1987
Jack Nicklaus, 1977
Polaroid Polacolor Type 108
4¼ x 3⅜ inches
Collection of The Andy Warhol
Museum, Pittsburgh
© 2011 The Andy Warhol Foundation
for the Visual Arts, Inc./Artists Rights
Society (ARS), New York

114
Andy Warhol
American, 1928–1987
Jack Nicklaus, 1977
Polaroid Polacolor Type 108
4¼ x 3⅜ inches
Collection of The Andy Warhol
Museum, Pittsburgh
© 2011 The Andy Warhol Foundation
for the Visual Arts, Inc./Artists Rights
Society (ARS), New York

115
Andy Warhol
American, 1928–1987
Jack Nicklaus, 1977
Polaroid Polacolor Type 108
4¼ x 3⅜ inches
Collection of The Andy Warhol
Museum, Pittsburgh
© 2011 The Andy Warhol Foundation
for the Visual Arts, Inc./Artists Rights
Society (ARS), New York

116
Andy Warhol
American, 1928–1987
Jack Nicklaus, 1977
Polaroid Polacolor Type 108
4¼ x 3⅜ inches
Collection of The Andy Warhol
Museum, Pittsburgh
© 2011 The Andy Warhol Foundation
for the Visual Arts, Inc./Artists Rights
Society (ARS), New York

117
Andy Warhol
American, 1928–1987
Wayne Gretzky, 1983
Polaroid Polacolor Type 108
4¼ x 3⅜ inches
Collection of The Andy Warhol
Museum, Pittsburgh
© 2011 The Andy Warhol Foundation
for the Visual Arts, Inc./Artists Rights
Society (ARS), New York

118
Andy Warhol
American, 1928–1987
Wayne Gretzky, 1983
Polaroid Polacolor Type 108
4¼ x 3⅜ inches
Collection of The Andy Warhol
Museum, Pittsburgh
© 2011 The Andy Warhol Foundation
for the Visual Arts, Inc./Artists Rights
Society (ARS), New York

119
Andy Warhol
American, 1928–1987
Wayne Gretzky, 1983
Polaroid Polacolor Type 108
4¼ x 3⅜ inches
Collection of The Andy Warhol
Museum, Pittsburgh
© 2011 The Andy Warhol Foundation
for the Visual Arts, Inc./Artists Rights
Society (ARS), New York

120
Andy Warhol
American, 1928–1987
Wayne Gretzky, 1983
Polaroid Polacolor Type 108
4¼ x 3⅜ inches
Collection of The Andy Warhol
Museum, Pittsburgh
© 2011 The Andy Warhol Foundation
for the Visual Arts, Inc./Artists Rights
Society (ARS), New York

121
Robert Mapplethorpe
American, 1946–1989
Arnold Schwarzenegger, 1976
Gelatin silver print
14 x 13⅞ inches
Curtis Galleries, Minneapolis, Minnesota
© Robert Mapplethorpe Foundation
Used by permission.

122
Stephen Shore
American, born 1947
**Sparky Lyle's locker, Ft. Lauderdale,
Florida**, 1978
Color coupler print
7¹¹⁄₁₆ x 9¹¹⁄₁₆ inches
Minneapolis Institute of Arts
Gift of American Telephone and
Telegraph Company, 81.120.59

123
Hank Willis Thomas
American, born 1976
Smokin' Joe Ain't J'mama,
1978/2006
Lightjet print
31 x 30 inches
Courtesy of the artist and
Jack Shainman Gallery, New York

124
Hank Willis Thomas
American, born 1976
Gotten, 1996/2007
Lightjet print
36 x 28 inches
Courtesy of the artist and
Jack Shainman Gallery, New York
Original photo by Annie Leibovitz

125
Annie Leibovitz
American, born 1949
Kirby Puckett, Orlando, Florida,
1988
Archival pigment print
Size variable
© Annie Leibovitz, 2011
All rights reserved.

126
Ezra Shaw
American, born 1974
Olympics Day 9—Swimming (detail),
2008
Gelatin silver print
Size variable
© 2008 Getty Images

127
Martin Munkacsi
Hungarian, 1896–1963
Spectators at a Sports Event, from
the series Crowd, 1933
Gelatin silver print
11⁹⁄₁₆ x 9¼ inches
San Francisco Museum of Modern Art,
Byron R. Meyer Fund purchase
© Estate of Joan Munkacsi
© Estate of Martin Munkacsi, courtesy
of Howard Greenberg Gallery

128
Henri Cartier-Bresson
French, 1908–2004
**This Fan Listens to a Distant Ball
Game While Watching Another**,
1957
Gelatin silver print
9¾ x 6⅝ inches
The J. Paul Getty Museum,
Los Angeles
© Magnum Photos

129
Lee Friedlander
American, born 1934
Baltimore, 1962
Gelatin silver print (printed later)
16 x 20 inches (sheet)
© Lee Friedlander, courtesy Fraenkel
Gallery, San Francisco

130
Toby Old
American, born 1945
KO'd on TV, New York City, from
Boxing series, 1983
Gelatin silver print
13¹³⁄₁₆ x 14¼ inches
Minneapolis Institute of Arts
Gift of funds from Michael K. Hsu and
an anonymous donor, 2000.68.37
© Toby Old

131
Tod Papageorge
American, born 1940
**Cotton Bowl (Notre Dame vs.
Texas), Cotton Bowl Stadium,
Dallas, January 1, 1971**
Gelatin silver print
8⁵⁄₁₆ x 12⁹⁄₁₆ inches
© Tod Papageorge
Courtesy Pace/MacGill Gallery

132
Tod Papageorge
American, born 1940
**Iron Bowl (Auburn vs. Alabama),
Legion Field, Birmingham,
Alabama, November 28, 1970**
Gelatin silver print
8⅜ x 12⅝ inches
© Tod Papageorge
Courtesy Pace/MacGill Gallery

133
Tod Papageorge
American, born 1940
**Iron Bowl (Auburn vs. Alabama),
Legion Field, Birmingham,
Alabama, November 28, 1970**
Gelatin silver print
8⅜ x 12⅝ inches
© Tod Papageorge
Courtesy Pace/MacGill Gallery

134
Tod Papageorge
American, born 1940
**Opening Day (Boston vs.
New York), Yankee Stadium,
New York, April 7, 1970**
Gelatin silver print
8⁵⁄₁₆ x 12⅝ inches
© Tod Papageorge
Courtesy Pace/MacGill Gallery

135
Tod Papageorge
American, born 1940
**Belmont Stakes, Belmont Park,
New York, June 6, 1970**
Gelatin silver print
8⅜ x 12⅝ inches
© Tod Papageorge
Courtesy Pace/MacGill Gallery

136
Tod Papageorge
American, born 1940
**Little League World Series,
Lamade Stadium, Williamsport,
Pennsylvania, August 26, 1970**
Gelatin silver print
8⅜ x 12⅝ inches
© Tod Papageorge
Courtesy Pace/MacGill Gallery

137
Tod Papageorge
American, born 1940
**Iron Bowl (Auburn vs. Alabama),
Legion Field, Birmingham,
Alabama, November 28, 1970**
Gelatin silver print
8⁵⁄₁₆ x 12⁹⁄₁₆ inches
© Tod Papageorge
Courtesy Pace/MacGill Gallery

138
Andreas Gursky
German, born 1955
• **Tour de France**, 2007
Chromogenic print
121 x 86⅕ inches (framed)
Courtesy Sprüth Magers Berlin London
© 2011 Andreas Gursky/Artists
Rights Society (ARS), New York/VG
Bild-Kunst, Bonn

139
Andreas Gursky
German, born 1955
Bahrain I, 2005
Chromogenic print
118⅞ x 86½ inches
The Museum of Modern Art, New York
Acquired in honor of Robert B. Menschel
through the generosity of Agnes Gund,
Marie-Josée and Henry R. Kravis,
Ronald S. and Jo Carole Lauder, and
the Speyer Family Foundation
© The Museum of Modern Art/
Licensed by SCALA/Art Resource,
New York
© 2011 Andreas Gursky/Artists
Rights Society (ARS), New York/VG
Bild-Kunst, Bonn

140
Sharon Lockhart
American, born 1964
**Goshogaoka Girls Basketball
Team:
Group III: (a) Chihiro Nishijima;
(b) Sayaka Miyamoto and Takako
Yamada; (c) Kumiko Shirai and
Eri Hashimoto; (d) Kumiko Kotake**,
1997
Four chromogenic prints
37⅛ x 31 inches (framed)
© Sharon Lockhart
Courtesy Gladstone Gallery, New York
and Brussels

141
Sharon Lockhart
American, born 1964
**Goshogaoka Girls Basketball
Team:
Group IV: (a) Ayako Sano**, 1997
Chromogenic print
44¾ x 37¾ inches (framed)
© Sharon Lockhart
Courtesy Gladstone Gallery, New York
and Brussels

142
(Three images)
Kota Ezawa
American (born Germany), born 1969
Brawl, 2008
Digital animation transferred to 16mm
film, with soundtrack
4 minutes, 11 seconds
Size variable
Courtesy the artist and Murray Guy
Gallery, New York

143
(Four images)
Roger Welch
American, born 1946
O. J. Simpson Project, 1977
Film and video installation, variable size
Courtesy Roger Welch

144
Unknown photographer (American)
**Untitled [Fight between Bob
Fitzsimmons and Peter Maher,
Coahuila de Zaragoza, Mexico]**
(detail), 1896
Gelatin silver print (print c. 1950s)
8⁷⁄₁₆ x 6⅝ inches
The J. Paul Getty Museum,
Los Angeles

145
Gjon Mili
American (born Albania), 1904–1984
**Joe Walcott Knocks Joe Louis to the
Canvas, Championship Match**, 1947
Gelatin silver print (printed 1997)
9⅛ x 9 inches
Courtesy of Howard Greenberg Gallery
Time & Life Pictures/Getty Images

146
Unknown photographer (American)
**Untitled [Floyd Patterson
knocking out opponent]**,
c. 1950s
Gelatin silver print, matte print
7⅜ x 9⁷⁄₁₆ inches
The J. Paul Getty Museum,
Los Angeles

147
Unknown photographer (American)
**Untitled [Floyd Patterson
knocking out opponent]**, c. 1950s
Gelatin silver print
7½ x 9⅜ inches
The J. Paul Getty Museum,
Los Angeles

148
Unknown photographer (American)
**Untitled [Two boxers in the ring,
one with a bloody eye]**, c. 1950s
Gelatin silver print
6⁹⁄₁₆ x 8⅞ inches
The J. Paul Getty Museum,
Los Angeles

149
Unknown photographer (American)
**Untitled [Boxer with referee in
the ring]**, c. 1950s
Gelatin silver print
6⁹⁄₁₆ x 8½ inches
The J. Paul Getty Museum,
Los Angeles

150
Unknown photographer (American)
**Untitled [Two boxers in the ring,
one being restrained by the
referee]**, c. 1950s
Gelatin silver print
6½ x 8⅜ inches
The J. Paul Getty Museum,
Los Angeles

151
Unknown photographer (American)
Untitled [Joe Louis knocking opponent to the canvas],
c. late 1930s–40s
Gelatin silver print
7½ x 9½ inches
The J. Paul Getty Museum,
Los Angeles

152
Unknown photographer (American)
Untitled [Two boxers in the ring, one falling to canvas], c. 1940s
Gelatin silver print
7¹¹⁄₁₆ x 9⁵⁄₁₆ inches
The J. Paul Getty Museum,
Los Angeles

153
Unknown photographer (American)
Untitled [Boxer knocked out on the canvas], c. 1940s
Gelatin silver print, ferrotyped print
4¾ x 8⅜ inches
The J. Paul Getty Museum,
Los Angeles

154
Charles Hoff
American, 1905–1975
Unidentified Boxers (Golden Gloves), c. 1950s
Gelatin silver print
7½ x 9½ inches
Courtesy of Howard Greenberg Gallery

155
Charles Hoff
American, 1905–1975
Unidentified Boxers (Golden Gloves), c. 1950s
Gelatin silver print
7½ x 9½ inches
Courtesy of Howard Greenberg Gallery

156
Tod Papageorge
American, born 1940
Shea Stadium, New York, 1970
Gelatin silver print
8⁵⁄₁₆ x 12⁹⁄₁₆ inches
© Tod Papageorge
Courtesy Pace/MacGill Gallery

Exhibition Only

The following works, not pictured in this catalogue, appeared in "The Sports Show" exhibition at the MIA.

Morris Berman
American, 1910–2002
Y. A. Tittle Toppled, 1964
Gelatin silver print (print c. 1970s)
18 x 15¹³⁄₁₆ inches
The Museum of Fine Arts, Houston
Gift of Robert H. Allen, M. Robert Dussler, Harry Gee, Javier Loya, D. Cal McNair, Wm. P. O'Connell, Corbin J. Robertson, Jr., Scott Schwinger, and Michael Stevens, in honor of Robert C. McNair and the Houston Texans at "One Great Night in November, 2005"
© Courtesy Martin Gordon Gallery

Joseph Beuys
German, 1921–1986
Filz-TV (Felt TV), 1970
Documentation of performance, TV broadcast "Identifications"
18 x 24 x 3½ inches installed
Collection Walker Art Center, Minneapolis; T. B. Walker Acquisitions Fund, 1995
© 2011 Artists Rights Society (ARS), New York/VG Bild-Kunst, Bonn

Charles M. Conlon
American, 1868–1945
How Charles Robertson (White Sox) Holds Ball, c. 1919–25
Gelatin silver print
8½ x 6⁹⁄₁₆ inches
The Metropolitan Museum of Art, New York, N.Y., U.S.A. Funds from various donors, 2006 (2006.49). Image copyright © The Metropolitan Museum of Art/Art Resource, New York

Edgerton, Germeshausen & Grier
Untitled [High-speed photograph of Bobby Jones as he hits a ball with a driver], c. 1938
Gelatin silver print
Size variable
Library of Congress Prints and Photographs Division,
LC-USZ62-117917
J26222 U.S. Copyright Office.Wittemann Collection (Library of Congress). Copyright by A.G. Spalding & Bros.

Amy Elkins
American, born 1979
Zak (Second Row, University Team Captain), Princeton, NJ, 2010
Archival inkjet print
16 x 20 inches
© Amy Elkins
Courtesy of the artist and Yancey Richardson Gallery, New York

Amy Elkins
American, born 1979
Rick (Tight Head Prop Forward), Princeton, NJ, 2010
Archival inkjet print
16 x 20 inches
© Amy Elkins
Courtesy of the artist and Yancey Richardson Gallery, New York

Fritz Henle
American (born Germany), 1909–1993
Watching a Football Game, c. 1930s
Gelatin silver print
3⅜ x 3¼ inches
The J. Paul Getty Museum,
Los Angeles
© Fritz Henle Estate

Charles Hoff
American, 1905–1975
Boxers, c. 1950s
Gelatin silver print
7¾ x 9¾ inches
Courtesy of Howard Greenberg Gallery

Charles Hoff
American, 1905–1975
Floyd Patterson vs. Tommy (Hurricane) Jackson, July 29, 1957
Gelatin silver print
7½ x 9½ inches
Courtesy of Howard Greenberg Gallery

Charles Hoff
American, 1905–1975
Untitled, n.d.
Gelatin silver print
9½ x 7½ inches
Courtesy of Howard Greenberg Gallery

Jacques Henri Lartigue
French, 1894–1986
Wheeled Bobsleigh Designed by Jacques Henri Lartigue, 1911
Gelatin silver print
6¹¹/₁₆ x 9¹/₁₆ inches
Minneapolis Institute of Arts
The Kate and Hall J. Peterson Fund,
72.118.7
© Ministère de la Culture—France/
AAJHL

Felix H. Man
British (born Germany), 1893–1985
Untitled [Weightlifting in Metzgerbräu Beer Hall, Munich], 1929
Gelatin silver print
3¾ x 5¹/₁₆ inches
Gilman Collection, Purchase,
Denise and Andrew Saul Gift, 2005
(2005.100.576).
The Metropolitan Museum of Art,
New York, N.Y., U.S.A.
Image copyright © The Metropolitan
Museum of Art/Art Resource,
New York
© Copyright Metzgerbräu, München

Eadweard Muybridge
American (born England), 1830–1904
Wrestling, Graeco-Roman,
plate 347, 1887
Collotype
6⅞ x 17⅝ inches
Courtesy Fraenkel Gallery,
San Francisco

Tod Papageorge
American, born 1940
Iron Bowl (Auburn vs. Alabama), Legion Field, Birmingham, Alabama, November 28, 1970
Gelatin silver print
8⅜ x 12¹¹/₁₆ inches
© Tod Papageorge.
Courtesy Pace/MacGill Gallery

Tod Papageorge
American, born 1940
Iron Bowl (Auburn vs. Alabama), Legion Field, Birmingham, Alabama, November 28, 1970
Gelatin silver print
8⁵/₁₆ x 12⁹/₁₆ inches
© Tod Papageorge.
Courtesy Pace/MacGill Gallery

Tod Papageorge
American, born 1940
Shea Stadium, New York, 1970
Gelatin silver print
7¾ x 11 ½ inches
© Tod Papageorge.
Courtesy Pace/MacGill Gallery

Irving Penn
American, 1917–2009
Dusek Brothers, New York, 1948
Gelatin silver print
19 x 14⅞ inches
Courtesy Fraenkel Gallery,
San Francisco

Herb Scharfman
American, 1912–1998
Untitled [Rocky Marciano KO's Jersey Joe Walcott], 1952
Gelatin silver print
Size variable
Library of Congress Prints
and Photographs Division,
LC-USZ62-107552

Wolfgang Tillmans
German, born 1968
Cliff, 2000
© Wolfgang Tillmans
Courtesy the artist and Andrea Rosen
Gallery, New York

Geoff Winningham
American, born 1943
Wrestling (Houston), 1971
Gelatin silver print
11 ¼ x 17¼ inches
The Museum of Fine Arts, Houston
Gift of Gamma Phi Beta with
additional funds provided by the
National Endowment for the Arts

Geoff Winningham
American, born 1943
Super Bowl (Houston), 1974
Gelatin silver print
11 ¹³/₁₆ x 17¾ inches
The Museum of Fine Arts, Houston
Gift of Gamma Phi Beta with
additional funds provided by the
National Endowment for the Arts

Unknown photographer
Untitled [Sgt. Torger Tokle won the first half of the ski-jumping tournament staged at Wrigley Field, Chicago, Ill., Jan. 1944]
Gelatin silver print
Size variable
Library of Congress Prints
and Photographs Division, from SSF

Unknown photographer
AP Wire Photo, New York Times
Press Archive
The Beatles and Clay Spar a Fast Roundelay, 1964
Gelatin silver print
8⅛ x 10 inches (sheet)
Private collection

Unknown photographer (American)
Untitled [Two boxers, one knocked to canvas], c. 1920s
Gelatin silver print (printed later)
5¹⁵/₁₆ x 9⁷/₁₆ inches
The J. Paul Getty Museum,
Los Angeles

Unknown photographer (American)
Untitled [Two boxers, both on canvas], c. 1950s
Gelatin silver print
7⁹/₁₆ x 9⅜ inches
The J. Paul Getty Museum,
Los Angeles

Unknown photographer (American)
Untitled [Two boxers, one tripping over downed boxer], c. 1950s
Gelatin silver print
7½ x 9⅜ inches
The J. Paul Getty Museum,
Los Angeles

Unknown photographer (American)
Untitled [Two boxers, one knocked through the ring ropes], c. 1940s
Gelatin silver print
7⁹/₁₆ x 9⅜ inches
The J. Paul Getty Museum,
Los Angeles

Unknown photographer (American)
Untitled [Two boxers in the ring, one falling to canvas], c. 1950s
Gelatin silver print
9⁷/₁₆ x 7½ inches
The J. Paul Getty Museum,
Los Angeles

Unknown photographer (American)
Untitled [Black boxer knocking out white boxer], c. 1940s
Gelatin silver print, ferrotyped print
7¹³/₁₆ x 9⅜ inches
The J. Paul Getty Museum,
Los Angeles

Unknown photographer (American)
Untitled [Two boxers in the ring, one falling to canvas], c. 1940s
Gelatin silver print
7½ x 9⅜ inches
The J. Paul Getty Museum,
Los Angeles

Unknown photographer (American)
Untitled [Two boxers in the ring],
c. 1950s
Gelatin silver print
6⅜ x 8⅜ inches
The J. Paul Getty Museum,
Los Angeles

Unknown photographer (American)
Untitled [Ace Hudkins fighting Sergeant Sammy Baker, Wrigley Field Arena, Los Angeles], 1927
Gelatin silver print
5¹¹⁄₁₆ x 9¹⁄₁₆ inches
The J. Paul Getty Museum,
Los Angeles

Unknown photographer (American)
Untitled [Two boxers in the ring, one falling to canvas], 1940s
Gelatin silver print, ferrotyped print
6⅜ x 8⅛ inches
The J. Paul Getty Museum,
Los Angeles

Unknown photographer (American)
Untitled [Boxing match between Billy Soose and Ernie Vigh, Madison Square Garden, New York City], 1941
Gelatin silver print
6⁷⁄₁₆ x 8¼ inches
The J. Paul Getty Museum,
Los Angeles

Unknown photographer
AP Press Photograph, San Francisco
Examiner Reference Library
Masked Arab terrorist at Munich Olympics, 1972
Laser photograph
7⁹⁄₁₆ x 9¾ inches (sheet)
Private collection

Unknown photographer
AP Press Photograph
Muhammad Ali press conference,
1971
Gelatin silver print
10 x 8 inches (sheet)
Private collection

Unknown photographer
AP Press Photograph
Hank Aaron hits 715th home run,
1974
Vintage wire print
10¹¹⁄₁₆ x 7³⁄₁₆ inches (sheet)
Private collection

Unknown photographer
Untitled [The prodigal son returns—great crowds greet Bobby Jones as he arrives at City Hall, Atlanta, Georgia with three new major golf titles], n.d.
Gelatin silver print
Size variable
Library of Congress Prints
and Photographs Division,
LC-USZ62-80560

Unknown photographer
Untitled [The last stroke— Bobby Jones sinking 45-foot shot that won him his fourth U.S. Open Golf title], 1930
Gelatin silver print
Size variable
Library of Congress Prints
and Photographs Division,
LC-USZ62-96295

Unknown photographer
Untitled [Jack Johnson, full-length portrait, standing facing front, wearing boxing shorts and boxing gloves], c. 1910
Gelatin silver print
Size variable
Library of Congress Prints
and Photographs Division,
LC-USZ62-93412

Unknown photographer
Untitled [Ty Cobb, Detroit, and Joe Jackson, Cleveland, standing alongside each other, each holding bats], c. 1913
Gelatin silver print
Size variable
Library of Congress Prints
and Photographs Division,
LC-DIG–ppmsca-18474

Unknown photographer
Untitled [Young man on roller skates that are pedaled], 1910
Gelatin silver print
Size variable
Library of Congress Prints
and Photographs Division,
LC-USZ62-55467

Arnaud, Pierre, and James Riordan, eds. *Sport and International Politics.* London and New York: E & FN Spon, 1998.

Baker, Aaron. *Contesting Identities: Sports in American Film.* Urbana and Chicago: University of Illinois Press, 2003.

Barthes, Roland. *Mythologies.* Selected and translated from the French by Annette Lavers. New York: Hill & Wang, 1972.

————. *What Is Sport?* Translated by Richard Howard. New Haven and London: Yale University Press, 2007.

Booth, Douglas. *The Field: Truth and Fiction in Sport History.* London and New York: Routledge, 2005.

Buck-Morss, Susan. *The Dialectics of Seeing: Walter Benjamin and the Arcades Project.* Cambridge, Mass., and London: MIT Press, 1991. First published 1989.

Buonanno, Milly. *The Age of Television: Experiences and Theories.* Translated by Jennifer Radice. Chicago: Distributed for Intellect Ltd by University of Chicago Press, 2008.

Cahn, Susan K. *Coming on Strong: Gender and Sexuality in Twentieth-Century Women's Sport.* Cambridge, Mass., and London: Harvard University Press, 1995. First published 1994 by Free Press.

Debord, Guy. *Society of the Spectacle.* London: Black & Red, 2000. First published 1967 in France.

Early, Gerald L. *A Level Playing Field: African American Athletes and the Republic of Sports.* Cambridge, Mass., and London: Harvard University Press, 2011.

————, ed. *The Muhammad Ali Reader.* Hopewell, N.J.: Ecco Press, 1998.

Elkins, James, ed. *Photography Theory.* New York and London: Routledge, 2007.

Farrell, Leslie D., Paul H. Hutchinson, Kendall Bridges Reid, and Samuel L. Jackson. *The Journey of the African-American Athlete.* New York: HBO Home Video, 1996.

Fleder, Rob, ed. *Fifty Years of Great Writing: Sports Illustrated, 1954–2004.* New York: Time Inc., 2004.

Foer, Franklin. *How Soccer Explains the World: An Unlikely Theory of Globalization.* New York: Harper Perennial, 2005.

Gorn, Elliot. *The Manly Art: Bare-Knuckle Prize Fighting in America.* Updated edition. Ithaca, N.Y.: Cornell University Press, 2010.

Gorn, Elliott J., and Warren Goldstein. *A Brief History of American Sports.* Urbana and Chicago: University of Illinois Press, 2004. First published 1993 by Hill & Wang.

Guttmann, Allen. *From Ritual to Record: The Nature of Modern Sports.* New York: Columbia University Press, 1978.

————. *A Whole New Ball Game: An Interpretation of American Sports.* Chapel Hill: University of North Carolina Press, 1988.

Halberstam, David, ed. *The Best American Sports Writing of the Century.* Boston: Houghton Mifflin, 1999.

Hall, Stuart, ed. *Representation: Cultural Representations and Signifying Practices.* London and Thousand Oaks, Calif.: Sage Publications in association with the Open University, 1997.

Heywood, Leslie, and Shari L. Dworkin. *Built to Win: The Female Athlete as Cultural Icon.* Minneapolis: University of Minnesota Press, 2003.

Jay, Kathryn. *More Than Just a Game: Sports in American Life since 1945.* New York: Columbia University Press, 2004.

Kellner, Douglas. *Media Spectacle.* London and New York: Routledge, 2003.

Kracauer, Siegfried. *The Mass Ornament: Weimar Essays.* Translated and edited by Thomas Y. Levin. Cambridge, Mass., and London: Harvard University Press, 2005. Original German edition 1963.

Krauss, Rosalind E. *The Originality of the Avant-Garde and Other Modernist Myths.* Cambridge, Mass., and London: MIT Press, 1989.

Krüger, Arnd, and W. J. Murray. *The Nazi Olympics: Sport, Politics, and Appeasement in the 1930s.* Urbana: University of Illinois Press, 2003.

Lapchick, Richard Edward. *Fractured Focus: Sport as a Reflection of Society.* Lexington, Mass.: Lexington Books, 1986.

Large, David Clay. *Nazi Games: The Olympics of 1936.* New York: W. W. Norton, 2007.

Lipsky, Richard. *How We Play the Game: Why Sports Dominate American Life.* Boston: Beacon Press, 1981.

Mailer, Norman. *The Fight.* New York: Vintage International, 1997. First published 1975 by Little, Brown.

Man in Sport: An International Exhibition of Photography. Directed by Robert Riger. Baltimore: Baltimore Museum of Art, 1967.

Maraniss, David. *Rome 1960: The Olympics That Changed the World.* New York: Simon & Schuster, 2008.

Mead, Chris. *Champion—Joe Louis, Black Hero in White America*. New York: Scribner, 1985. Reprinted as *Joe Louis: Black Champion in White America*. Mineola, N.Y.: Dover, 2010.

Miller, David. *The Official History of the Olympic Games and the IOC: Athens to Beijing, 1894–2008*. Edinburgh: Mainstream Publishing, 2008.

Miller, Patrick B., and David K. Wiggins, eds. *Sport and the Color Line: Black Athletes and Race Relations in Twentieth-Century America*. New York and London: Routledge, 2004.

Mitchell, W. J. T. *Picture Theory: Essays on Verbal and Visual Representation*. Chicago: University of Chicago Press, 1994.

Nelson, Murry R. *Encyclopedia of Sports in America: A History from Foot Races to Extreme Sports*. 2 vols. Westport, Conn.: Greenwood Press, 2009.

O'Reilly, Jean, and Susan K. Cahn, eds. *Women and Sports in the United States: A Documentary Reader*. Boston: Northeastern University Press, 2007.

Oriard, Michael. *Reading Football: How the Popular Press Created an American Spectacle*. Chapel Hill: University of North Carolina Press, 1993.

Perrottet, Tony. *The Naked Olympics: The True Story of the Ancient Games*. New York: Random House Trade Paperbacks, 2004.

Rader, Benjamin G. *American Sports: From the Age of Folk Games to the Age of Televised Sports*. 6th ed. Upper Saddle River, N.J.: Pearson / Prentice Hall, 2009.

———. *In Its Own Image: How Television Has Transformed Sports*. New York: Free Press, 1984.

Reeve, Simon. *One Day in September: The Full Story of the 1972 Munich Olympics Massacre and the Israeli Revenge Operation "Wrath of God."* With a new epilogue. New York: Arcade, 2006.

Remnick, David. *King of the World: Muhammad Ali and the Rise of an American Hero*. New York: Vintage Books, 1999.

———, ed. *The Only Game in Town: Sportswriting from the New Yorker*. New York: Random House, 2010.

Rhoden, William C. *$40 Million Slaves: The Rise, Fall, and Redemption of the Black Athlete*. New York: Three Rivers Press, 2006.

Riefenstahl, Leni. *Leni Riefenstahl: A Memoir*. New York: Picador USA, 1995.

Riordan, James, and Arnd Krüger, eds. *The International Politics of Sport in the Twentieth Century*. New York: Routledge, 1999.

Ritter, Lawrence S. *The Glory of Their Times: The Story of the Early Days of Baseball Told by the Men Who Played It*. New enlarged edition. New York: William Morrow, 1984.

Roberts, Selena. *A Necessary Spectacle: Billie Jean King, Bobby Riggs, and the Tennis Match That Leveled the Game*. New York: Crown, 2005.

Roche, Maurice. *Mega-Events and Modernity: Olympics and Expos in the Growth of Global Culture*. London and New York: Routledge, 2000.

Simmons, Bill. *The Book of Basketball: The NBA According to the Sports Guy*. Updated. New York: Ballantine Books Trade Paperbacks and ESPN Books, 2010.

Stump, Al. *Cobb: A Biography*. Chapel Hill, N.C.: Algonquin Books of Chapel Hill, 1996.

Tomlinson, Alan. *Sport and Leisure Cultures*. Minneapolis: University of Minnesota Press, 2005.

———, ed. *The Sport Studies Reader*. New York: Routledge, 2007.

Weiner, Jay. *Stadium Games: Fifty Years of Big League Greed and Bush League Boondoggles*. Minneapolis: University of Minnesota Press, 2000.

Whannel, Garry. *Fields in Vision: Television Sport and Cultural Transformation*. London and New York: Routledge, 1992.

Williams, Raymond. *Culture and Society, 1780–1950*. New York: Columbia University Press, 1983. First published 1958.

———. "Culture Is Ordinary" (1958). In *The Everyday Life Reader*, edited by Ben Highmore. London and New York: Routledge, 2002.

Wombell, Paul. *Sportscape: The Evolution of Sports Photography*. London: Phaidon, 2000.

David E. Little is Curator and Head of the Department of Photography and New Media at the Minneapolis Institute of Arts. He has served as Associate Director, Helena Rubinstein Chair of Education, at the Whitney Museum of American Art and was Director of Adult and Academic Programs at the Museum of Modern Art. Little holds a Ph.D. in art history from Duke University and has published and lectured on contemporary artists' groups, photography, and media art. He calls Minnesota home, but remains an avid Boston Red Sox fan.

Simon Critchley is Hans Jonas Professor of Philosophy at the New School for Social Research. He is the author of many books, including *The Book of Dead Philosophers*, *Things Merely Are*, and *Infinitely Demanding*. His newest book, *The Faith of the Faithless*, will be published in March 2012. He is the moderator of and regular contributor to "The Stone," a popular philosophy column with the *New York Times*. In 2010, Critchley organized the exhibition "Men with Balls: The Art of the 2010 World Cup" at apexart in New York. He remains a lifelong fan of Liverpool Football Club—his only religious commitment.

Joyce Carol Oates is a recipient of the National Book Award and the PEN/Malamud Award for Excellence in Short Fiction. She has written numerous novels, including the national bestsellers *We Were the Mulvaneys* and *Blonde* (a finalist for the National Book Award and the Pulitzer Prize), and the *New York Times* bestsellers *The Falls* (winner of the 2005 Prix Femina Etranger) and *The Gravedigger's Daughter*. She is the Roger S. Berlind Distinguished Professor of the Humanities at Princeton University and has been a member of the American Academy of Arts and Letters since 1978. In 2003 she received the Common Wealth Award for Distinguished Service in Literature and The *Kenyon Review* Award for Literary Achievement, and in 2006 she received the *Chicago Tribune* Lifetime Achievement Award.

Roger Welch is a conceptual artist and pioneer of video and multimedia art whose work has been exhibited internationally since the 1970s.

Tom Arndt is a Minnesota-based photographer whose works are in the permanent collections of the Museum of Modern Art, the Art Institute of Chicago, and the Minneapolis Institute of Arts. His photography books include *Men in America* and *Home: Tom Arndt's Minnesota*.

Nicole Soukup holds an M.A. in art history from the University of Florida. She assisted with research for "The Sports Show" as an intern in the Department of Photography and New Media at the Minneapolis Institute of Arts.

156